PAINTING LANDSCAPES IN

Watercolour

Paul Talbot-Greaves

THE CROWOOD PRESS

First published in 2009 by
The Crowood Press Ltd
Ramsbury, Marlborough
Wiltshire SN8 2HR

www.crowood.com

British Library Cataloguing-in-Publication Data
A catalogue record for this book is available from the British Library.

ISBN 978 1 84797 085 5

Typeset by Simon Loxley

Printed and bound in Singapore by Craft Print International

CONTENTS

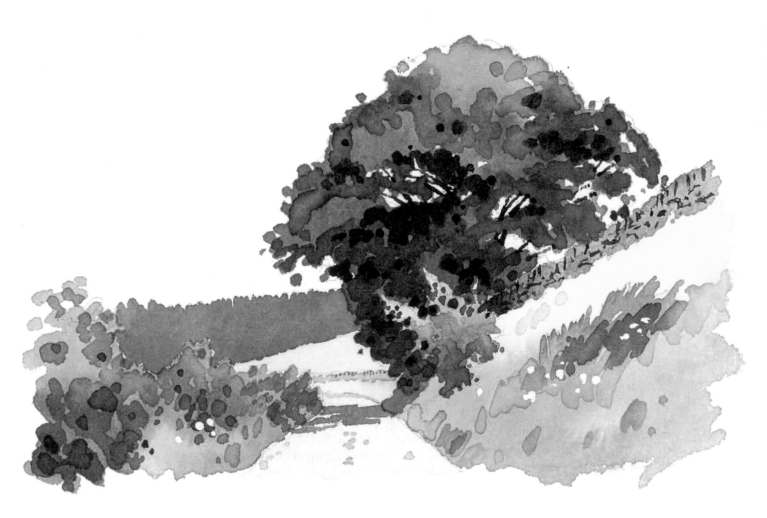

Watercolour is capable of producing a full range
of tones, from thin translucent washes of light
to bold dark shadows and shades, making it
the ideal choice for landscape work.

Acknowledgements

This book is dedicated to all of my students, both past and present, who have not only learned from me but who have also inadvertently taught me so much. To all those dedicated artists struggling to better themselves and a special thank you to my regular students who enjoy my courses and keep me doing what I am doing. A thank you goes to my friend Trevor without whose advice, encouragement and direction in my early years of painting I may never have reached my intended goals. To my parents who introduced me to the countryside as a young boy and lit a fire inside that has since never gone out. To my dear wife Sarah for her unending support and help with everything I do. I am also indebted to the Society for All Artists for their encouraging support throughout my career, to *Artists and Illustrators* magazine and to St Cuthberts Mill for making and supplying me with my favourite Bockingford paper.

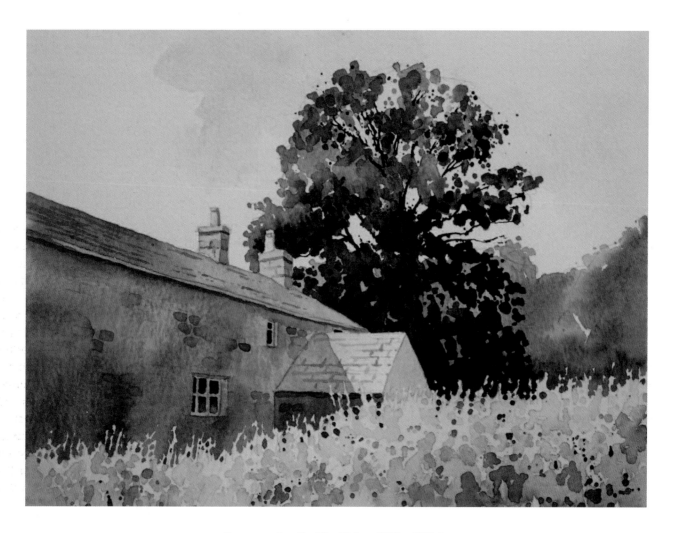

Farm near Pendle, 30 x 22.5cm (11³/4 x 8³/4in).
Here the feeling of summer light is captured in the
varicoloured washes of warm and cool colours in the
stonework, shadows and trees. Notice the inclusion of
dark tones, as these are so important for creating the
effects of light and shade.

INTRODUCTION

As in any kind of development throughout the world, painting has evolved through innovative and pioneering artists forging new ground and exciting new techniques. Other artists then gain inspiration from those leading the way, creating further new ideas, experiments and genres. The evolution of influence continues today in exactly the same way, as artists carry on producing works that inspire others to experiment in various different directions. The communication channels where influence can be derived from have increased over the centuries, from work seen only at exhibition to modern work shared with others in books, through the Internet and in film and television. Inspiration can be sought in many ways, from the way a particular artist employs his or her personal style to a simple but effective technique that might change the course of an individual's approach to painting. On the flip side there is a very fine line between being inspired by a favourite artist and being totally absorbed by his or her work. This is often apparent in amateur exhibitions where sometimes paintings for sale can be generally identified as being taken directly from a book. There are many arguments revolving around doing this, and my own opinion is that on the one hand the artist has enjoyed painting a work by his or her mentor and may have indeed learned about a certain technique or approach to painting that he or she has not already explored. On the other hand, selling that work technically breaches copyright law, although in most cases the intention is probably only to share the painter's enjoyment with those who are viewing the work and not to profiteer from their actions. I suppose one also has to explore morally the ethics of selling such a 'second-hand' painting to an unsuspecting customer. Copying directly from paintings or photographs or even enforcing oneself to paint 'in the style of' stifles the individual's own talent and freedom of expression. Whilst it may be beneficial for

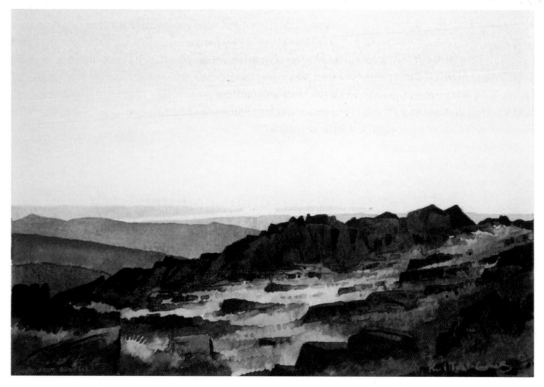

Dawn from Bowfell, 30 x 21cm (11¾ x 8¼in). **This painting was completed after one of my sketching excursions into the mountains. After spending a cold night under canvas, the visual treat of studying a sunrise from a high vantage point was a memorable occasion for the artist.**

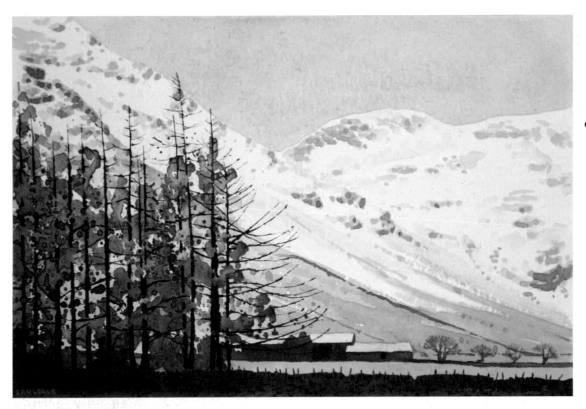

learning in the early stages, there is no better way of learning to paint than to paint as yourself. Style and an individual approach to working develop with time and practice, and these will evolve in their own time whilst the individual studies the real art of technique and applying paint to paper.

Landscape painting

In its early stages, landscape painting developed as a mere backcloth to other subjects and gradually it became a focus for painting in its own right. Initially, classical painters would use landscape as a setting for an alternative, often visual story. Paintings would contain certain standard elements such as trees, a building or two, usually some cattle in the foreground and depending on the story, figures in seemingly various states of terror, rescue, romance or repose. These would be large oil paintings, intended to impress and inspire, and watercolour, still in its infancy, would have been reserved only for small, compositional thumbnail sketches. Gradually, artists began to experiment with watercolour as a medium in its own right with the likes of J.M.W. Turner, Thomas Girtin and John Sell Cotman exploiting its potential as an expressive means. The development of landscape painting has continued to the present day and will perpetuate into the future as artists experiment with varied concepts, subjects and materials. Landscape painting offers so much in the way of subject matter that it can have a

twofold effect on the painter. On the one hand there is so much selection to paint, from small vignettes of landscape features to wide and expansive panoramic scenes taking in everything from trees, cattle, lakes and mountains to big skies and expressive moods. This provides the individual with an almost endless combination of different painting material. On the other hand the sheer choice of subject matter and the amount of content within a landscape painting can be quite daunting and it is often a reason why so many people find the topic so difficult to undertake. The best advice is to work within your means and chase the elements of landscape painting that interest you most of all. When you are comfortable with your painting you can keep your interest levels up by developing further your approach or choice of subjects.

Watercolour painting

Nowadays watercolour as a medium has been developed and exploited to a much greater depth than in Turner's day. Watercolour papers are acid free and comprise a huge range of styles, textures and weights. Manufacturing processes with watercolour pigments have been perfected to a fine degree and as a consequence much brighter, bolder and enduring paintings can now be achieved. A vast array of colours in different forms available from different manufacturers offers us an almost endless choice of materials to work with. Brush manufacture has been

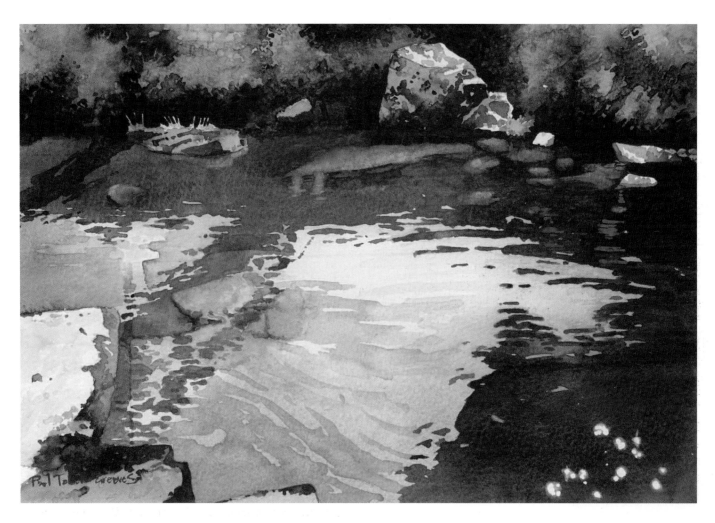

Light on the Wharfe, 30.5 x 21cm (12 x 8¾in).
Here I was inspired to paint the abstract shapes and tones of a section of river. The process of painting the picture was certainly a test of wash technique and each stage had to be considered before the washes were applied in order to paint them in the correct sequence. Within the technicalities, however, there would be many other ways of completing the picture, with very similar results.

finely adapted to cater for all abilities and personal budgets although the traditional method of making brushes is still employed. Artists can now choose from top-quality Kolinsky sables right down to inexpensive synthetic fibre brushes, all of which are made with the watercolourist in mind. As the materials for painting have progressed over the years it is only to be expected that artists exploiting these new advances have also further developed in technique and approach.

Watercolour is seen at its best when confident fluid washes of paint are placed with accurate deliberation and allowed to settle into the paper in a naturally drying state. Crisp, bold washes tend to please the eye and the reflection of pure white paper through transparent colour creates a luminance that is unre-

peatable in any other medium. No wonder then that although watercolour painting is deemed to be the hardest process to master it is also one of the most popular painting mediums to work with. This must also be down to its sheer convenience. You do not need much equipment to be able to paint with, it is clean, washable and only a small space is required to work in. Also, its portability is extremely convenient for artists wishing to work outdoors.

When compared to other mediums, such as oils, acrylics, pastels and so on, watercolour is seen as instant and manageable. You do not need an easel as with oils but instead an ordinary work surface is fine with maybe a book or two to prop your board at an angle if necessary. Oils require long periods of drying, which makes them ideal for slower work or for building up areas of fine detail but a watercolour can be finished before the first coloured ground for an oil painting has even begun to dry. Pastels are capable of producing fine blends of colour and tone and are able to create realistic paintings but they can be dry and powdery and as a result they may be fairly messy to use. Acrylics can be used thinly in the manner of a watercolour or thick like oils but either way the paint forms a fixed state and cannot be removed when it is dry. This can be advantageous if you want

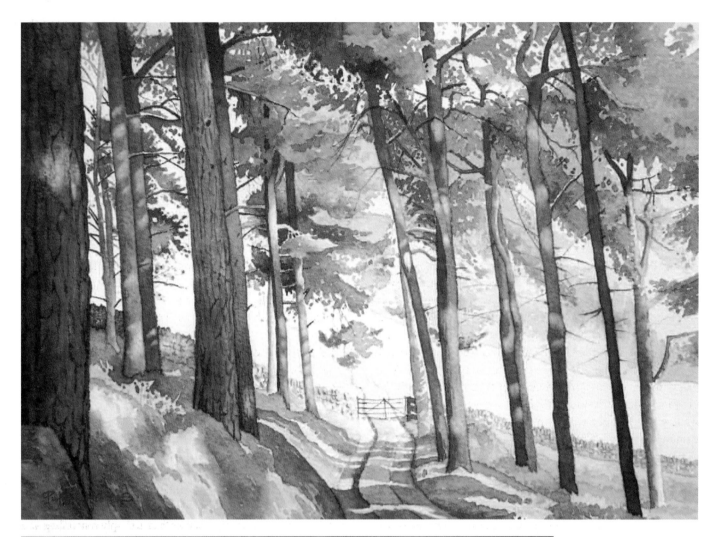

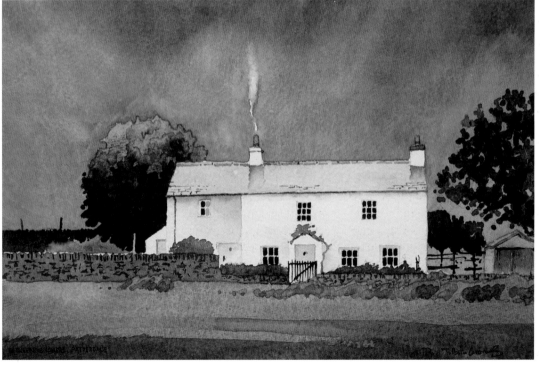

Between showers, Patterdale, 25.5 x 18cm (10 x 7in). The cottage huddled at the foot of a mountain slope had an inviting feel to it with smoke rising from the chimney. The day was grey and dreary but even on such occasions subjects can be found and paintings can be made interesting.

OPPOSITE LEFT: *At the edge of a wood*, 33 x 23cm (13 x 9in).
**The trees provided a grand scale to the painting and their
reflective bark and cast shadows dappled the whole scene with
light. When your senses are attuned to the elements that make
a striking painting you cannot help but see beauty in everyday
objects. The people I walked with on this occasion strolled
through the picture blissfully oblivious to the patterns of
colour, tone, shape and so on.**

to layer up many applications of paint as each layer is guaranteed not to disturb the previous one when washed over. However, as dry acrylic does not wash out of paper, neither does it wash out of clothes, carpets and brushes! Acrylics become tacky as they dry and they do not flow as well as watercolour. You should not discount using any of these mediums because what might not work for one person may very well be fine for another. Their comparisons do illustrate though the convenience of watercolour as a quick and clean medium to use and as such its transparent qualities and fresh finish project it into a world of its own. There are infinite ways of laying down paint and building up paintings, which are of course, exploited by different artists in many different ways. This is what makes us individual and what marks out our very own unique style and approach to painting. Washes can be laid down in several layers, over-tinted or applied as a single application. The amount of work that is applied to a painting depends partly on the subject and partly on the personality and decision-making abilities of the individual. There is no single way of undertaking a particular technique and certainly no clinical right or wrong approaches. However, the wise will adhere to the general guidelines for techniques such as washes, brush control and so on.

It is easy to compare one's own style and abilities with other artists but I feel that this can often be more of a hindrance and a distraction than anything of any benefit. Artists who have their own distinctive style and identity in their work are those who have concentrated solely on their own creation, probably over a number of years, rather than trying to closely imitate their peers. During one's early years of painting, emulating or copying work by other artists may be deemed as helpful, for instance in learning how to achieve a particular effect or technique but nothing can compare to the joy of truly creating your own production, unique to yourself and free of any other direct influences. Although progression is borne out of inspiration by other artists, that influence should be absorbed and interpreted subconsciously rather than through direct copying or imitation. Have your favourite artists, your heroes, enjoy their work and relish in creating your very own paintings fired by your reactions to their work.

On a realistic level, many painters form an addictive love-hate relationship with watercolour as they endure a roller coaster ride

of emotions. Things can go well one day and not so good the next. In extreme cases one can swing from top professional standards to less than basic ability within a couple of paintings. Just some of the qualities required of a watercolour painter are patience, perseverance, determination and a general acceptance that things do not always go to plan. One has to lower one's expectations and accept a certain tolerance level, for example you might aim for a particular effect or technique but the watercolour will always do something slightly different. More often than not this does not match your expectation but the critical factor lies in how you interpret things. There are artists and then there are perfectionists, the difference between the two is that the artist will gladly take on board the unexpected whilst the perfectionist will try to alter it to fit with his or her plan. Creation is only part control, the rest is down to happy accident although this is more of a misnomer than anything else, as there can be nothing more stressful than watching the wrong colour run into the wrong area at the wrong moment. Accidents are rarely happy occasions. With so much at stake then, why do we continue to paint landscapes in watercolour and what drives artists of all abilities to paint the world around them?

Painting watercolour landscapes

From a personal perspective, watercolour landscape painting combines the sheer pleasure of putting paint onto paper with a passion for the outdoors, whether that is simply marvelling at a particularly attractive group of mountains or taking delight in watching flickering light dance amongst the pebbles under slow moving, shallow water. There is also something attractive about our environment that remains undeveloped. To me, the hand of man is in many cases rather blind to aestheticism and the removal of greenery is all too readily accepted as progress rather than destruction of our natural habitat. I personally feel most inspired when I am out of sight of any human habitation, for example way up in the mountains or on a vast expanse of moorland, and this may reflect my inner fears or insecurities for the present and also the future. I enjoy history and I often enthuse about the past, painting images that often summarize an idyllic bygone lifestyle that directly relates to my inner feelings. I muse over the many layers of history laid down in the landscape and I find it fascinating to think that artists have been recording that history through their paintings for hundreds of years.

Landscape painting for me is a reaction to nature in which my inner thoughts, feelings and personality are expressed through the medium of watercolour. On a more basic level, I also enjoy the physical aspects of painting the magic of light and how this changes the appearance of the world around us. I do not set out

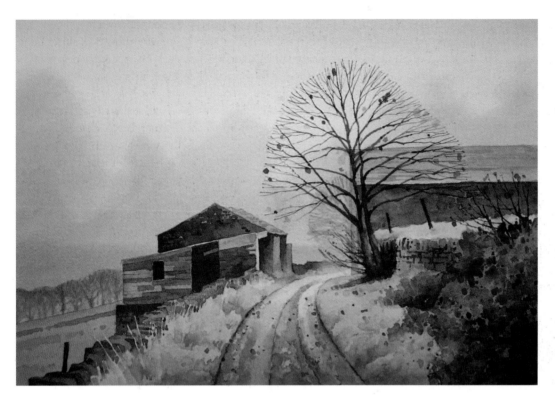

A farm in the Pennines,
33 x 23cm (13 x 9in).
**This painting depicts the
typical kind of subject
matter that I personally
find interesting. A Pennine
farmhouse hugs the
rugged slopes as it has
done for the last two
hundred years or so. The
lives it has harboured and
the passing history it has
witnessed are part and
parcel of the background
inspiration behind why
I painted it.**

to create grand stories though my paintings. I simply record patterns of tone, colour and shape, which are constantly appearing, disappearing and changing within the world around us. What one person reads into a painting may be different from another, and may be entirely different from how the artist interpreted the scene he or she chose to paint in the first place. Some art critics may pontificate over a work, unravelling their own opinions about the background story and what the scene epitomizes but perhaps the artist just painted what he or she enjoyed painting for the sake of it.

Certain painters can often appear to be more popular than others through their style and approach to painting. Although beauty is in the eye of the beholder, there must be a common thread within all of us that recognizes an attractive-looking painting out of the thousands of works created every year. Elements that catch the eye are often the simpler visual aspects such as limited amounts of colour, blocks of tone and less detail. Some artists have a natural affinity of combining these aspects in their paintings and others have to work hard or seek tuition in making their works more striking. Atmosphere grabs at the soul and those with a poetic eye and a creative vision will use

atmospheric effects to achieve paintings that have a great amount of mood and romanticism. Light changes the landscape in many different ways and it can induce lively paintings of bright summer sunshine complete with dancing shadows and dappled shade. In other muted lights the same scene may be passed by, not even being considered interesting enough to warrant putting a brush to paper. Our lives revolve around the cycle of light and atmosphere and perhaps this is why its magical effects influence us. There is nothing better than a patch of light cast onto a dark, shaded hillside to fire my imagination and get the paint flowing from my brushes. Whatever theories and explanations there may be as to why we paint what we paint the overriding answer is clear. Painting should be a pleasurable experience, in fact John Constable reputedly once said, 'Painting is just another word for pleasure.' I could not agree more.

OPPOSITE RIGHT: *A passing storm*, 29 x 21cm (11½ x 8¾in).
**Here a patch of light cast across the landscape lifts an
otherwise ordinary scene into a different dimension. Effects
like these tend to prod the senses of many people.**

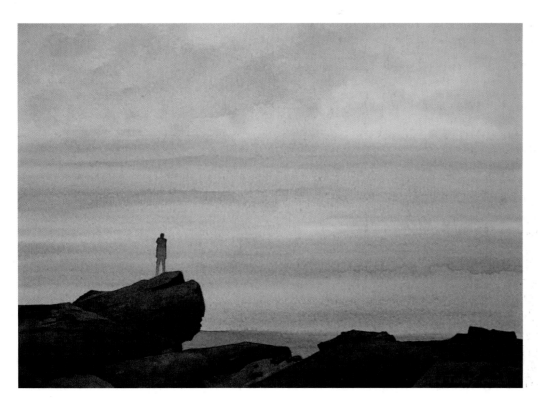

Looking east from Blackstone Edge, 33.5 x 24cm (13¼ x 9½in).
Here I was fascinated by the colour of the sky set against the dark foreground rocks. I painted the figure as a later addition in order to add scale. At exhibition, some people commented that the figure reminded them of either themselves or a loved one enjoying the view. I do enjoy the connections that people make with a painting and this kind of interaction is just one of the joys of painting.

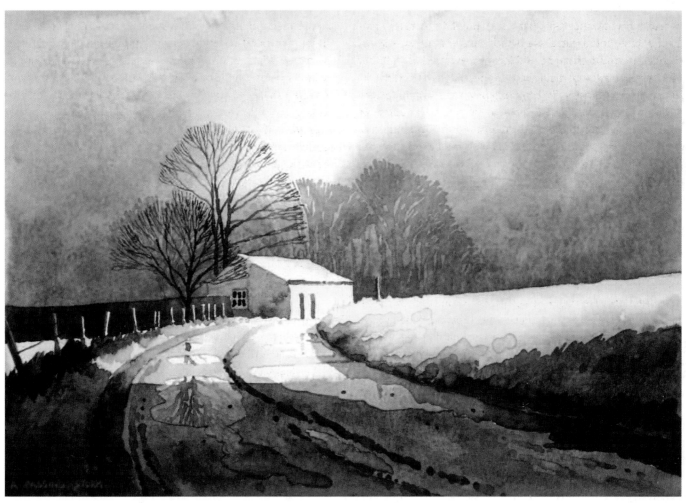

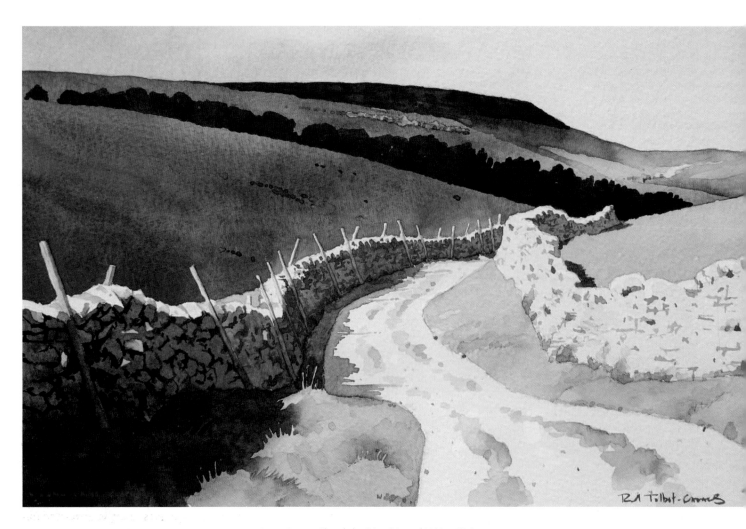

Long Lane, Clapdale, 29 x 20cm (11$\frac{1}{2}$ x 8in).
**A carefully executed watercolour with crisp, clean washes,
which are so important for such a subject.**

DEALING WITH WATERCOLOUR

Watercolour painting is often described as the most difficult medium to get to grips with, but why? The main reason is because its characteristics and handling are different from most other mediums. It may be complicated to overcome the many hurdles and master the many skills required but the appearance of a crisp, clean watercolour far outweighs that of other mediums. Watercolour is the perfect medium for those even with the most vague interest in painting, simply because it is so inexpensive and you can get away with using the most basic of materials. The greatest skill required for working with watercolour is in understanding its transparency and how this impacts on its handling and treatment.

Choosing your materials

The best results will only be achieved by using good-quality materials and equipment. I often meet very competent painters who insist on regularly using cheap or inferior materials without realizing that a simple switch to using good-quality items would improve their work no end. It may be beneficial to use cheaper equipment at an early stage of your development in order to keep costs down but there is no reason why you should continue with its use once a reasonable standard of painting has been attained. Often at my workshops I will lend some of my students a decent brush or two or donate a squeeze of artist's quality paint so that they can see the difference between quality and inferior materials. This usually has a big and immediate impact on their work, resulting in them stocking up with supplies more in line with their standard of painting. The amount of equipment needed for watercolour painting is technically very low although we do, as individuals, tend to collect many extra items that are either useless or remain unused throughout our painting occupation. I know of some artists who feel a need to purchase every colour of paint on offer just in case they need it but in reality they will only ever use a handful of their collection. One of my friends who paints with me regularly has every size of a particular brand of Kolinsky sable brush, including five different sizes of rigger brush. Most of these remain unused in his brush case although I know he does like to admire them from time to time. Sometimes buying a new brush or tube of paint, even though you may not need it, can have beneficial consequences from a psychologically charged 'feel good' point of view.

Paints

Only the finest watercolour paints of artist's quality will spread and settle with the elegant excellence required of a wash. The depth of colour, transparency and permanence of a reputable, quality paint can be instantly felt when switching from some of the more inferior paints. Some cheaper brands tend to be quite grainy with visible granules of pigment settling in unwanted formations on the paper. The permanence of cheaper paints cannot be measured in the same way as artist's quality watercolours. I have seen people using very cheap brands that are not much

The basic collection of brushes, paints, palette and water pot need never be expanded on but most artists do tend to collect extra items.

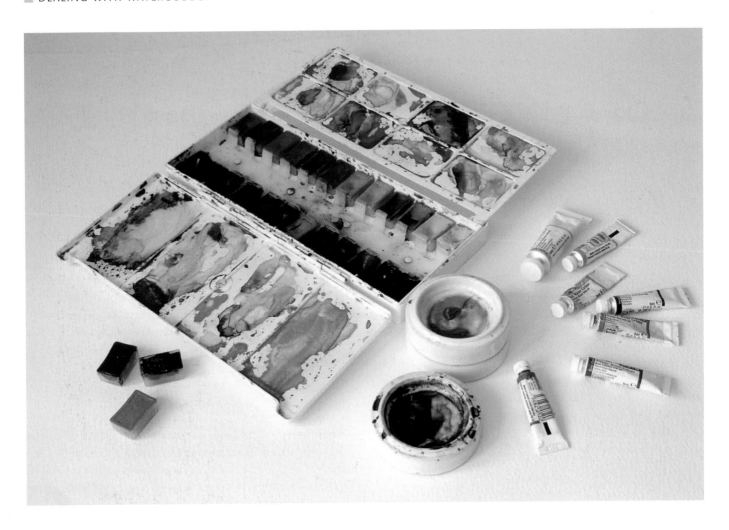

A variety of watercolour pans and tubes. Both are of artist's quality and
their fine pigments and permanence ensure the colour goes a long way.
The pan set shown here is ideal for outdoor work or for smaller paintings.
Anything larger than quarter imperial 38 x 28cm (15 x 11in) and I would
consider using tube paints in conjunction with a bigger mixing palette.

better in quality and handling than children's poster paints. If your work is of a reasonable standard then you should be buying your paints from your local art shop and not a bargain store or supermarket. Although good-quality watercolour paints seem expensive, the intensity of the pigments guarantees their permanence and as a result the colours do go a long way. Quality paint will also flow better and its performance will ensure that your colours blend easily leaving a professional finish. Cheaper brands tend to leave chalky deposits and the paint sometimes appears waxy due to the gums and fillers that are added. This leads to further painting problems with streaks and brush marks appearing in the washes as they dry. I prefer to use tubes of paint rather than pans as this ensures that I have instantly ready soft paint as I need it. Tubes are also kinder to your brushes as they do not require long periods of scrubbing to generate the colour.

Pans can have a negative effect on your studio work as a result of this. If you use pans and your work is lacking in depth and tone, try switching to tubes. Pans are more useful when tackling a painting or a sketch outdoors.

Papers

Paper is just as important a tool as quality paint and brushes. Certain cheap practice papers or paper retrieved from twenty years of being stored in the loft will not handle the paint like a fresh crisp sheet of good-quality watercolour paper. Again, I continue to see many artists trying to paint onto almost anything that becomes available – cartridge paper, raggy scraps of

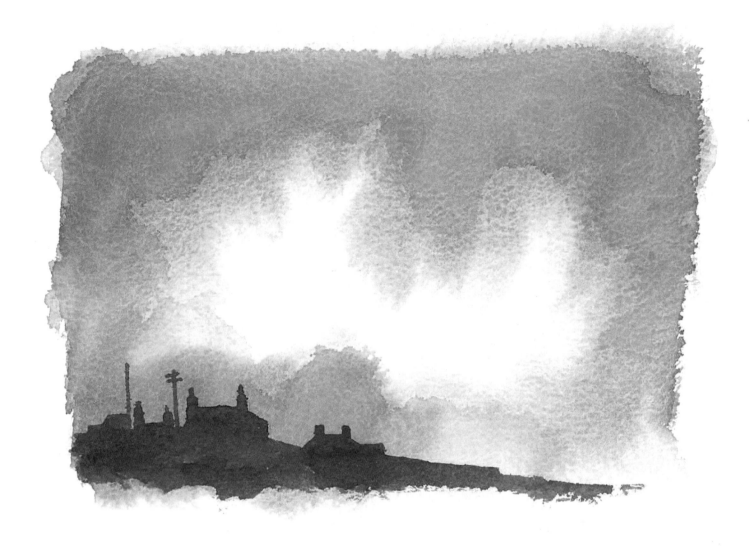

This paper has a damaged and scuffed surface, which made the application
of the paint frustratingly difficult. In places the detail of the roof shapes has
bled, leading to a fuzzy outline rather than a crisp neat edge.

old watercolour paper that have been dragged from place to place covered in greasy finger marks, dirt, gouges and so on. Paper should be handled and treated like a precious photograph and carefully stored with the same respect, ideally flat down in a large folder or container. There are many different types and makes of paper available throughout the world and all of them have their very own characteristics and handling abilities. Some are handmade, others are machine made; either way, the paper is formed by pressing the pulp into a mould, which gives it its characteristic texture associated with watercolour paper in general. This is then sized or waterproofed so that watercolour paint settles with a crisp, clean edge. When the size has either perished over time or if it becomes over-diluted when wetting it to stretch the sheet, the paper will return to its raw state of blotting paper. A mottling effect throughout a wash or an incredi-

bly absorbent surface making the application of paint virtually impossible is generally indicative of this.

It is worth familiarizing yourself with different papers in order to discover which paper works best for you. Try out different brands over a period of time and really get to know how they perform. Some papers can be heavily sized, which makes them almost waterproof, and others can be much more absorbent. These properties affect how the paint handles on the paper in addition to how well the paint can be removed, and in turn these qualities can affect the painting process and indeed your style. Make your own choices about paper and do not discount a paper on someone else's word. Try it for yourself first. After years of painting I tried out a new paper and discovered it performed perfectly for my style and approach to watercolour. Unfortunately when I tried to purchase more of it I discovered it

A selection of watercolour papers in various weights and shades. Some papers are brilliant white, some are a natural off-white cotton shade while certain manufacturers such as St Cuthberts Mill create a range of tinted papers to bring a key colour through a painting.

was no longer being manufactured and the only other choice was that of its heavier weight counterpart. I bought a large batch of the heavier paper but subsequently discovered that it behaved quite differently from the paper I was accustomed to. I generally work on a brilliant white surface, which helps to keep my colours bright, clean and fresh. The use of the paper should be a consideration at the outset of a painting, for example a painting incorporating lots of texture or dry brushwork may warrant the use of a rough surface type. Here the heavily grained paper surface catches the brush in a hit and miss affair leaving

behind bobbles of paint that are suggestive of many different textures, surfaces and so on. In general most watercolours are conducted on a cold-pressed paper, which is also known as NOT surface. NOT simply means not hot pressed and therefore it is cold pressed. Cold-pressed paper has a medium tooth to the surface and is a good all round type of paper to work on. Hot-pressed paper on the other hand has a smooth surface, making it the ideal choice for highly detailed work or paintings that do not really warrant any texture or granulation. Watercolour paper is designed specifically for the best handling of paint you can

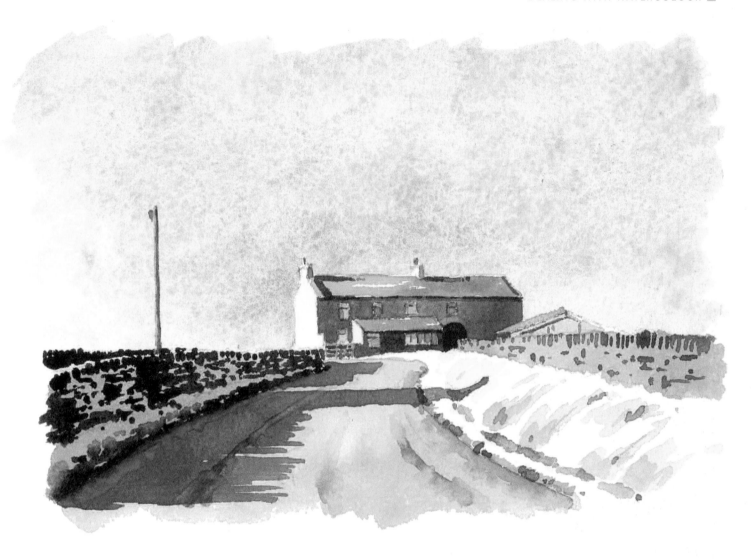

The bright colourful effects have been achieved by working on a brilliant
white paper. When I am painting a subject involving light and shade,
I deliberately choose this kind of paper for the best effects.

achieve. Anything else will not give you the appropriate results
so if you paint on cartridge paper, do not expect to achieve per-
fect washes. Regard your paper as one of your most valuable
tools. It is more than just something to paint on!

Brushes

Out of all the watercolour painter's tool kit, the item that is often
compromised on the most is the brush. This is quite alarming as
the brush forms the direct link between the artist's interpreta-
tion of the subject and actually applying those mental process-
es to the paper. The brush is how you express yourself as a
painter and the greater the quality the better you can make that

communication. I come across many leisure painters using old
worn out brushes, brushes that are far too small and on many
occasions the wrong sort of brushes altogether. Watercolour
brushes must be soft as any old stiff bristled brush will scrub the
paint off rather than put it on!

Of all the brushes available, Kolinsky sable still performs the
best, as it comprises the necessary top-end qualities with which
to apply watercolour. A good standard of brush such as this
should hold copious amounts of paint, have a good springy
head and, depending on the individual's taste, a fine point.
Kolinsky does not automatically mean quality. The fibres used
may be superior but it really depends on the expertise of the
manufacturer making it as to whether or not the end product is
worthy as a top-quality tool. The holding capacity of a Kolinsky
sable brush enables you to brush paint much further in one

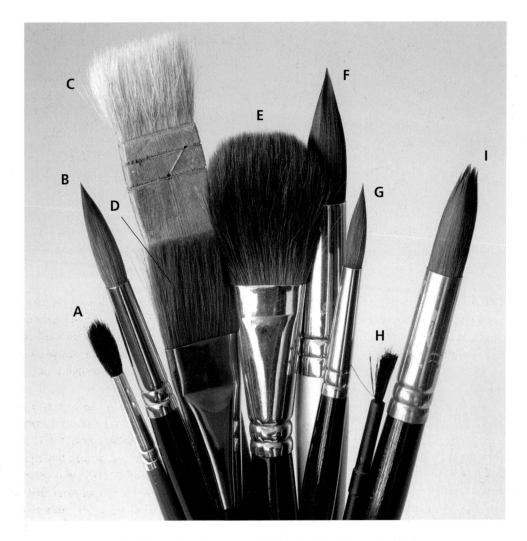

A range of different brushes that are both suitable and unsuitable for watercolour. From left to right:

A. A cheap, bristly haired round brush that does not hold a point. This is typical of a brush found in a bargain paint set from a stationery shop.

B. A fine-pointed, size 12 Kolinsky round brush. This is a quality brush that will go a long way to creating quality paintings.

C. An inexpensive hake brush, probably camel hair. These are fantastically soft brushes that hold copious amounts of paint and are ideal for laying down large sky washes and so on.

D. A sable flat brush. More expensive than a hake, it has better handling qualities including the spring of the hair for accurate paint application.

E. A squirrel-hair mop brush. Squirrel hair holds lots of paint but lacks the springy qualities of sable. These brushes are great for large washes.

F. A size 20, synthetic round brush. A great paintbrush but when compared to a fine Kolinsky sable it lacks belly and a certain amount of liquid retention.

G. A size 8, Kolinsky round brush.

H. A cheap, children's paintbrush of a quality for which it is intended. This has no place in the serious painter's kit.

I. A size 16 synthetic brush. This is an older brush that has lost its point but it still has the ability to apply paint.

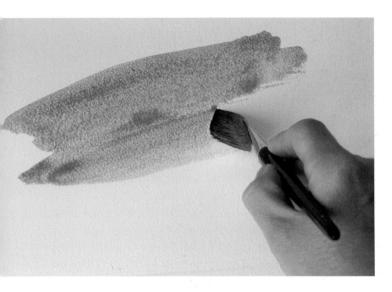

A 19mm sable flat brush spreading on a large area of paint in one application. Applying paint quickly and consistently will generate the best results, leaving a flat wash area with no marks or streaks.

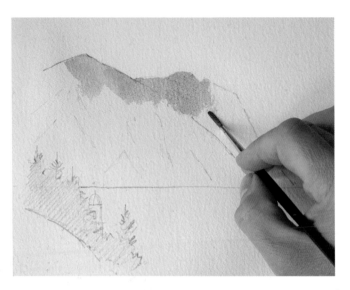

This brush is far too small to cover the area required and this is evident in the lack of a reservoir of paint at the bottom of the wash as well as the dry scratchy marks that the brush is making. A larger brush would be more helpful here, which illustrates the benefits of having a range of sizes to hand.

Here a small detail is overloaded to flooding point by using too large a brush. If this happens in your work, select a smaller brush that will equally describe the feature without flooding paint beyond reasonable control.

application, resulting in an even finish to the wash area. The softness of the brush hairs are also sympathetic to the application of the paint, and providing you use a gentle pressure on the brush you will not leave brush marks or streaks in your washes. A well made Kolinsky sable brush will probably cost a fair amount of money but the outlay will be well worth it.

Synthetic brushes are fine, the main difference in comparison is that they do not hold as much fluid as a sable and therefore they need to be reloaded with paint more often. This can sometimes lead to drying problems as time spent reloading the brush

allows the paint on your paper to soak in and dry before the wash area has been completed. The manmade hairs can be slightly rougher than sable hair and this can also cause some problems with streaking in a wash but again a gentle pressure on the brush will alleviate this. As a general rule it is best to increase the size of a synthetic brush so that you compensate for the loss of paint handling, for example where a Kolinsky size 8 is to be used, try a size 10 or 12 synthetic and so on. The overriding difference of course is the price between the two, which is bound to be a deciding factor for many people. Synthetic brushes perform very well and are actually the preferred brush type for a number of professional artists.

The development of synthetic and sable blends has brought together the springy qualities of a synthetic brush with some of the softness and holding capacity of a sable brush. These brush types offer a value for money alternative between the two types, and again they will usually offer excellent performance in handling and application. If you are considering upgrading from synthetics but the price of Kolinsky sable is too much then these are worthy of serious consideration.

Brush sizes

It is beneficial to have a number of brushes of varied size in order to be able to deal with different sizes of wash. Although technically the watercolour artist can get away with one, big round brush for many different applications this can create problems of blobbing or overloading with the smaller wash areas. A brush

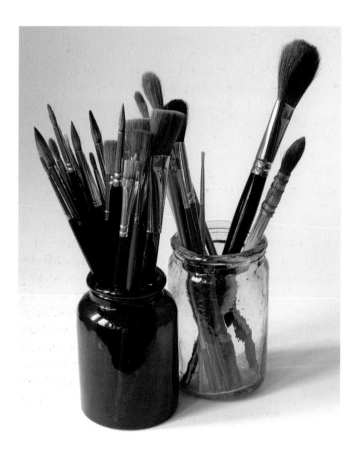

After washing and drying your brushes store them upright in jars since air circulation will prevent mildew from forming on the hairs. If you use a closed brush case, make sure the brushes are definitely dry before storing them.

Look after your brushes

Watercolour brushes are manufactured specifically for watercolour painting and have been developed to offer the best possible handling of the medium. Look after your brushes and they will look after you, so occasionally treat them to a makeover. Sables can be periodically washed and conditioned using shampoo and conditioner in the same way as you would treat your own hair. Synthetics can be given the same treatment and also they can be dipped in a cup of boiling water to reset a bent point. I would recommend washing your brushes in this way after you have used any staining pigments. If this is not done, the residue from the pigment will stick to the brush fibres even though you may have rinsed it clean. Over time this residue builds up on the brush stiffening the hairs and wearing the head out much quicker than through normal usage. Store brushes upright in a container, never with the hair downwards unless you like painting with permanently bent and damaged brushes. If you are travelling with your brushes, make sure they are held tight in a rigid brush case or container. Make sure they are dry before storing them for long periods in a case otherwise they will be prone to mildew, which can damage the brush fibres.

should be loaded full of paint and applied straight to the paper. The only time that you take some of the paint off the brush before applying it is when you are employing a wet-into-wet technique (*see* page 110). You can use this as a general guide for selecting an appropriate size of brush. As an example, if your loaded brush is taking far too long to apply the paint throughout your wash area, you need a larger brush. Conversely if your brush quickly blobs and overfills the wash area then you need to select a smaller brush. There is no set answer for which brush type or size you should use but following this guide should help to indicate what action to take when painting. Having a range of brush sizes from small, such as a round size 4, to a large, round size 20 will enable you to alter the size quickly when painting. Other useful brush types are flat brushes or hakes, which are capable of quickly laying down large amounts of paint. I prefer to use a sable flat brush as this performs much better than a synthetic flat type. Rigger brushes are excellent for painting very fine details although they are not always necessary, as sometimes a fine-pointed round brush will do a similar job.

Mixing palette

There are numerous types and designs of mixing palette available, all of which perform within their limitations of size and practicability. Watercolour requires space for preparation and this is especially important when a large wash is to be applied. The palette lid of a set of watercolour pans is never really big

A large mixing palette, tray or white plate is of immense benefit to the watercolour painter.

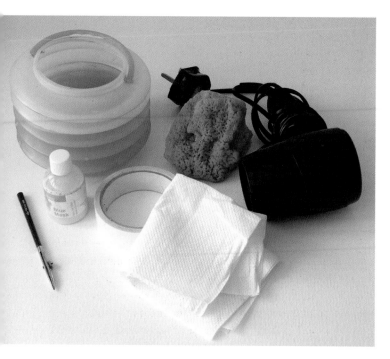

A large water pot keeps the painting water cleaner for longer. A sponge and paper towels are useful for correcting wayward washes and a hairdryer is useful for finishing the drying process of a wash if speed is of the essence. Masking tape is easy to find and masking fluid can be purchased from an art or craft shop.

Accessories

Paint, paper and brushes, the main working tools used by the watercolourist, should be sought from specialist retailers and manufacturers but many other items can be substituted with ordinary household items. Jam jars, buckets and old pots can be used to store brushes and hold water. I tend to use a decorator's paint kettle or a collapsible lantern pot so that I do not have to change my water too frequently. White trays or plates for mixing can be found in hardware stores or kitchen shops. Watercolour is not suited to working vertically on an easel but some artists do actually prefer this way. The more conventional painter will work at a table and if you do, use a couple of books to prop up your work if necessary. A table lamp with a daylight bulb fitted is a useful accessory if light is an issue or you intend working at night. Ordinary decorator's masking tape is very handy for taping down loose sheets of paper or for masking off a neat edge to a painting. Masking fluid is a specialist item and it does have its uses, as does a hairdryer for speeding up the drying process of certain washes. Dip pens and ruling pens are a useful alternative to using a rigger brush. Kitchen roll or paper towels are essential items, as is a sponge for mopping up or removing errors and large areas of paint.

The characteristics of watercolour

Watercolour paint is created from pigment mixed with gum, which is soluble in water. The water becomes the carrier and as this dries away it leaves behind the pigment on the paper. The

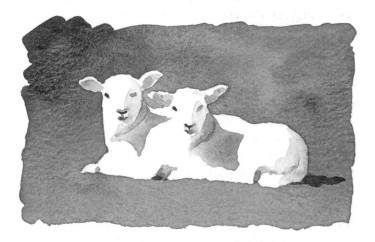

The recognizable shapes of the lambs are described by painting around them with the surrounding green. The lambs themselves are left as bare white paper with just one or two features and shadows added to give them form.

enough to hold a reasonable quantity of paint especially for larger paintings, neither is a small palette of wells or small mixing bowls. Although this may sound unimportant, the size of the mixing area for the watercolour painter is paramount to the success of clean colour mixing, tonal ability and wash technique. If you experience any problems with your work in these fields, take a look at your palette! Deep wells and bowls provide a false impression of the strength of the paint. The depth of liquid intensifies the tone of the colour but when it is applied to the paper, nine times out of ten it will be too pale. Small mixing areas quickly become full of paint and this can contaminate further mixes. Also the smaller the mixing area, the less paint you will inevitably mix, leading to scratchy washes as you attempt to push what little paint you have as far as it will go.

I use a large white plastic catering tray or plate and I squeeze out the colours that I am using at the time around the edges and this allows me to pull in vast quantities of colour as and when required. The large mixing area ensures that I can spread out my colour with ease and see its tonal strength more clearly. The tones and colours that I see in the palette are what I will achieve on the paper. As soon as the mixing area is used up, I wipe the residual paint mixtures off and I continue painting with little fuss.

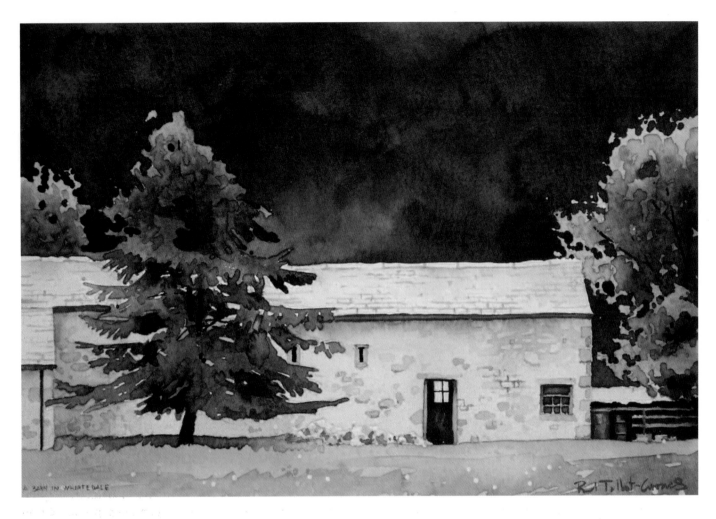

A barn in Wharfedale, 30 x 21cm (11³/₄ x 8¹/₄in).

**In this painting I have utilized a full range of tones, and the process was to paint the
nearest trees first in order to establish their forms; then I brought in the dark
background of massed foliage in order to add contrast. After the washes had dried,
I was able to work on the paler tones of the building, carefully ending the washes at the
dark edges. The strength of the background tones helped me to judge the paler colours
of the barn more easily than if I were painting them against white paper.**

same pigments are used for other mediums such as acrylic and oils, the only difference being the binder – gum for watercolour, oil for oils and so on. The most important difference between watercolour and all other mediums in terms of handling is that watercolour pigment is laid onto paper in transparent veils rather than opaque blocks.

In oil painting, acrylic painting and so on, colours are lightened by adding white paint and they can be applied to different coloured grounds without any detrimental effect to the overall appearance of the hue of the paint. This follows the general pattern of how the human brain reads and interprets an image. A light-toned feature set against a dark background for example would be interpreted in painting terms as blocking in the darker background first, then applying the lighter feature on top. In watercolour this process has to be reversed and it is a case of training the brain to see things differently. When using a watercolour medium the white of the paper is utilized to lighten colours, so for a pale colour more water is added to the paint mix thus allowing more of the white to influence the see-through colour. For a heavy, strong colour, less water and more pigment is used, thus blocking out the influence of the white paper. The properties of the medium extend beyond this as its transparency has an impact in other areas, such as where mistakes cannot be easily covered up because they continue to show through subsequent layers of paint. Usually it is best to wash off the error with a damp sponge before continuing with

the painting. Also, in some lighter parts of the painting, overlaid colours will change hue, for example a yellow overlaid with blue is likely to turn green as one layer shows through the next. For areas of pure white, the paper is left unpainted. As a rule, white paint is not used in watercolour although it is perfectly acceptable to use white gouache (Chinese white) from time to time to reinstate any missed highlights, usually at the end of a painting. White paint is certainly not intended to be used as a colour lightener in watercolour and if it is the colour will generally turn milky and dull.

Working from light to dark

Paintings are built up working from light to dark although one should not become confused over the order in which this is undertaken. Sections of a painting may be built up individually, for instance the background or the focal point and so on, and these will need to be worked up from the lightest tones to the darkest darks before progressing further. The term light to dark by no means implies that the whole painting should be tackled in a mechanical fashion from all the lightest tones to all the darkest ones throughout the entire scene. It is often beneficial to work up a section of a picture, including the darkest parts, at an early stage so that the overall tonal balance can be seen better or the contrast between a light area and a dark area can be better judged. First of all, it is best to study the scene you are about to paint. Look for the lightest tones (which may not necessarily be white) and then the darkest tones within the image to be worked from. Once you have recognized where these tonal extremes are, you will find the construction of the painting a little easier to undertake. However, do not confuse colour with tone. Tone refers to how strong or how light a feature is as opposed to the colour of it. A green tree for example may be dark in tone or light in tone depending on the lighting situation and how much the tree may be in the shade. The colour green however remains constant throughout the tree. Separating the two can be likened to placing a sheet of coloured glass on white paper and then on black paper. The colour remains constant but the tonal properties of that colour can change depending on the location of the feature. (Reference to colours and how they are made darker and lighter in tone is covered in more detail later on in the book.) Any areas of white need to be preserved, either by painting around them, or by masking out with masking fluid or masking tape before the painting process begins. This is because the white of the paper is utilized as white in the painting. Work the painting up in layers, gradually increasing the tonal values of each layer so that a full tonal scale is utilized. This will give your painting body and it will be visually striking.

There are no rules to say that a pale tone cannot be painted after a dark tone has been applied elsewhere in the picture, only that a paler tone will not show if it is painted over the top of a darker one. If pale tones are painted right up to the edge of a strong wash, certain problems can arise with colour bleed and softening of the edges. With this in mind, it is best to have some sort of plan so that you know where the lighter tones are going to be and you can work around them accordingly. For this reason it is generally best to paint the pale tone first, allow it to dry and then bring in the stronger dark tone, which will create a crisp sharp edge, so characteristic of watercolour.

Handling paint on paper

Watercolour is extremely self descriptive as the use of watery colour is very important when painting. Although this sounds remarkably obvious it is a constant problem among painters, including beginners and those of more advanced abilities. Not using enough paint on the brush leads to dry, scratchy washes with brush marks showing and occasionally runbacks forming as the paint dries. Paint should be applied methodically with a fully loaded brush in constant contact with the paper. Using a round brush on its side will help to spread the paint and a gentle advancing movement should be utilized to allow the paint to work into the paper surface. As soon as the paint has discharged from the brush it should be reloaded and the process continued throughout the area of the wash. If the paint is pushed too far and the brush not reloaded, dry brush marks will form. The paint should be neither dry nor puddling on the paper and if conducted appropriately the wash will be of an even wetness throughout when completed.

The application of the paint need not be rushed and it can always be applied in a calm and controlled manner. Any amount of overworking or using too much heavy-handed pressure on the brush may disturb other layers of paint and this is where muddy, dull effects will appear. Colours should be softly introduced together on the paper so that each shows its identity as well as creating a gentle mix. As an example, cobalt blue and burnt sienna work well for suggesting the colour of stonework. When mixed together in the palette they will create a grey but that can be livened up by mixing the colours on the paper too, allowing some of the blue and some of the brown to show independently. If colours are mixed too much the area will become flat and devoid of sparkle. Use a light touch on the brush, ideally keeping it well balanced and allowing the weight of the brush to apply the paint to the paper. The edge of the wash should be constantly monitored as the paint is applied. Keeping a wet edge to the wash area while you work will ensure a good application of paint. If the edge dries, it will leave a permanent mark. If you find washes difficult to control, try working with your board flat down as this will induce the paint to puddle more and

Here the streaky finish to the wall and field has come about by
working too slowly with not enough paint on the brush. Paint must
flow otherwise it will dry on the paper as soon as it is applied,
leading to messy results like this.

I worked over and over the grass shapes right until the wash
had begun to dry and this has left brush marks in the paint
finish. Avoid all temptation of going back in when a wash has
been applied.

Here the reflections of the mountains have been painted with disastrous results.
I painted an initial wash of colour over the lake but this was drying as I added
fluid reflections. The results are a perfect example of what happens with varied
drying rates within a wash.

therefore it will stay wetter for longer. Sometimes artists become a little impatient and apply paint over washes that have not had a proper chance to dry. Again, this will create no end of problems in retaining the cleanliness of a watercolour. Dirty paper will show through subsequent washes and hence lose the clean light effects. Often using the correct equipment can be beneficial in ironing out certain repetitive and unwanted results.

Drying rates

A skill that becomes easier the more painting you do is that of understanding how fluid to use the paint. Many painters make the mistake of simply not using enough fluid on the brush, even when they have been shown how much to use. Hesitancy does not work well with watercolour so a confident bold approach is often the answer. I regularly see painters wiping paint from their brushes before applying it to the paper and when confronted about it they had no idea it was happening, nor what the consequences are. Not using enough fluid will prevent the wash

from settling evenly and may also produce streaks, brush marks and runbacks as each area of the wash dries at a slightly different rate. Wiping paint onto a tissue or rag prior to applying it is bad practice and reflects a confidence issue with your painting. If you recognize this symptom, make a deliberate attempt to address it and you will see an immediate improvement in your work.

Streaks

Streaky washes highlight a problem with the flow rate of the applied paint or the speed at which the artist is applying it. If the brush is inadequately loaded, the paint will dry almost instantly as it is brushed onto the paper. When the next brush load is applied it will form a line or streak where it adjoins the previous brush line. Streaks are synonymous with this incorrect approach and the same goes for working too slowly. Paint must be applied fluidly and at a consistent rate to allow the wash areas to flow into each other.

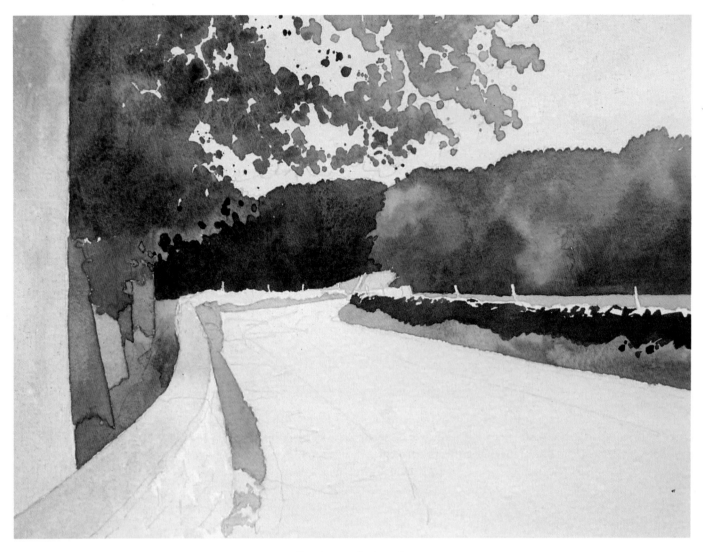

Country road, stage 1.
All the features of the picture are painted in varicoloured washes, including darker
shadows and shades. I have allowed each wash to dry, for example where the
trees overlap each other and where the wall meets the grass on the right-hand
side. Notice how the greens consist of various shades of green, yellow and blue.

Brush marks

A wash must be applied as an even wetness and once it has
begun to settle into the paper it has to be left alone. When
viewed against the light the wash should take on a satin sheen.
When the sheen has turned matt the wash is settling into the
paper and it is at this critical stage that it must be left alone. Any
further brushwork laid over a matt sheen will produce ghastly
brush marks that will show through all subsequent washes. Los-
ing interest in a wash and randomly scrubbing the brush over
an area again and again will only make things worse. Apply the
wash with a calm manner and leave it to dry naturally.

Runbacks

Runbacks are unique to watercolour painting and they are
caused by uneven wetness in a wash. Knowing how runbacks
form is part of understanding how to avoid them in the first
place. A runback is sometimes referred to as a cabbage mark or
bloom and it is basically a water stain that has been highlighted
in pigment. When a partially dry area abuts a wetter area, the
dryer section draws the moisture from the wetter section form-
ing a star-shaped crescent. The pigment is left along the edge
as it dries, creating an outline of the bloom. It is imperative to
keep the wash area evenly wet and this can be done by con-
stantly moving the paint around using a gentle pressure on the

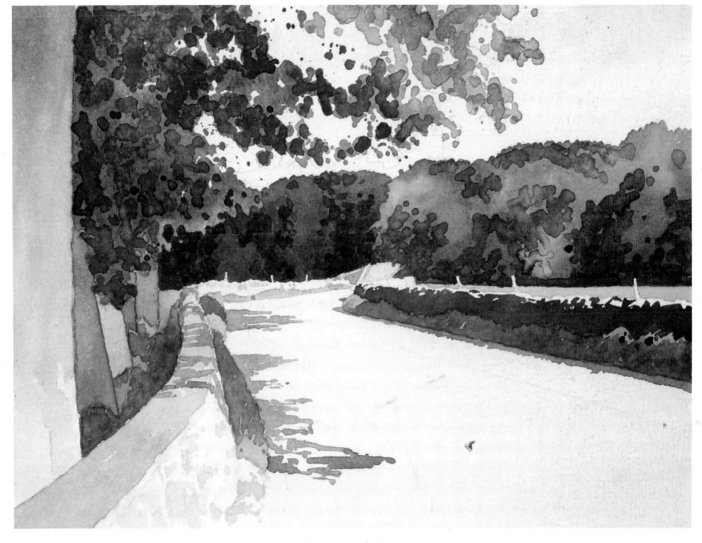

Country road, stage 2.
The trees are overlaid with darker patches of shadow, applied in a stippling
manner and softened here and there to give them shape and form.
Cast shadows are also applied around the left-hand wall and the verge
on the right of the picture.

brush and keeping it in constant contact with the paper. When the wash is complete it must have an even overall sheen. One of the biggest causes of runbacks is when the artist is selecting a second colour to add to the wash area. If the colour is more fluid than what is already on the paper, the likelihood is that a conflict of drying rates will result leading to runbacks in the wash.

Correct application

Use the side of the brush with plenty of paint and keep the brush in constant contact with the paper. Working the paint gently into the paper texture will generally iron out drying rate

problems. Make a habit of continually reloading the brush as this will help enormously if you are experiencing the kinds of problems highlighted. Once applied, the wash should have a nice even sheen to it when seen against the light, no matter how big the wash area or complex the shape is. Your brush type will make all the difference to how well your wash is applied. One of the more difficult techniques in which wash control is paramount is the wet-into-wet technique. If the paper has not been prepared properly or you have been a little unwary and not checked the sheen of the area before applying paint, then there is every chance the wash will not dry evenly, leaving behind runbacks and blemishes. With wet-into-wet you must keep an eye on the overall sheen and try to match the wetness with the

same on the brush. If you apply paint that is wetter than the paper, this will inevitably lead to drying rate problems.

Building up a painting in layers

Watercolours are generally built up in layers with each layer playing a significant part of the overall picture. Initial layers show through subsequent layers and it is this build up that characterizes the medium, giving it a crisp, translucent finish. The downside to this process is that the more layers there are, the more chance there is of disturbing paint and merging the layers together, resulting in unclean colours and muddy tones. With this in mind, it pays to create a painting in as few layers as possible and therefore reduce the risk of spoiling the overall finish. It is entirely possible to create a painting in three layers, so long as you achieve the appropriate spread of colours and tones with immediate accuracy. The process of layering a watercolour begins with colours first, then shadows and shades, finishing with darks and details.

First layer

The first layer should reflect the general pattern of colour and tone throughout the area to be painted. This should include varicoloured washes to add interest, for example in a green, grassy area the wash could include amounts of yellow and blue within the overall green. This is far better than just one flat green throughout. Areas of shade or darker tone also need to be roughly described within the wash so it is important to concentrate on how the tones change and differ throughout the area to be painted. As an example a field that is darker in the foreground needs the dark added in the initial wash stage so that the change in tone shows through subsequent washes as the painting is built up. The initial layer will probably involve several drying stages too, for example where one colour abuts

a different one and so on. Each colour will need applying and leaving to dry before the adjacent one is painted in the same manner. If all the different features and coloured areas are painted in one go, and therefore allowed to blend where they meet, the painting may take on a confused and unclean undertone. Some artists use this method to great effect, however, but it does take skill in keeping all the colours coherent and the painting vibrant.

Second layer

Next, any shadows, shades and slight detail may be built up on top of the initial washes. These are carefully painted as layers, taking great care not to disturb any of the previous washes. Shadows may encompass general areas of dividing tones where lighter parts of the scene are adjacent to darker parts, such as in a cliff where certain sections of rock stand out lighter than others. This layer will build up body within the scene and add depth and three-dimension. Also, if they are present in the picture, cast shadows will need to be painted before any finer detail is built up on top. Again, within this general stage there will usually be a number of drying stages as the different areas of tone and shadow are allowed to dry and settle before progressing further.

Third layer

Finally, the darkest areas and further fine details are applied to the painting. By keeping the application of darks and finer details until last, you will achieve a crisp, clean effect to your watercolour. Any glazing on top of such work would more than likely blur the colours and any potential fine definition would be lost, creating a softer, dirtier finish.

Although this general way of layering is very subjective and does not always apply to every painting it is a good rule of thumb to follow.

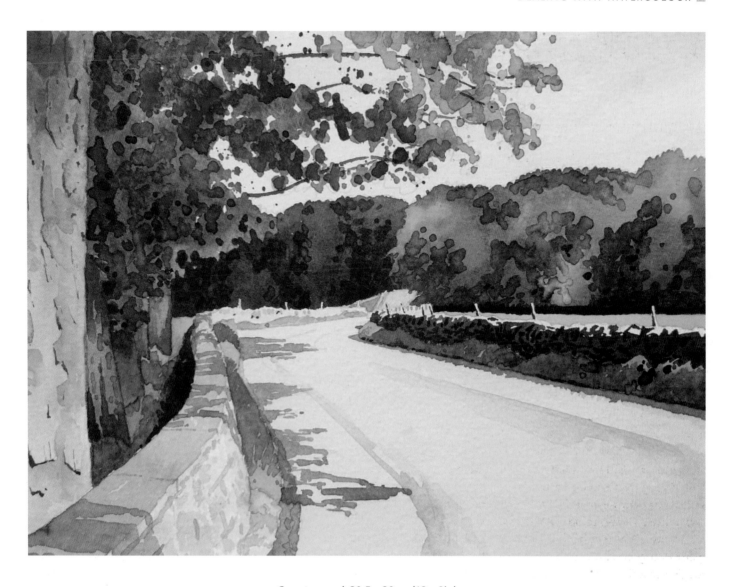

Country road, 30.5 x 20cm (12 x 8in).
Finally, I added the darks and finer details of the
walls and textures of the nearest tree trunks.
The painting retains its crisp, clean appearance
because each layer has been applied in an
appropriate order.

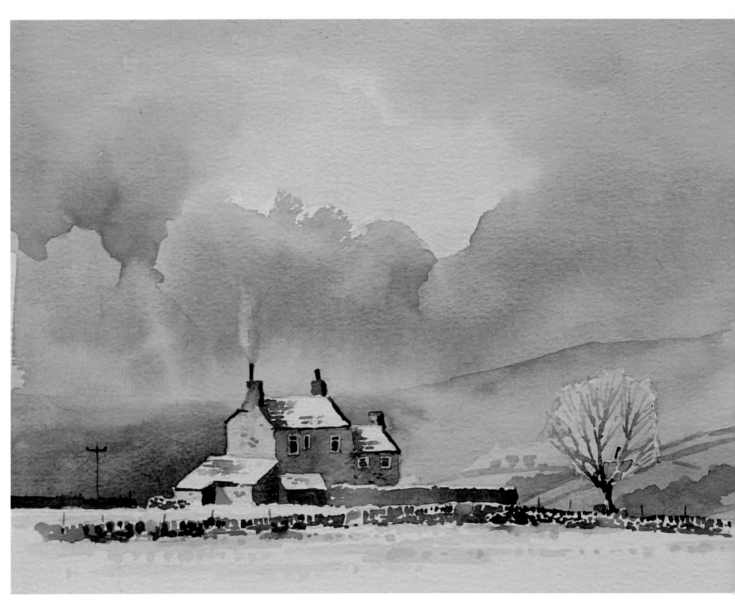

February snow showers, 25.5 x 20cm (10 x 8in).
A watercolour sketch created from pure observation
and finished from memory after the weather
conditions had passed over.

SKETCHING AND DRAWING

At one time, sketching a scene would have been the only way of recording a subject for the artist to work from at a later date. Turner's sketchbooks of his travels unveil to us, not just his drawings from which he would work later, but also a complete pictorial record of his trips. Nowadays, we would most probably take a camera with us and think nothing of it. Usually full landscape paintings were and still are rather difficult to complete outdoors in front of the scene and if the artist wished to create a large, involved and detailed masterpiece then a certain amount of shorthand information would be needed for later reference. Creating these detailed plans and drawings is not as necessary nowadays with the evolution of the modern camera, so if we now have the technology to record subjects at the click of an electronic button, what relevance does sketching hold in our present way of working?

Sketching is one way of recording a subject that has more or less been replaced by the camera but it also has far more bene-

fits in training our drawing skills and fine-tuning our visual interpretations of a subject. I hear many people simply dismissing pencil work as being far too difficult and this is usually followed by a personal admission that they cannot draw. Drawing is not something that you can or cannot do, it is a skill that requires practice and time just like any other ability. The people who say they cannot draw are usually those who have been more than despondent at their first efforts and have never ventured any further than that since. Improvements do come slowly the more you try and sketching is just about the best way of improving your eye to hand coordination and manual dexterity of your painting hand. Sketching and drawing should be an enjoyable experience and it can easily be fitted into a daily routine, as even just a few minutes sketching every day will build up the necessary skills to help you along with your watercolour painting. The skills and mental processes required to control a pencil are exactly the same as those used when painting with a brush so there

A watercolour sketch completed on a cold December morning. I used cartridge paper and added washes of colour, working into them with a watercolour pencil whilst the paint was still wet. Perfect washes are not an issue when quickly recording subjects in sketch form.

Blackstone Edge - shadow sketch

A ten-minute sketch done in pencil with over-washes of Payne's grey to add solid tone. In this sketch, I aimed to capture the light and shadows on the rocks so working quickly was paramount.

A longer study conducted in pencil. The sketch took somewhere between twenty and forty minutes to complete, the focus being the tones and the relationships of the buildings.

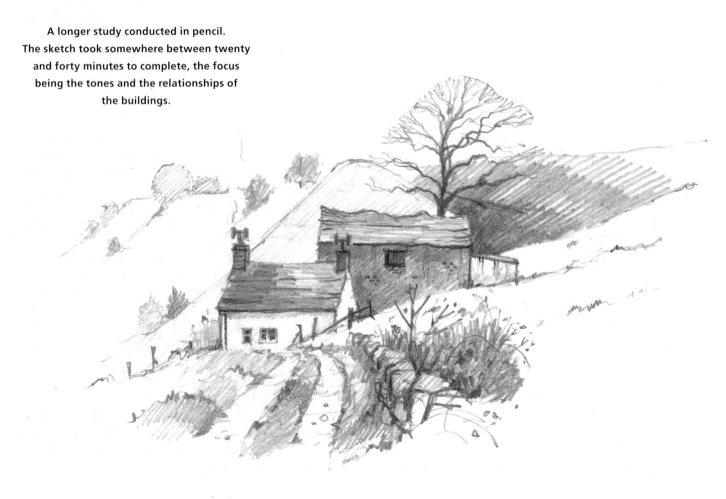

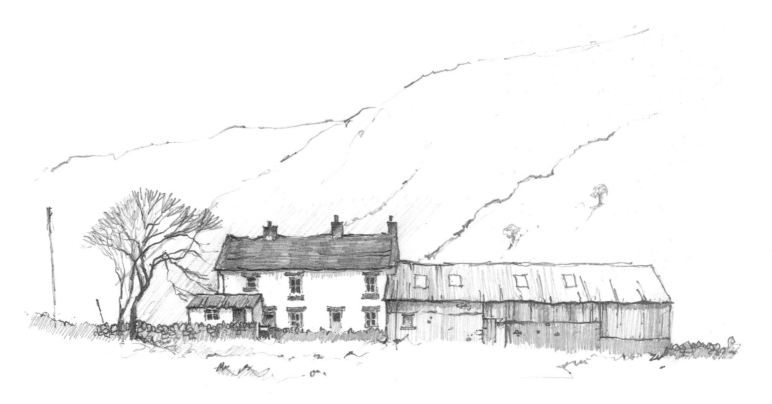

is no real difference between the two disciplines. Draw what you enjoy first of all, as drawing something for its own sake is not likely to induce much inspiration. If you select a subject that really interests you, you are more likely to achieve your best. Do not be put off by singling out subject themes such as drawing only landscapes for example, as this will reduce your drawing times to sketching only when you are outdoors. Drawing your favourite pet, a plant or a family member will still build on the necessary basic skills required for painting landscapes.

Sometimes it can be beneficial to set a timetable, especially if you find little time to engage in the subject or if you are really struggling to muster any kind of interest at all. Try creating a ten-minute sketch per day. Time yourself and really strive to put down the relevant marks quickly and with determination. These can be contrasted with a longer study when you may have more time to dedicate to the subject, for example during the weekend. Here you could set up a still life or just focus on a single subject. Spend at least a couple of hours creating a carefully studied graphical drawing using a number of different grades of pencil. Make sure you are comfortable with no imminent outside pressures or disturbances and create for yourself a relaxed environment. Putting on quiet background music or a radio can very often stimulate your concentration further and enhance your enjoyment of your drawing time. Keep all of your sketches, studies and drawings and review them periodically so that you can really see your progressive improvements.

If you do not have the time or inspiration to draw at all, then try to mentally draw. Look at your surroundings and take note

Here my focus was the farm buildings and in the sketch I have concentrated on capturing them with only an essence of their surroundings. Leaving out extraneous material, old cars, silage bales and so on makes for a simplified picture, which, in turn, helps to lead towards a simplified painting.

of the different shapes, how they relate and interact with each other. Compare angles, shapes and sizes and take note of how one feature stands out against another. The benefits of visually studying your surroundings in this way are that you can do it anywhere and you can be guaranteed that nobody will look over your shoulder or pass comment on your work. The overall benefits of sketching, apart from accruing necessary observational skills, are that you will condense the information into a simplified format and this will come through into your general painting work. As an example, you may be sketching a landscape and your main focus might be a building within that scene. With a sketch, you are more likely to end up with your focal point being prominent because you will have concentrated mainly on that particular feature. Your landscape will be simplified and much easier on the eye of the viewer and after returning from a sketching trip you will have collected only the information that counts. Sometimes when taking photographs the reason behind the image and why you took it can become lost or forgotten over time. A sketch is inspirational whereas a photograph is instructional.

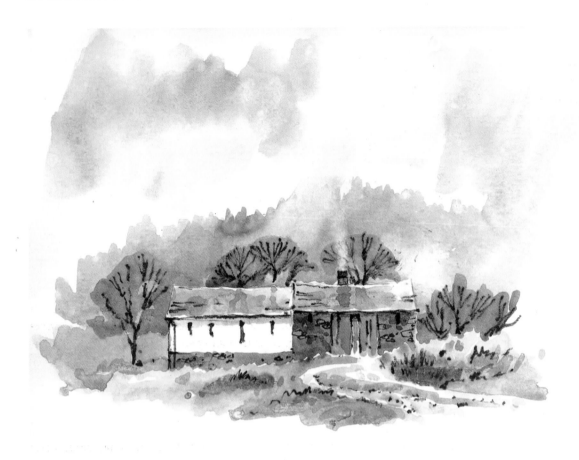

This watercolour sketch was built up rapidly in fading light with the weather against me. The freshness of the washes is indicative of working quickly, and certainly with watercolour this approach works well in more concentrated painting efforts too.

Sketching materials

There are a great variety of materials to use for sketching. Most people tend to associate sketching and drawing with ordinary graphite pencils. Whilst these are useful instruments for recording subjects, other mediums are just as practical and in some cases even handier than using graphite. Watercolour can be used for quick colour references or for rapidly recording a fleeting weather pattern. Other colour mediums may inspire the individual or make sketching and drawing more of an exciting prospect than working with black and white. Try out as many different mediums as you can in order to find out what works best for you. Here I have outlined some of the more common mediums that I use when I am out and about recording landscapes in my sketchbook.

Graphite pencils

One of the reasons why many artists dismiss sketching is the control and use of graphite pencils. Used incorrectly, pencils will create messy, smudged drawings with relative ease. If you really cannot find inspiration in a pencil drawing, then there are a number of other alternatives to lighten up your inspiration. Used correctly, however, pencils can create effects from carefully

shaded drawings of the finest graphic quality, to lively linear drawings full of character and life. For graphic images containing various tonal shades, a range of pencils is handy from about HB through to 4B. Aim to keep an even pressure on the pencils as you shade. It is the grade of pencil that will create the various strengths of tone, not necessarily using heavy or light pressure with the hand. Try shading with a HB pencil then swap to a 4B grade and use the same weight as you mark the paper. The 4B pencil, being the softer grade, will create a much darker area than the HB. To correct any areas a simple eraser works well but choose a soft one otherwise you may end up spreading your errors rather than erasing them. For areas where lots of graphite has been laid down, use a putty rubber, initially with a dabbing action to take off the excess graphite. Keep the eraser clean by picking pieces off it to expose fresh bits. Working in pencil is a great way of understanding how to work with watercolour, as the process of building up the tones is intrinsically the same – light to dark. The bonus of using a set of pencils is that you can take as much time as is required to build up an image without worrying about drying rates of a wash and so on. Use good-quality cartridge paper, ideally a spiral-bound pad so that you can keep your drawings together. Graphite pencils really are very versatile. If you dislike the black-and-white finish to a drawing, you can wash over your drawing with tints of watercolour and this is a very useful way of recording information

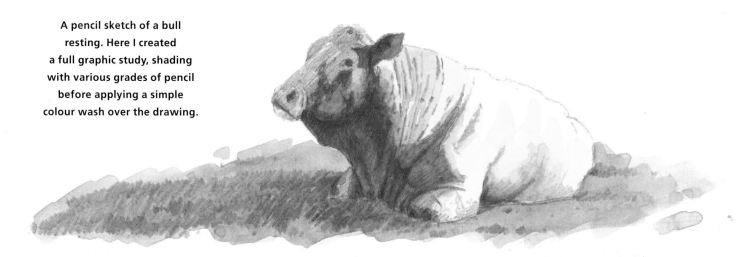

A pencil sketch of a bull resting. Here I created a full graphic study, shading with various grades of pencil before applying a simple colour wash over the drawing.

about a subject as not only do you collect the graphical detail but the colours too.

Water-soluble graphite

An alternative to pure graphite is the water-soluble graphite pencil, which combines all the qualities of a traditional pencil but with a watercolour twist. There are a number of ways of using these pencils, which again are available in grades, usually from soft to medium and dark. They can be used in a traditional manner as an ordinary pencil or alternatively, for larger areas of shading or fine tone, the lines of the drawing can be softened and blended with a damp brush. On the other hand, some of the graphite can be scrubbed off onto either a small piece of sandpaper or a stone, mixed with water and painted onto the sketch. Once the graphite has been wetted, it becomes fixed so

removal is a little more difficult than with ordinary pencils. Water-soluble graphite pencils can be very handy if you happen to be caught out in the rain when sketching outdoors as the performance of the pencil is not jeopardized by damp.

Watercolour pencils

Watercolour pencils work in very much the same way as water-soluble graphite pencils. The main differences are that they are manufactured from watercolour pigment rather than graphite and, as a result, they tend to be softer. They are available in a vast array of different colours, allowing you to build up a coloured-pencil sketch with the added bonus of being able to blend and mix the colours with water. They are also very useful for adding coloured details into a watercolour sketch without having to wait for washes to dry – a great time-saving exercise

A watercolour and watercolour-pencil sketch. I generally make no preliminary drawing, favouring instead to launch straight into the sketch with watercolour washes and following into these with a black watercolour pencil. The pencil glides through the washes, and sketches like this can be built up in no time. The strange marks in the sky area are where ice has formed on the washes as I have worked.

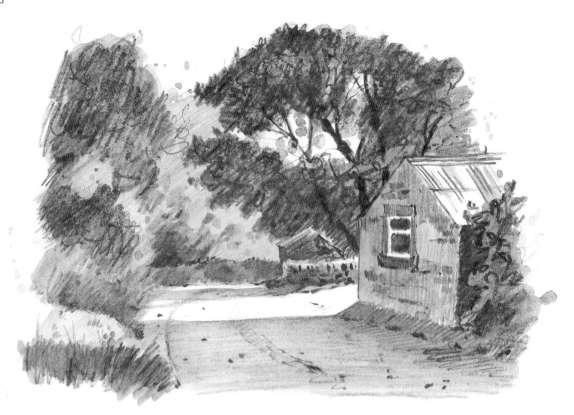

Here I built up the image using a watercolour stick for larger areas of tone, scrubbing the crayon onto the paper and then washing over it with a wet brush. For the finer details and shaded areas I used a watercolour pencil.

when working outdoors. The darker colours of the range can be used as drawing tools in a watercolour wash, again saving time waiting for drying. Sketches can be created in monochrome too when using a black, blue or sepia-coloured pencil for instance.

Watercolour

One of the best ways of increasing your dexterity of the watercolour medium is to use it freely in your sketches. This not only frees up any general inhibitions about using it but it also livens up your sketches and makes the process of creating images much more appealing. Used in conjunction with water-soluble

graphite or watercolour pencils, images can be quickly built up that involve colour, tone and detail. When working outdoors, I tend to make watercolour sketches on cartridge paper. Although this is not the best paper on which to handle watercolour it does ensure that washes dry quickly, and in any case I am not worried about ruining the odd sketch if things do not go as expected. Mistakes can be rectified by washing off the watercolour pigment with clean water; however, I feel that a sketch should reflect honesty and in that respect mistakes are part and parcel of the overall lively image. This mental approach really does free up your style, understanding and use of watercolour. After a while, sketching in watercolour becomes second nature and you become more relaxed about the whole process.

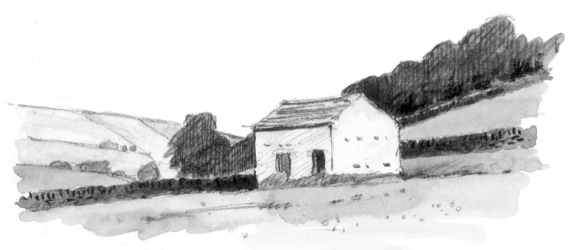

Watercolour washes were allowed to dry before using a black conté crayon to define lines and add some shading.

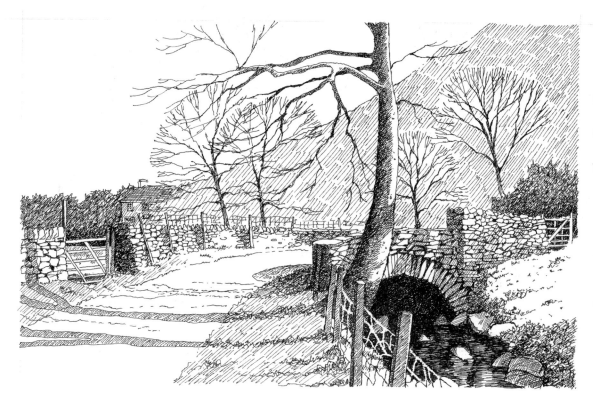

A technical-drawing pen sketch, using hatching as a means of shading. Working in this way really makes you concentrate on where you are placing your lines as well as studying how best to make features stand out from each other by using tone.

If you can control a wash crouched in the corner of a field with wind and rain lashing your back, you can control a wash in the comfort of your home whilst working at your painting table.

Watercolour sticks

Watercolour sticks look like wax crayons and, as with watercolour pencils, are available in a range of colours. They can be used in the same manner as watercolour pencils although they are thicker and creating fine details can be difficult. I have used them when I have needed to apply a large area of colour or tone to a watercolour-pencil sketch. They are great when used in conjunction with watercolour pencils as the pencil creates finer detail whilst the stick applies a controlled volume of colour and tone. Carrying a number of these sticks could be an alternative to taking a set of paints outdoors.

Charcoal

Charcoal produces a very black colour and is ideal for creating images with strong tones, although it can be tricky to control and if you are not careful you will end up with a smudgy drawing. Fingers become dirty quickly and part of the characteristics of a charcoal drawing is the array of finger marks that are left around the edges. This medium can be used for a broader sketch where fine details are not paramount, although charcoal pencils

can be used to introduce finer line work. The use of a soft art eraser is handy to clean up messy edges or for erasing unwanted lines. Once the drawing has been completed, it should be fixed with a fixative to prevent the image smudging beyond recognition.

Conté crayon

Conté crayon is a hard, slightly waxy pastel, which can be sharpened for fine details or used on its side for a broader spread of colour or tone. Available in different colours, the sticks allow you to build up sketches either in full colour or in monochrome. Try using a dark brown for a different look and feel to your drawings. Conté crayons are fairly responsive and by using more or less pressure with the hand you can create a vast array of different tones for shading with. You can also add a different dimension to a sketch by using watercolour washes as a colour base on top of which a drawing is built up with conté crayon. The washes must be dry, however, before you work on top of them.

Pens

Pens have a lovely quality of finish to them and there are many different types that can be utilized. Biro is a wonderful tool for drawing with and most people will be familiar with doodling in biro, but try using it as a serious drawing implement. Biros are

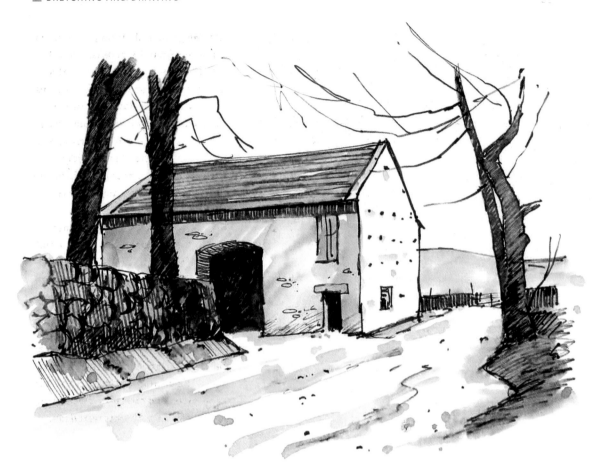

A slightly different approach to a pen sketch. Here I drew with a felt-tip pen and washed the ink in places with a wet brush, creating washes of delicate tone. When these sections had dried, I continued to work into the drawing, thus combining hatched shading with a watercolour undertone.

fairly responsive to hand pressure and so a range of tones can be built up as well as a number of different shading styles. Dip pens have a quality of their own and grades of tone can be built up by cross hatching. The more concentrated the hatching, the more intense the tone will be. You can use any colour of ink with a dip pen or quill pen and different-sized nibs can be obtained for different thicknesses of line. These pens allow you to use various types and colours of ink as well as using watercolour. Gel pens have a beautiful flow and are extremely responsive to drawing techniques and styles. A sepia-toned gel pen leaves a unique quality to the finish of a drawing. Technical-drawing pens have a constant flow of ink and are available in a number of different grades. Similar to dip pens, these can be used to build up cross-hatched sketches of the finest detail. Felt-tip pens create thicker more direct lines and if the pen is water soluble they can be softened with water or washed over with a wet brush, adding a further dimension to your sketch. Of course with any pen the marks you make are irreversible so any mistakes in your drawing either have to be worked into something else or corrected at an early stage with the unwanted lines left showing. I think pens have honesty about them and it is nice to see the construction lines, thoughts and errors of the artist within the drawing. They certainly do make you think twice about where you are putting your lines on the paper.

Making sketches

You do not need the entire list of drawing media with you on a sketching excursion but it helps to know which work best for you. Over time, experiment with each form of sketching so that you become familiar with the best techniques for the situation, for example if you find yourself with an hour to make a sketch, you might use a range of graphite pencils to create an accurate depiction of the scene. If you only have ten minutes, you might brush on a few loose watercolour washes and quickly draw into them with a watercolour pencil. Whatever process you are using, you will still be employing the skills of eye-to-hand coordination, which are vital for manipulating and controlling watercolour washes in a finished piece. I usually carry an A4-sized spiral-bound cartridge pad, which is ideal for drawing with pencils as well as for accepting watercolour washes. The added advantage when using cartridge paper and watercolour together is that the paint dries very quickly, albeit a bit unevenly, but that does not matter too much for a sketch. When working outdoors with watercolour, the speed of drying is paramount to how long the sketching process takes and therefore how long you can keep warm and on schedule. Some important accessories when sketching outdoors are either bulldog clips or elastic bands to hold down flapping pages. It is amazing how even the most

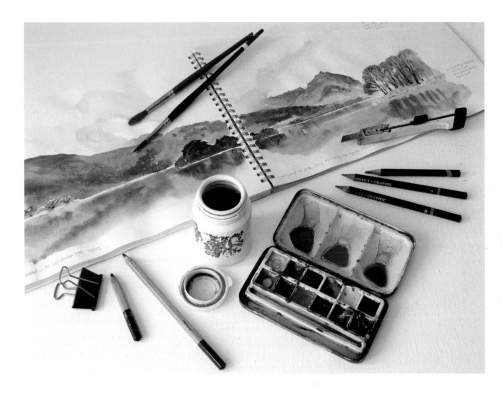

LEFT: **My general sketching kit consists of a few graphite pencils, a spiral-bound sketchbook, a small water container, a retractable knife, a couple of brushes, a small tin of paints containing my most commonly used colours, some watercolour pencils and a bulldog clip. Keeping your equipment light is important if you are intending to walk any distance.**

BELOW: **A rapid sketch of a winter sunset, conducted in watercolour and watercolour pencil. The light was fading fast and it was freezing, plus I had to get off the hill as I did not have a torch. On my retreat, I stopped to make a sketch but under the circumstances it had to be quick! The paint froze almost immediately, hence the visible shading with the pencil but I continued and concentrated only on the elements that interested me.**

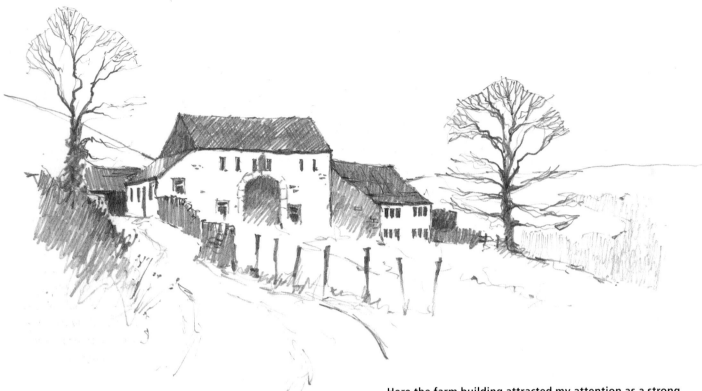

Here the farm building attracted my attention as a strong focus to a painting. I concentrated on the subject, working my way outwards from there and eliminating any extraneous detail towards the edge of the picture. When you have found your subject, keep focused on the elements that enticed you to draw it.

gentle of breezes can cause havoc with a sketchbook propped on your knee. If you are sketching indoors or from a car, then the choice and size of paper can be expanded upon, as can your approach to the subject. For outdoor sketching, I usually carry a range of pencils, both graphite and water soluble, a few watercolour pencils, a retractable knife for keeping them all sharp, a few small brushes, bulldog clips and a small tin of paints containing the colours I use most of all. All these fit into a small, pocket-sized camera case that I keep in a side pocket of my rucksack. Comfort is essential when sketching for a while and a foam sit mat or folding stool is a good lightweight addition to a sketching trip.

Always begin with the part of the scene that interests you most and work outwards from there. In a landscape situation, this is most likely going to be your focal point. To place your focal point in the relevant area of your picture, think about locating it one third into the picture and one third up from the bottom or down from the top. The eye will naturally rest in these areas, which is why artists and photographers use the theory to gain better pictures.

Making a quick, faint pencil plan of the subject to ensure it will fit into the page before you start is usually a good idea if you are going to go into some in-depth study. This does not have to be in any kind of detail, just literally a series of shapes in order to gain the overall scale of the scene on the paper. Try to stay focused on your objectives while you sketch. If you have

Using two pieces of L-shaped card often helps to isolate a picture from the bigger surrounding landscape.

decided to make a study of a farm building, for example, then stick to it without also adding the surrounding landscape features, distance and so on. Taking on too much can quickly become daunting and this will dampen your initial enthusiasm somewhat.

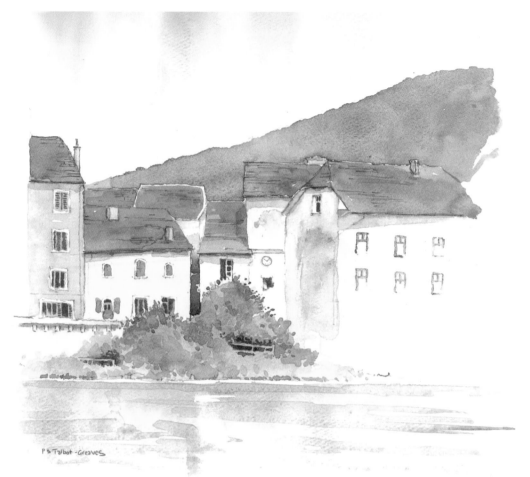

P S Talbot-Greaves

A lengthy watercolour sketch of a French Alpine town made whilst relaxing on holiday. Combining the pleasure of painting with touring can provide you with a variety of sketching subjects.

In order to help you select a portion of a scene, it may be useful to carry a viewfinder. These can be purchased from art stores or you can create your own, either by using two small L-shaped pieces of cardboard or an empty photographic slide holder. The idea is to help you focus on an area of the landscape that interests you. With L-shaped mounts you can play about with the format of the scene, however I would be tempted to do this as part of a compositional plan in the studio rather than as part of a sketching process outdoors.

Think about composition whilst you are sketching and consider what other elements you might include in the finished picture as not every scene in nature is presented with the finest of compositional arrangements. Think about a lead into the scene, for example. There may not be anything obvious leading up to your subject – in which case, look around to see if there is anything else you can use. You can sketch additional features such as close up details either at the side of your main drawing or assemble them on the paper in a compositional format as you think fit. Looking for additional features and considering composition whilst sketching is also good training for increasing your perception and recognizing subject material. As you

become more and more selective about what to put in a sketch and what to leave out, you will notice that this process of simplification creeps into your paintings in general, making them less cluttered and easier to view.

Sketching outdoors

Lacking the confidence to sketch outdoors is probably the first hurdle to overcome. In such a situation you are opening up your artistic endeavours for all to see, although the majority of people who glance over your shoulder will either say nothing or be very complimentary towards your work. After all, you are doing something they probably wished they could do too. I have found that very few people will approach and those who do will generally engage in friendly conversation, which makes the experience of being outdoors all the more enjoyable. Many of my artist friends have sold their work on the spot or picked up valuable commissions through chatting to passers-by who stop to admire their work. Sometimes, however, you can find

45

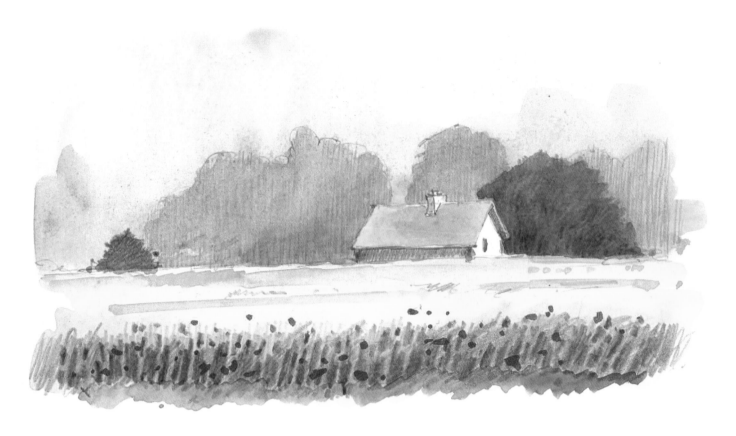

**A rapid pencil and watercolour sketch made in about fifteen minutes
whilst taking a break from driving.**

yourself in certain situations requiring no comment, like the time I was sketching a footbridge at the head of a steep, narrow gorge. It was a misty day and the surrounding woodland oozed an ethereal atmosphere amongst the trees. I was perched at the top of a slope above a stream holding onto a small shrub with my left hand whilst sketching with my right hand, trying desperately not to slither down the muddy bank into the water below. I must have looked like a lurking madman as a lady walking her dog suddenly saw me crouched just below her in the undergrowth. She let out a surprised yelp and hurried off at a fast pace. I considered trying to explain myself but I let the moment pass and in the end I opted to say nothing. Another time, whilst in the Canadian Rockies, I was sketching a whirling blizzard covering a spectacular mountain vista. The scene was incredibly wild except for the fact that I was standing in the relative safety of a public car park. As I continued sloshing watercolour paint onto the page, I suddenly became aware of a presence over my left shoulder. There was not one, but about thirty Japanese tourists who had formed an orderly queue and were all taking it in turns to view my sketch before alighting their coach. There were no comments made as such but they all nodded and smiled at me in mass appreciation for what I was doing. For most of my sketching time, I get about my objectives with no onlookers at all.

Before you embark on an outdoor sketching trip, it is usually a good idea to have a plan of what you are aiming to achieve. One way of doing this is to plot a walk from an ordnance survey map, which takes in a number of points of interest. These become your main targets and they could be anything that you potentially find interesting – old farm buildings, bridges, rocks and so on. As you walk from one to the next, keep a look out for other potential subject material. You could balance a few lengthy sketches with a number of shorter, more rapid drawings. How much you put into a sketch depends on how important the scene is to you and how much time you have to work on it. Concentrate on the most relevant parts first so that you collect your information in priority order.

It also helps to make notes of anything you consider to be of further importance to the scene, either alongside or in the margin. These can make references to details, colours or even parts of the scene that you may not have included in your drawing. I often write about the quality of the light and the weather in order to jog my memory about the conditions when referring to my sketches at a later date. Also a note or two about the light direction and maybe how high or low the sun is in the sky at the time will be valuable information at a later date. If you are working in graphite, then a few notes about the colours are often helpful. Sometimes a simple linear drawing will suffice or if you

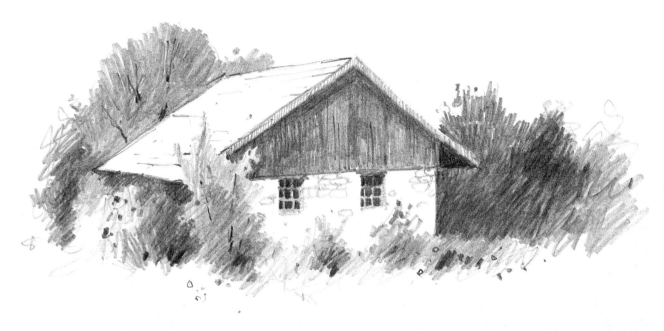

A twenty-minute sketch of an Alpine chalet. The scribbled but controlled
pencil work shows how I worked in a quick but concentrated manner.

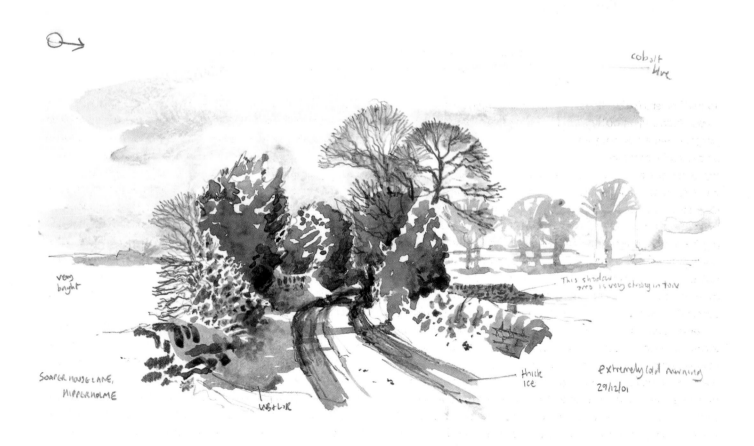

I often write notes alongside my sketches to add further information to the visual record. Here I have
shown the light direction, indicated by the arrow (top left). Notes about colours, the temperature and
the weather help me to relive the moment when I create a finished painting from it at a later date.

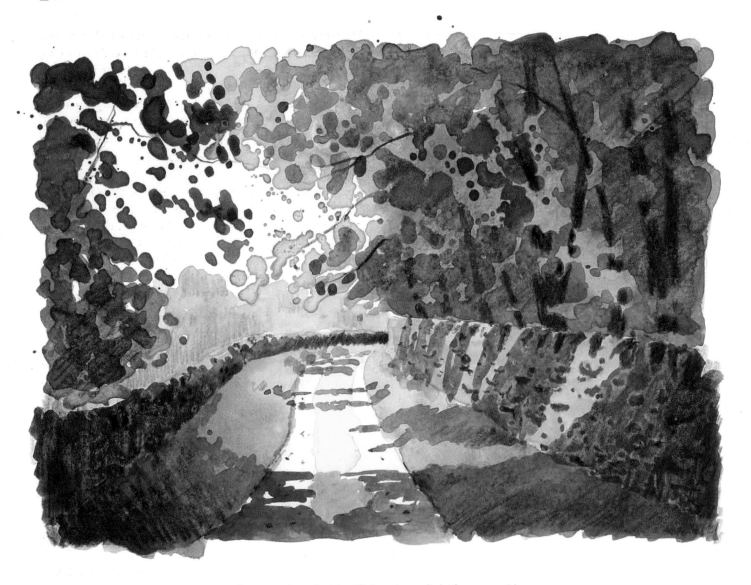

A watercolour sketch utilizing strong light from one side.
When out in the landscape, you have the advantage of
being able to locate yourself in the best position and
on a sunny day that would ideally be with the light
from the side. This scene would not be the same without
those shadows.

really want to put some colour into the sketch, try a quick pencil drawing and add watercolour over the top. You might not refer to this information again, however do not disregard the importance of collecting details in this way as the whole process is one of self-training in visual perception and these skills will increase with practice.

Bright sunlight or low light can really transform an otherwise uninteresting scene into something quite special. In these conditions, it is helpful to find subjects with lighting from one side so that you can include the cast shadows across your sketch. If walking is not an option or if you are not so mobile there are still many subjects to be found by car or public transport. Having a companion to do the driving is a good idea as you will see far more if you are concentrating only on the scenery. Working from a car can sometimes be a little cramped but you cannot deny the benefits of being comfortable, dry and warm. If the driver's seat slides back far enough, it may be possible to use the steering wheel as a board rest or makeshift easel – that is assuming you are parked facing your subject and not driving through town at the time! If the driver's side is cramped or you are right-handed, try using the passenger seat. In some vehicles the glove-box lid houses cup holders, which can be very handy for keeping water pots stable and so on. If using a car is impossible, then take a scenic bus and position yourself to be able to take some photos or quick sketches out of the window. I sometimes resort to this method as a car passenger if we have a long drive ahead with no time for stopping. It is quite amazing how clear your photographs can turn out even when snapped out of the car window at high speed on the motorway. In the outdoors, keeping warm is your first priority as you may be sitting still for anything up to an hour whilst sketching your subject. Foam sit mats are ideal for providing not only a soft seat but also insulation from cold rocks or damp ground. A fleece-type jacket and a hat in colder weather will retain your body heat provided you put them on the moment you stop. If you are out all day your body temperature will acclimatize to the conditions, making sketching breaks fairly easy to cope with. A flask of hot tea can work wonders for your morale in colder situations. It is really a personal choice whether or not to carry a seat or an easel but I find it much easier to keep things to a minimum and as lightweight as possible. Trial and error is just about the best lesson you can have. It really is amazing how much equipment you do not need with you.

Painting outdoors

Painting outdoors poses its own problems, especially if you are working away from any potential shelter or warm comforts, as you are more likely to spend longer on a painting than a sketch.

The amount of equipment needs expanding from that needed for brief sketching. Particularly useful is a thin board to work on; sometimes watercolour boards or blocks can be beneficial too. If your subject involves a fair amount of walking to get to it, then lightweight equipment is paramount, such as an aluminium easel and a small folding stool. Lantern pots for water take up little room in a rucksack and water can often be obtained from streams or rivers. I use a smaller catering tray for outdoor work purely because of its portability. The main factor, of course, is the weather and if showers are forecast then an umbrella might be wise to protect washes from being spoiled. Otherwise, if there is any sign of prolonged inclement weather, it is probably best to resort to sketching rather than taking on a full day of painting. Wind can be very problematic and even the slightest breeze can tip an easel over. Here, tent pegs and a few lengths of string can help to anchor your work down whilst you paint. Painting outdoors is extremely pleasurable and you can learn a lot more about your style and approach to watercolours than you might otherwise do with a quick sketch. Make sure you are comfortable so that you do not pressure yourself to finish your work quickly. For me, lighting makes all the difference to the landscape but after a few hours of painting the light direction will usually have changed. With this in mind, I always begin with a brief sketch to map in the shapes of the shadows at the time I begin to paint. This can be done in monochrome, either in pencil or watercolour, as it is just a reminder of what was there when I first saw the scene. The fundamental rule is not to change your mind about your painting once you have started and never try to alter your shadows with the progressively changing light. Make your decisions before you begin and stick to them throughout.

There are no guidelines to how long a painting should take but certainly when painting outdoors there is an amount of waiting time whilst washes dry off and you certainly cannot just pop to the kitchen and make a cup of coffee. However, sitting in one position for a few hours can sometimes give you a privileged view of the wildlife around you. Whilst out painting in different locations, I have watched a weasel foraging for food a few yards from my position, a pair of otters playing and fishing, dolphins surfacing in a coastal bay, kingfishers darting up and down rivers and so on. The hollow echo of a raven's call high on mountain crags creates an eerie atmosphere, which can add inspiration to a painting done on location.

Being on site and having the availability to study and explore your subject first hand has an enormous benefit over working from photographs. First of all, you can see much more detail and features are not flattened like they can be with the photographic lens. Experiences such as wildlife spotting or just having the warm sun on your back for a day can really inspire you to paint something extra special. Occasionally I finish off or touch up a painting back at home, adding one or two extra dark areas

A sketch map of the lighting for an outdoor painting. After settling on a viewpoint, the initial steps are to compose the scene, eliminating any unwanted details, and then map in the shadow patterns cast by the light. Throughout the course of the painting, these will change dramatically so the sketch forms an important reference.

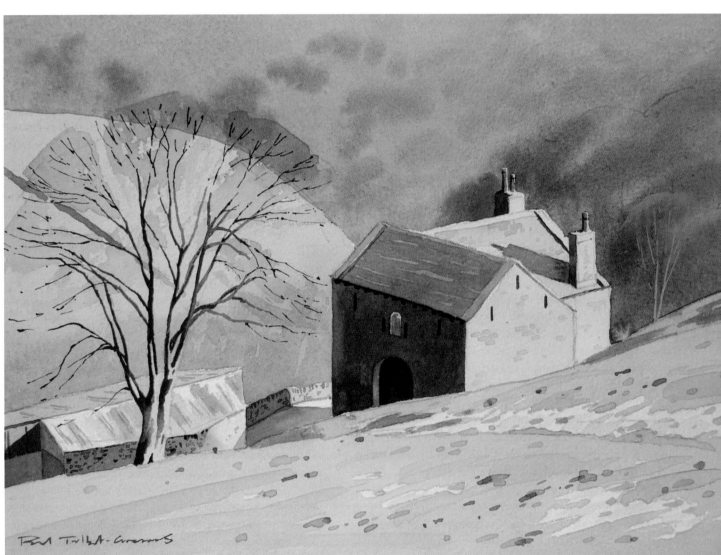

Morning light, Luddenden Dean, 36 x 26cm (14 x 10¼in). The finished painting was conducted entirely on site. The morning winter light changed fast and I was glad that I had made a quick sketch of it first.

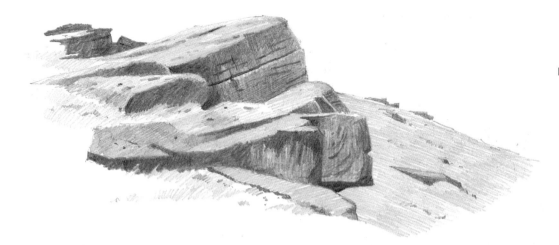

At first glance, the rocks looked like simple blackened lumps of stone but whilst carefully sketching them I noticed delicate shades of blue and brown as well as subtle textures, fracture lines, shapes and angles. Look beyond the basics in order to understand your subject fully.

or bits of detail that I see fit. The experience of painting outdoors is certainly worth the effort for the benefit that it brings to your work in general.

Drawing skills

Only a few specific skills are required for creating drawings. The rest of it lies within the feel and perception of the particular individual involved. Whatever subject one person perceives to draw and how he or she draws it will differ from that of another, purely because of the individuality of the person, his or her temperament and personality. Therefore, do not ever feel intimidated by another artist's work, as we are, most definitely, very different from each other in personality and in paint. In any case, some people pick up certain skills quicker than others and some find particular tasks easier to perform. Drawing is about looking carefully at a subject, not necessarily at the feature itself but also deep within it and around it. For example, a familiar face may be recognizable to you by the basic structure of the facial shapes. However, on closer inspection you might notice a few, previously unseen, subtle lines and wrinkles, the patterns of negative shapes within the hair, slight colour changes in the eyes and unexpected hues within the skin colour, such as greens and blues. The more you look into a subject the more you will see and it is these subtleties that will lift a drawing, and consequently a painting, out of the ordinary. Generally begin with the centre of your subject and gradually work your way outwards from there. Make sure that your drawing is going to fit on the paper before you begin and, to do this, it is worthwhile sketching out the shapes lightly at first. Use a B grade of pencil with very little pressure so that if things need adjusting then the pencil work will erase easily.

Scaling up a drawing

Whether you are working from a flat image such as a photograph or a page from a magazine or from real life, you will inevitably have to scale the scene in order to fit it onto your paper. It is usually best to have a starting point and in these circumstances you may need to make a few measurements, for example the length of a feature in order to gain the correct proportion and shape. This also helps to ensure that features adjacent to one another are in scale and proportion to one another and for this there is a simple method. First establish the length (or height) of a known feature within the scene, such as the height of a building and then use this to compare it to all further measurements within the picture. Draw the line at an appropriate length on your paper within a reasonable scale to your working area. To measure other lines in the picture and keep them in proportion to your drawn line, hold your arm out straight in front of you as this will help you to maintain a consistent measure. Hold your pencil either vertically or horizontally depending on the orientation of the line you are measuring and using your thumb as a sliding gauge, measure the approximate length of the feature. Now compare this to the length of the known line that was drawn initially; as an example let us say it is about two and a half times longer. The line can be easily plotted on your drawing by making the new line two and a half times longer than your drawn line. Often this is a great way to get going with a more complex drawing.

Sometimes you may need to establish only a few of these measured lines before you progress further into the drawing, gauging other lines and angles by eye. You should constantly check distances, angles and, if it helps, talk to yourself while you are doing it in order to reiterate the logic of what you are doing. When you absorb yourself in this kind of in-depth study, the general recognizable shape of the subject becomes almost immaterial as you concentrate on plotting all the bits and pieces that go together to make up that shape in the first place.

Using a sliding thumb to gauge the proportions of the other features. Here the height of a tree is being checked and used as a comparison to plot the relative sizes of further shapes within the scene.

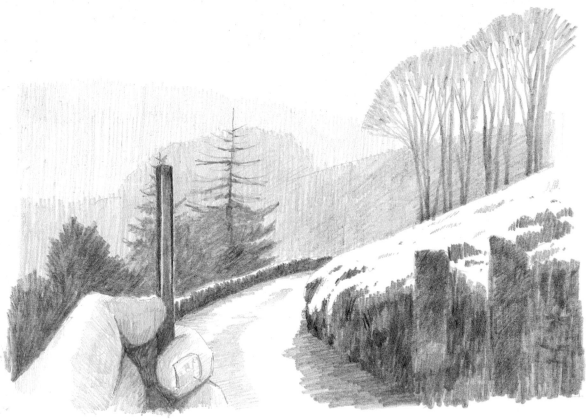

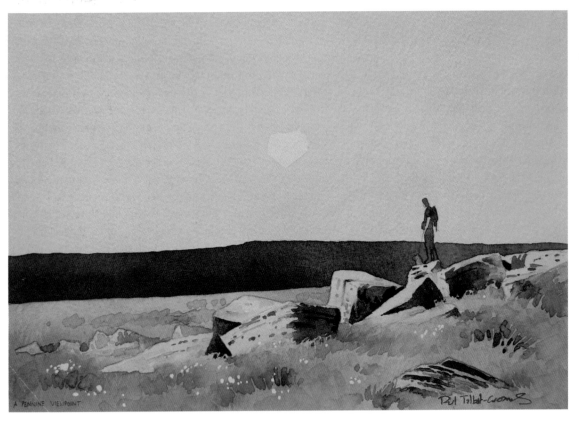

A Pennine viewpoint, 28 x 19cm (11 x 7½in). Here the figure is the central focus of the picture, so getting the right scale was crucial. I plotted the size of the figure and the location of some of the larger rocks using a sliding thumb method, comparing their sizes to the height of the distant hill.

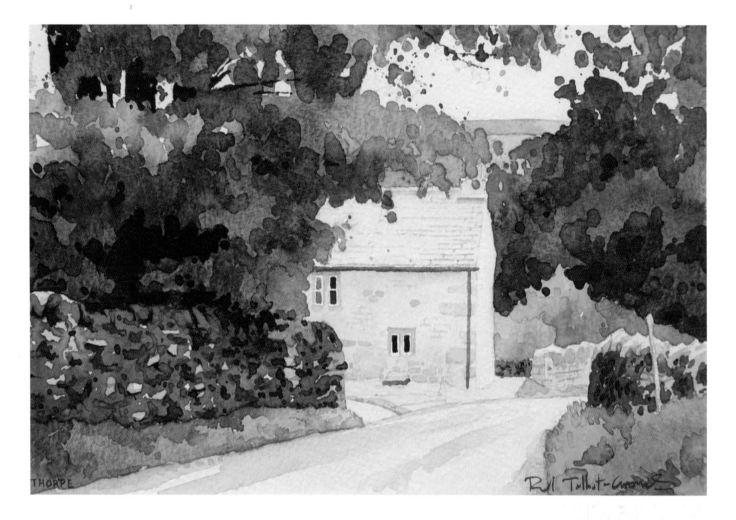

Thorpe, 25.5 x 17cm (10 x 6³/₄in).
Carefully plotting positions, shapes and angles is important when drawing out for a finished painting but do not let the techniques stifle your expression. Although I had a careful framework drawn out for this scene, I still employed loose washes of colour, especially in the trees and the walls.

Drawing to scale with precision

More concentrated methods of drawing and scaling can be used but the essence of sketching is about freedom of expression and some of the more precise measuring techniques may actually stifle a freehand sketch. However, carefully plotting angles, shapes and lines is required when drawing a scene onto watercolour paper in preparation for a painting and in these cases some of the following methods may be useful.

Measuring

The technique of roughly measuring by thumb can also be employed using a ruler and this tends to be more accurate as your measurements will be mathematical rather than simply being gauged. Measuring with a ruler is tricky if you are sketching and drawing outdoors from real life. However when working from photographs or putting a drawing onto paper in preparation for a watercolour painting, the ruler technique can help to plot precise lines, distances and so on. Essentially the technique is the same except that, instead of measuring a

distance along the pencil using the thumb as a sliding gauge, you are literally measuring the lines. At first it pays to create a proportion to work to, and this can be achieved by dividing the length of the paper to be worked on by the length of the photograph to be worked from. As an example a quarter imperial piece of paper measures approximately 38cm in length and a 6in x 4in photograph measures approximately 15cm in length. The calculation for these sizes is 38cm divided by 15cm, which equals 2.53. This figure is the ratio to which all your measured lines are multiplied, so each distance measured on the photograph is then multiplied by 2.53 and this will scale up your drawing accurately. It is fairly time-consuming and, as with thumb measuring, it is often useful to plot the main sections of the picture this way and fill in the rest by eye.

53

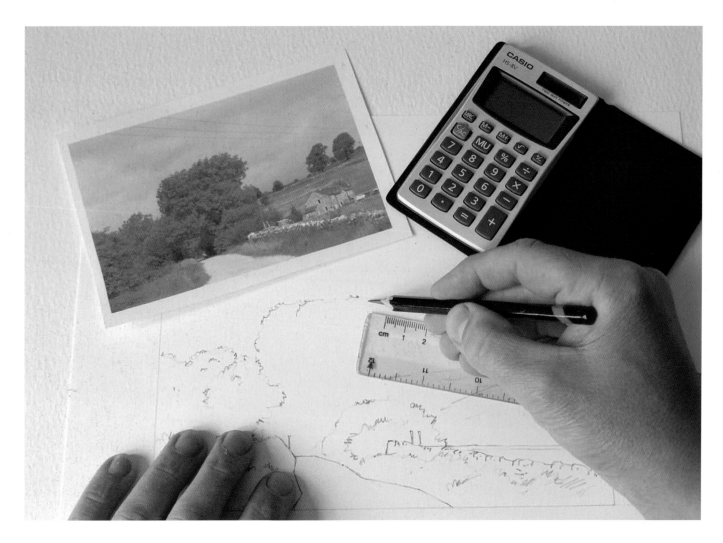

Plotting the main elements and proportions of a drawing using a measuring method. The remainder of the scene is constructed by eye.

Grid

Sometimes artists find using a grid works well, although it does mean having to remove the gridlines at the end of the drawing, which can be very time consuming and clumsy. In principle this method works in the same way as measuring. As an example, a grid of 1cm squares is drawn over the picture to work from and a grid of the same proportion but bigger-sized squares, say 3cm, is drawn onto the paper to work on. Each square can then be analysed and the lines of the features carefully compared to the criss-cross gridlines. Where the lines intersect the gridlines the corresponding position on the drawing paper can be plotted and the rest of the drawing worked up from there. This method is more usual for transferring a drawing onto watercolour paper in preparation for a painting than for a simple sketch.

Tracing

Although tracing is sometimes seen as cheating, it depends on the circumstances and how you do it. Simply tracing someone else's work or photographs may be regarded as cheating and indeed it may breach copyright laws but used creatively it can help take the strain out of drawing, especially if you are transferring a complex scene onto watercolour paper. The best way of working here is to create the drawing on a separate piece of paper without worrying about incidental gridlines or erroneous line work and erasing. What you are aiming for is a drawing in the correct proportions. When this is complete, the outline can be traced and then applied to the watercolour paper. The lines on the tracing paper can be loaded with graphite on the reverse, using a soft pencil. Alternatively it may be possible to obtain tracing paper ready primed in this way. This method of transference keeps the watercolour paper free of corrections,

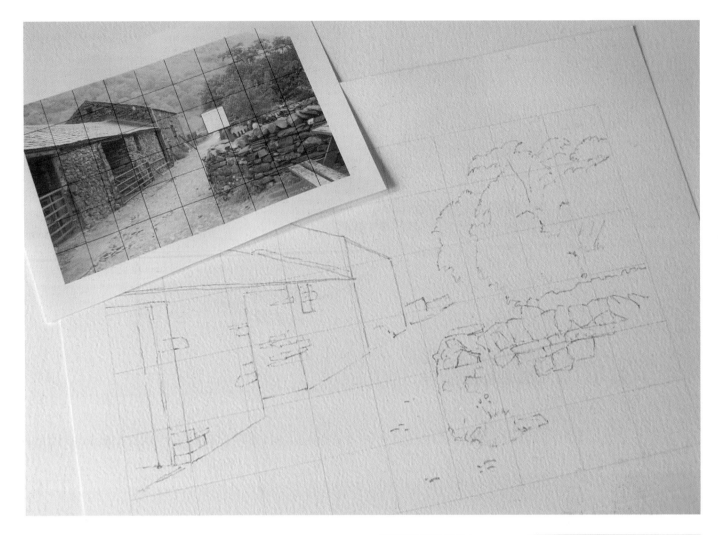

ABOVE: **Using a grid to scale up a photograph.**

gridlines and any potential damage through overworking the pencil lines and so on.

Projector

Projectors scale images up and down in seconds but they can be an expensive accessory for a leisure painter. Although they cut down drawing time, allowing you to get on with the painting sooner, they should not be used as a replacement for the skills of looking, gauging and expressive freehand drawing. A photographic print or a small drawing is loaded into the light chamber and the image is projected through a magnifying lens via a mirror. Sometimes the image may become slightly distorted through the refraction of the lens and this will need to be corrected by hand if the drawing is to look realistic. Artists have used this kind of technology for centuries with the invention of

Tracing a complex scene onto watercolour paper. Make all your alterations on a separate piece of paper and when the drawing is correct transfer it to your watercolour using tracing paper in conjunction with light pressure on your pencil.

Here the black-and-white image of the building is entirely recognizable but the outer individual shapes that make up the whole are not. These are the shapes that the artist should study as well as their proportions and how they relate to the overall picture. Break your drawings down in a similar way as you work.

the camera obscura being a similar kind of device. This equipment probably explains the scale and sheer accuracy within the paintings of some of our well-known masters.

Draw what you see

A concentrated drawing will involve lots of attention and indeed you should ideally find yourself looking more at your subject than at your drawing. It can be a very tiring process and raising your head from your drawing to the subject every few seconds requires a fair bit of discipline. If you find yourself looking at the subject only a few times and struggling to make sense of your drawing, then you need to stop and redress your technique. Stylized or lazy drawings are often the result of drawing what you think you know, not what you actually see. If you are continually making a repeated mistake, then you are not studying your subject hard enough. An example of a stylized approach could be when an individual learns how to draw a tree and repeats that tree throughout a picture. Trees differ in so many ways and each tree exudes individual character. You should strive to draw each tree afresh, concentrating on its individual characteristics and shape, not just replicating what you know. Often it is the subject itself that diverts the artist's attention, for example if you were drawing a horse your brain would recognize the shape of the animal and instruct your hands to draw it

from recognition and memory. In these circumstances you are likely to end up drawing what you think you see, based on your visual knowledge of the shape of a horse. Turn the image of the horse upside down however and the study becomes a whole new ball game. You no longer recognize the shape and as a consequence your brain instructs your hands and your eyes to study the layout of the incoherent mass of lines and angles. I once conducted this experiment with a class of drawing students, with remarkable results. Fight the urge to draw recognized shapes and instead break the subject down visually into chunks of easily managed forms so that you consistently look at the subject and process the information onto paper.

Building up a framework

When you are confident that the drawing will fit into the boundaries of the paper, you can continue lightly plotting lines and angles until the drawing has a strong, skeletal framework. Do not draw a line without first checking how it relates to its surrounding shapes. When the basis of the scene is drawn, you can then work over your faint outlines in heavier pencil work. Depending on what you want out of your drawing, you have the choice of either leaving it as purely outline or you can add shading or colour for further reference.

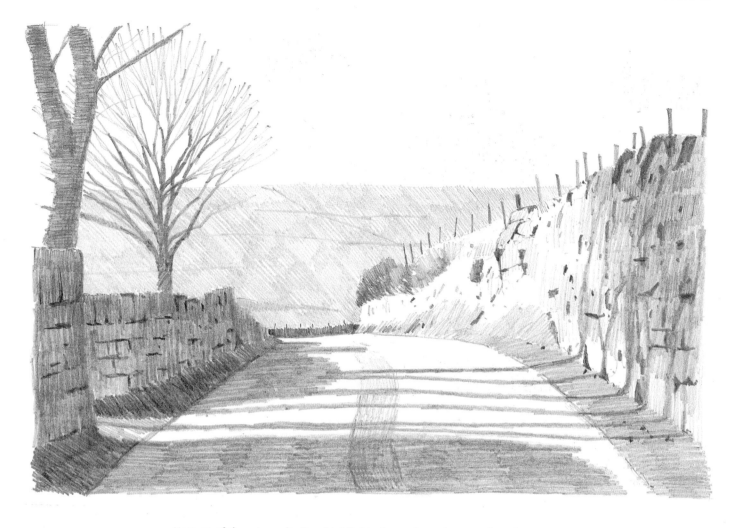

Here careful contour shading highlights the various slopes and angles within the scene. Painting the image would follow the same approach with the brush.

Shading

Shading in pencil should be carefully executed with as much concentrated study involved as creating the line drawing. First of all, look carefully at the subject and make a note of the lightest and darkest areas, as these are the tonal extremes within which are placed all the other tonal shades. Work the tones up gradually, using a range of pencil grades. It is good practice to use a consistent pressure on the pencil, changing the grade for lighter or darker tone, for example HB for light areas, 5B for darker areas and so on. It is possible to shade with a single grade although the softer the pencil is, the more likely the lighter tones are going to be grainy and easily smudged by the side of your hand. If a careful steady approach is used, a highly graphic image can be built up using a full range of pencil grades. This way of working is ideal for a deliberate and disciplined study. For sketches or drawings requiring less time, a more spontaneous approach can be employed using a narrower range of tones and

contour shading. Contour shading involves making short pencil strokes in the direction or slope of the features and this can add a real, three-dimensional aspect to a drawing or sketch. However you go about shading, the progression of building up an image from light to dark is identical to painting in watercolour and for this process alone it is an excellent and highly valuable discipline towards improving your paintings.

Pencil care

A neat and tidy drawing is not only attributed to careful study and execution but also to sharp and tidy pencils. Pencil points can be shaped using a craft knife and this is a preferred method of sharpening to that of a pencil sharpener, which exposes only a small amount of highly pointed lead. Any slight pressure on the tip instantly breaks the nib, and if the artist is a little too

A typical, quality digital camera capable of up to 18x optical magnification and with a high megapixel feature for detailed printouts. The unit is lightweight and has automatic or manual setting options for amateur or more professional photographers.

casual it is not long before the drawing being produced becomes untidy due to the blunted stub of graphite smearing thick lines onto the paper. I generally use a craft knife to carefully pare away approximately 1.5cm of the pencil, exposing around 5mm of lead. This is shaped at the end into a chisel form, which, when rotated on the drawing, will produce thin and thick marks, creating character within the line work.

Working from photos

It would be impractical to ignore the use of a camera when collecting subject material and working landscape images into finished paintings as photographs are the most obvious and productive way of collecting subject material to paint. The advancement of the modern camera has brought digital media beyond the capabilities of older film cameras and as a result great photography is no longer for the elite armed with the knowledge of f-stops and shutter speeds. Cameras are now crammed with intelligence and excellent pictures can be taken by photographic amateurs like myself. The overriding advantages of digital cameras are that they are relatively inexpensive and you can take an endless number of shots without having to

worry about the cost of film. This is an important consideration because it is of great advantage to have several photos of your subject, ideally from different angles as well as close-up and distant shots. Cameras are also reducing in size and incredible pictures can be taken with gadgets the size of a credit card.

The advancement of modern technology has made taking photographs and manipulating them easier than ever before, even for those who may be a little computer illiterate. One of the many benefits of a digital camera is the electronic preview screen at the back. Through regular usage, I have discovered that it is far easier to balance an image with both eyes using the preview screen than it is to use one eye when the eyepiece is utilized. This is not always the case though, as it is better to use the eyepiece when zooming, making the camera more stable and therefore avoiding camera shake. The size of camera and the quality of image are also additional bonuses to those who travel or need to move around the landscape carrying as little weight as possible. Cameras are extremely useful tools for capturing fleeting changes in light, atmospheric effects or references of colour. Although they should not entirely replace the traditional disciplines of sketching, looking and studying, cameras are an essential part of the landscape painter's kit.

When faced with a panoramic scene, the viewfinder or preview screen of the camera is an excellent start for cutting out or

Cameras are ideal accessories for allowing the landscape painter to capture fleeting moments of changing light or weather. Effects like these can be married to other scenes, making creativity part of your painting style.

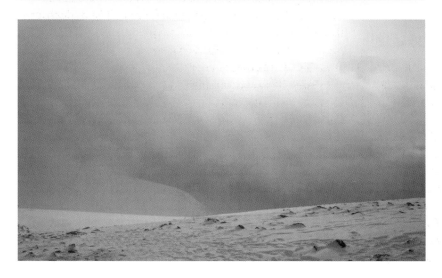

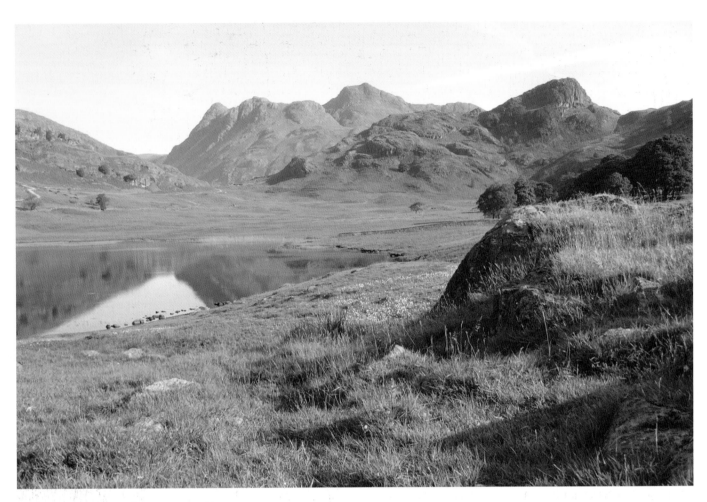

ABOVE: **A typical Lakeland scene, composed with the camera.**

RIGHT: **I was able to zoom in on the distant mountains from exactly the same viewpoint and this would either make a second painting or act as detail reference to the previous shot. Take as many photographs as you feel are relevant to you and your work.**

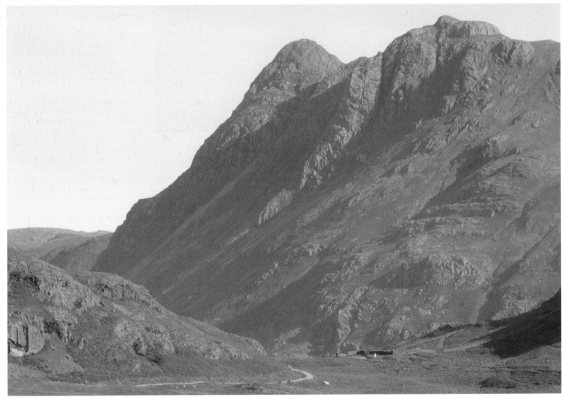

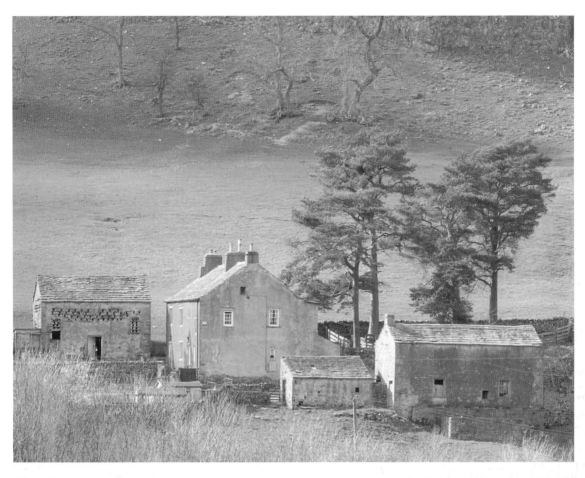

A photograph taken with a high optical magnification camera across a wide valley. The buildings were visible only as shapes by eye and here the clarity of the shot was assisted by image stabilization technology.

cropping extraneous parts of the landscape. In fact, some cameras now have an option of visually over-layering the preview image with intersecting third lines to aid your photographic composition. When taking photographs this should be an important consideration, with the same approach to constructing the scene as for sketching. Compose the scene as best you can with the camera as this will cut down the amount of any further composition that you might undertake back home. Start with your focus and either zoom in or out to include either less or more of the surrounding scenery. When you spot something that will stand out in a picture, take a moment to visually construct the scene in your mind. Ask yourself, what would you do to it if you were painting it? Do not stick with your first choice of viewpoint, move around the subject and find the best angle. You may even discover a lead in. The more you compose scenes with the camera, the easier they become to spot as you learn what makes a good picture and what does not. It is worth studying the scene visually at first and deciding which parts to include and which may need some extra information. If you need the stonework detail of a building, for example, then you can either move in closer and take further photographs or simply zoom in on that area. I generally aim to take a number of photographs from different angles and viewpoints so that I have as much information about the subject as possible. If it is impractical to

In this photograph the heron, although some distance away, has been magnified with digital magnification and this has led to a loss of detail and sharpness of the image.

return to the viewpoint at some future date, then having as much information to hand from which to paint later is very important. Make notes to cross reference your photos if necessary. The camera also has the ability to pull out scenes that you might not have otherwise even considered. On several occasions I have been able to record up to six different scenes from the same viewpoint just by zooming in on various different

The fishing boats make a pleasant colourful subject but I found the background a little distracting to my intended focus.

Using an easy-to-operate digital editing programme, I took away the background and replaced the area with ocean. The result gave me a realistic interpretation of how the picture would look before I embarked on the painting.

subjects and composing them as new paintings. Using a strong zoom on a camera can produce some striking results but to succeed you will either need a tripod for camera stability or a camera with built-in image stabilization technology.

Read the manual

Cameras can do so much more nowadays. Some have enhancements for things like sunsets. Some have filters and anti-glare attachments. Some cameras can have lenses added to increase magnification or wide-angle features. Some even have compensation filters for adjusting the light when taking pictures indoors or under fluorescent lighting. If you are thinking of buying a digital camera, look for one with good lens quality. You do not really need to go beyond 3mp (megapixel) unless you are thinking of printing your photos at A4 size. Manufacturers can be a bit misleading with their descriptions of zoom magnification so be aware of what you are buying. Magnification is described as both optical and digital. Optical zoom refers to the capabilities of the lens and this will give you the traditional clarity that you would expect from your camera. Digital zoom is

when the camera reproduces the original pixels from the image in order to electronically enlarge the picture. This generally results in loss of detail and blurring of the image occurs. It is better to use a camera with a bigger optical zoom and less digital zoom and this should be marked on the packaging. If you do not own a computer or a printer, you can still have your photos developed at any photo-developing shop. The advantage of this is that you can usually select only the photos you want to print, which makes them very cost effective.

Manipulating digital images

Some of my regular painting students have inspired me over time to look at further composing a scene using photo-editing software on a computer. Pictures for painting are traditionally composed in pencil with any features to be introduced, moved or omitted dealt with in the drawing. In this way, only a brief interpretation of the compositional idea can be obtained and it is not until the painting is completed that you really discover whether or not the ideas work properly together. By manipulating a photograph on a computer, it is possible (depending on your skill levels and time) to produce an altered yet lifelike image from which to conduct a painting. Images can be cropped, copied, pasted and cloned to create modifications to the original scene. In this way, the newly composed scene can be clearly studied before the paint even touches the paper. The photograph can also be used as a direct source from which to work. The obvious advantage to this way of working is that you can see your subject in clear reality rather than looking at a vague pencil sketch. The downside is that you may end up over-detailing your painting when you are working purely from photographs. One of the best advantages of digital media as opposed to photographic negatives and prints is the luminosity and depth of field seen in the computer screen. Images are much more lifelike and definitely do not appear flat, which is how some photographs and prints can turn out. I know a few painters who work directly from their computer screens almost as though they were sitting in front of the scene in real life.

Waterfall, Church Beck, Coniston, 29 x 20cm (11½ x 8in).
**The wild mountain elements provide many varied
painting subjects.**

PAINTING SUBJECTS

The following is not a 'how to paint' section as, although certain techniques and methods can be conveyed, there is not necessarily one correct approach to painting landscape features. Each artist interprets things in his or her way and no doubt will employ slight differences in skill. This is what determines style and what makes one artist's work recognizable against another's. The subjects covered here are more or less the most popular features found in classic landscape painting and I hope to convey some ideas and inspiration within the chapter.

Mountains

The mountain environment can be a serious affair, especially when harsh weather prevails, and it does pay to be prepared if you are thinking of venturing out into this kind of terrain. Waterproofs, warm clothing and spare food are really all-year-round necessities when venturing into hill country. On your list should be a map, compass and whistle, even if you are walking as part of a group, although they are pretty useless if you do not know how to use them. You should also know your limits and whilst it may be regarded as healthy to scare yourself now and again you should definitely know when it is time to turn back. Once when climbing Scafell Pike in the Lake District I was approached by a girl asking the way to the top. Heavy mist swirled around us and it was difficult enough seeing your own hand never mind the direction of ascent. Pointing almost vertically into the gloomy cloud, I directed her upwards towards the summit plateau but she alarmingly replied that it was rather steep. What did she expect? The scenario then took a further nosedive when I asked her to show me her map and she sheepishly produced a large-scale tourist plan of the entire Lake District. Why she had ventured into such a situation when she was so inadequately equipped was anyone's guess and her explanation of her whereabouts was that she had simply followed the signs from down below. The valley was baking in glorious May sunshine but at 3,000ft it was a different kettle of fish. It was dark, cold and wet and anybody not dressed in full winter kit would be very foolish. I advised her to return and made my way up the rock-strewn slopes of Mickledore but much to my surprise she followed me. On top, the visibility was incredibly low and I had no option but to escort my eager companion to the summit. Luckily in my bag were spare winter clothes, which she gladly accepted trying desperately to stave off her uncontrollable shivering. When we finally descended back below the cloud line, she admitted she had been foolish and she was very grateful for my assistance. She had actually been very lucky.

Walking amongst the mountains absorbing the atmosphere and taking in the changing light and weather is a great way of bringing a deeper understanding into your work. Memories and experiences have a strong influence on expression and creativity. On one particular occasion when I was camping with a friend, we were treated to the most memorable sunset and sunrise from our high-level pitch. On another excursion we were subjected to the most appalling weather. My intention was to capture the winter mountains clad in snow and ice, but when we arrived we discovered that, due to weeks of heavy rainfall, there was no snow or ice, and typically, it was still pouring with rain and also very windy. Our route began in Eskdale in the west of the Lake District where the rain lashed incessantly as we gradually made our way through thick mud, stopping for sketches here and there. The pace of the walk had been calculated to take in stoppages as well as the terrain and difficult snow conditions, but as the snow was not an issue, we made good time and pitched our tent at Great Moss just before dark. Half way into the night the wind began to increase, bringing with it hail and heavy rain, which pelted the tent with an incredible roar. A storm was blowing in and strong southwesterly gusts were being channelled up the Esk valley and across Great Moss with growing ferocity. Suddenly, we noticed one of the tent poles had been bent by the gusting wind, which subsequently left one side of the tent weakened and vulnerable to the elements. Using two trekking poles, we tried to shore up the material in order to stave off any further damage but it did not have much effect. The winds were soon intolerable and seemed to be getting

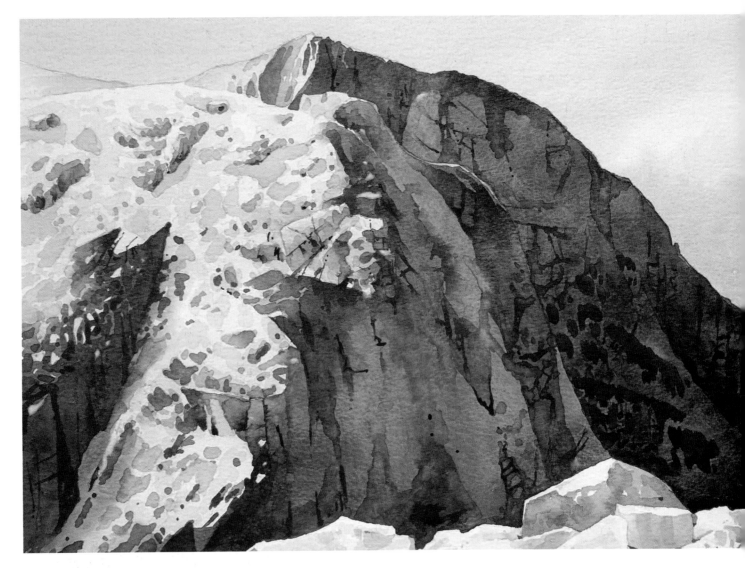

Scafell from Scafell Pike, 42 x 30cm (16¹/₂ x 11³/₄ in).
**Mountains make excellent subjects so long as you are fully prepared and
equipped to go hunting for them. This high-level subject focuses on the
plunging crags of England's second highest mountain.**

worse by the minute. Suddenly and without much warning an almighty gust of wind hit us, and the tent began flapping helplessly but before either of us could do anything, a second frightening blast struck. With a simultaneous snap and a bang, all the poles were shattered into splinters and the whole tent was left flapping around in the wind like a broken kite, held only by the guy ropes and a few pegs. A storm in the mountains can be frightening at the best of times, but on a cold winter night it can be rather unnerving. At times like this, there is no room for panic. Confidence in yourself, your equipment and how to use it must take precedence. We took it in turns to hold up the remains of the tent as we dressed in waterproofs and packed our gear. The seemingly sheltered spot had turned into an exposed area taking the full force of the weather and without a tent we

were now in a serious situation. To try and make our way back down the valley in these conditions would be somewhere beyond insanity, so with head torches and essentials we headed off for a sheltered bivouac site and a wilder night out than we had bargained for. Memories like these invite the artist to put a little extra feeling into the brushwork and this in turn brings out a potentially extra special painting.

I climb mountains partly for the thrill of the sport but mainly to collect subject matter to paint. Travelling light is essential so I carry the minimum amount of painting equipment and it is in these circumstances that you realize just how little equipment you really need. For sketching I have a pad, a few paints squeezed into a tin of pan cases, a couple of pencils and two or three brushes. I also have my camera in a padded case clipped

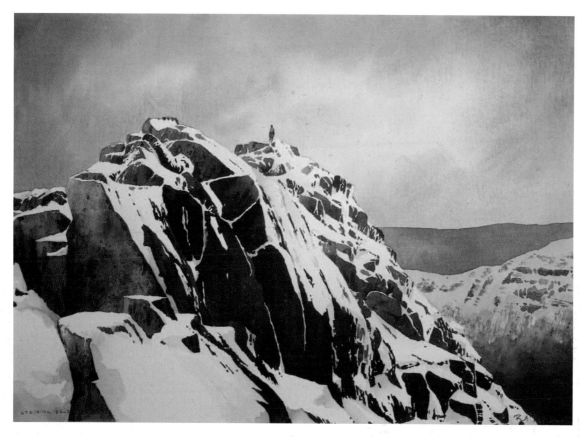

LEFT: *Striding Edge*, 68 x 48cm (26³/₄ x 19in). Painted from a determined trip to capture the mood of snow and ice at high level. The figure adds scale to the picture and portrays the vulnerability of the person in such an environment.

BELOW: A mountain sketch conducted on the return to the valley after a day's walk. Keeping sketching equipment to a minimum is essential when walking and climbing.

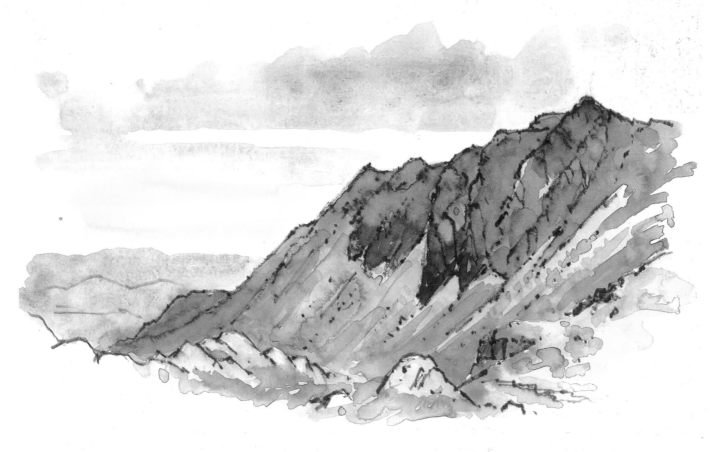

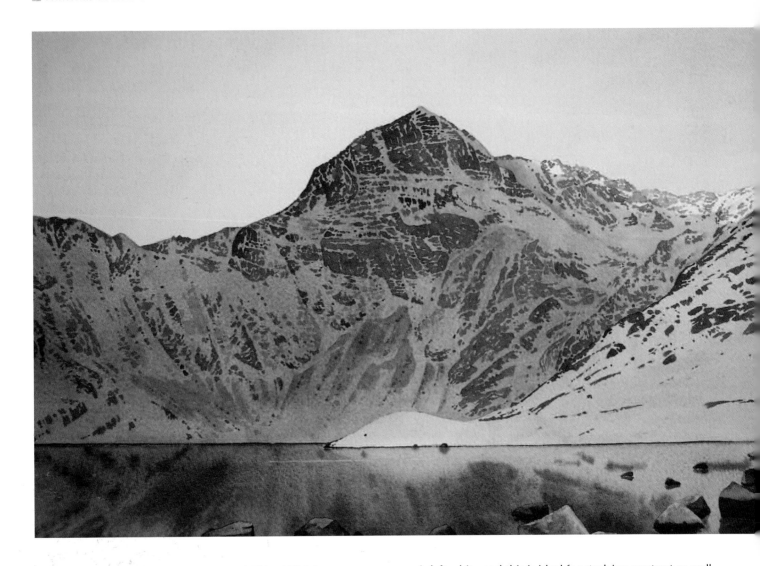

Snowdon from Glaslyn, 45 x 35cm (17³/₄ x 13³/₄in).
This viewpoint is not exactly at valley level but at least the summit did not have to be scaled to take in such a classic mountain composition. Mountains offer many compositions from many vantage points, making them fairly accessible subjects for most people.

to my side for ease of accessibility. There is so much subject matter to be found in the mountain environment that I generally decide on what I am going to tackle according to the weather conditions. Bold stormy skies or towering crags can often add an impressive backdrop to a particular focal point such as a cottage or a figure and it is often good practice to interweave some kind of atmosphere into a scene of this sort.

If the mountains are covered in cloud, then there is no point making an ascent and instead many compositions can be sought out on the valley floor. Snow turns the mountains into an exciting kaleidoscope of contrast and sometimes I go equipped specifically for snow and winter conditions. Painting winter mountains is a challenge in itself as the majority of the

paper is left white and this is ideal for studying contrast as well as learning about form and the various profiles of rocks, mountain slopes and so on. High summer generally flattens distance and also the heat makes mountain climbing hard work, so valley subjects such as streams, waterfalls, and woodlands are all good alternatives to scaling the peaks. Climbers and walkers placed on exposed mountain sections can bring over a feeling of vulnerability and exposure. I often fill the picture space with an entire mountainside and place a recognizable feature in the foreground or mid-ground area in order to create a sense of scale. Exaggerating the scale of the landscape is another way of magnifying the feel or mood of the painting. Composing a mountain scene is not easy as there is often so much topography to consider, so finding a focal point should be the first objective. Small buildings, bothies and mountain huts are all great subjects to draw the eye into a picture, and figures and animals can work just as well too. For the wider panorama a particular crag or prominent rock could be used as a focal area, or maybe even a tree or group of trees. Waterfalls, bridges and streams also have their place in mountain scenery and although

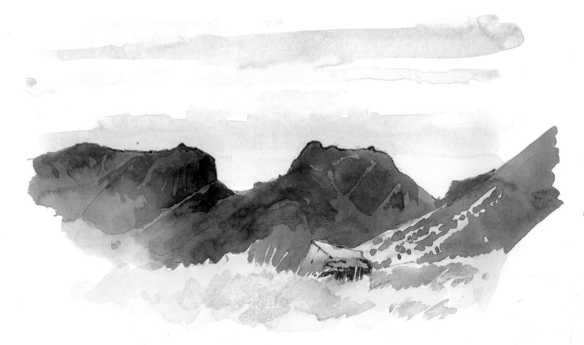

A watercolour sketch of the mountains Scafell and Scafell Pike, which uses their distinctive profiles as a focus to the scene.

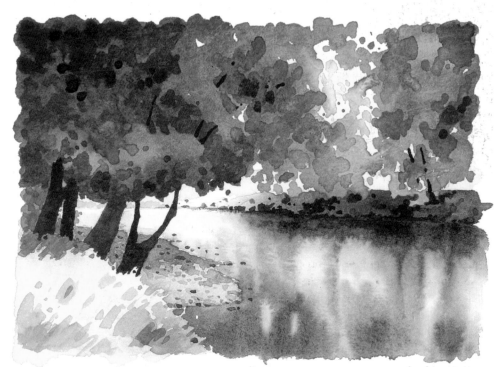

In this painting, the mass of pebbles on the exposed section of riverbed have been simplified to a few stippled marks layered on top of a varicoloured wash.

this sounds as though the mountain environment is only for the fit and able, many of the better compositions are actually found on the valley floor.

Rocks, walls and crags

Rocks vary in size, colour and shape according to the local topography and nobody notices them more than those who have to paint them! Study rocks in all their guises because once you have mastered the basics it is only a slight extension to painting elements made from stone such as walls and buildings as well as bigger crags and mountains. Aim to paint the varied colours first, taking care to plot the shaded parts within the first wash. Next, a shadow layer will give the rock shape a three-dimensional element and this needs to be layered over the first wash after it has dried. Finally, apply any texture or further detail to the rock. Drystone walls and cliffs can be painted in a similar

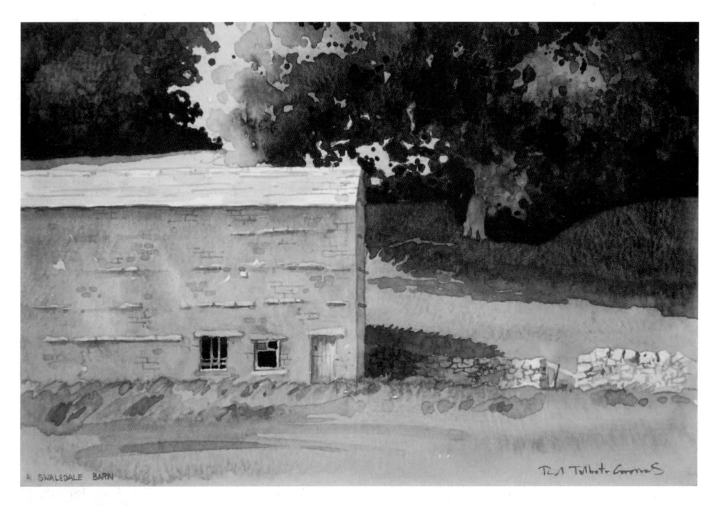

A SWALEDALE BARN

RA Talbot-Greaves

A Swaledale barn, 29 x 20cm (11¹/₂ x 8in).
The walls of the building were depicted in an initial variegated wash of raw sienna and cobalt blue and this has suggested at least half of the stonework. After adding shadows under the eaves and on the gable end of the structure I applied very little detail, thus avoiding overworking the feature.

progression, finishing by adding the wall details or the cracks and fissures of a craggy mountain face with a fine-pointed round brush, rigger or ruling pen. Pebbles and smaller stones such as shingle can be suggested quite loosely and there are a number of ways of describing this kind of detail without overdoing it. Spattering paint is a very liberating exercise and creates a very loose, random effect. It is possible to spatter two or three layers with drying in-between, in order to build up a three-dimensional feel to the area. Stippling creates a similar effect, which can look very realistic, especially if you combine the technique with softening here and there. Stipple a small area with colour, then rinse the brush and continue the technique a short way using clear water, pulling out some of the fresh paint as you go. Alternatively, a dry-brush technique works too. Use this on a rough surface paper for best effects and as with the other techniques, a few layers will give the area solidity. Mix some colour and drag it across the area using the belly of the brush, making sure you keep the point off the paper to avoid creating lines. Soften some of the areas immediately with a clean damp brush to create a natural feel. All the techniques described above will need an initial colour wash before the textures are applied (*see* Chapter 4, Useful Painting Techniques, pages 93–113).

Buildings

Buildings make great focal points in a landscape and they can be extremely useful at not only placing a familiar feature in a picture but also for creating a sense of scale and sometimes for reinforcing a particular atmosphere. In a snow scene for example, a building set amongst a cold, barren wintry backdrop could include a warm glow of a light in a window and smoke rising lazily from the chimney. These touches may not be how you saw the scene but a little creative intervention like this can often make a huge difference to a painting. Very often when a painting of a building looks flat and lifeless, it is because the artist has not taken the time to look at the variety of colour within the stonework and instead, has painted a single colour depiction of the subject. Raw sienna or burnt umber are popular colours for

stonework but if you use a flat wash, for example an entire building painted in a single tone of burnt umber, then no matter what you do to the building subsequently, it will always look flat. The first wash is therefore very important. Look closely at the stonework and pull out a colour scheme. There may be yellows, browns, blues and even reds in it, albeit in small quantities, but it is worth noting the colours you can see and using them in your painting.

Mix colours on the paper

To create the overall variety of the stonework colours it is often best to mix them loosely on the paper as you work. For example, you may be able to see a reddish stone surrounded by ochre-coloured stones with the odd blue one intermingled here and there. Do not try to paint each one individually, just brush these colours loosely together in a variegated way as an initial colour wash (*see* Colour mixing, page 117). Keep the wash in control by working in small areas at a time with fluid paint,

French chateau, stage 1.
I used raw sienna, burnt sienna, cobalt blue, lemon yellow and sap green to depict the mass of colour and detail within the castle walls. Notice how the colours vary without changing tone as any shift in their strengths may create contrast, which becomes a distracting element of the technique.

making sure the leading edge to the wash is always wet. If you brush your paint out too much to an extent where it dries very quickly and leaves texture, then you will not achieve the necessary soft blends of colour.

Shadows before detail

When you have painted the colours on the building, the next step is to add shadow and shades in exactly the same procedure as painting rocks and walls. Shadows can be described as those cast by light, for example a cast shadow thrown by an adjacent

71

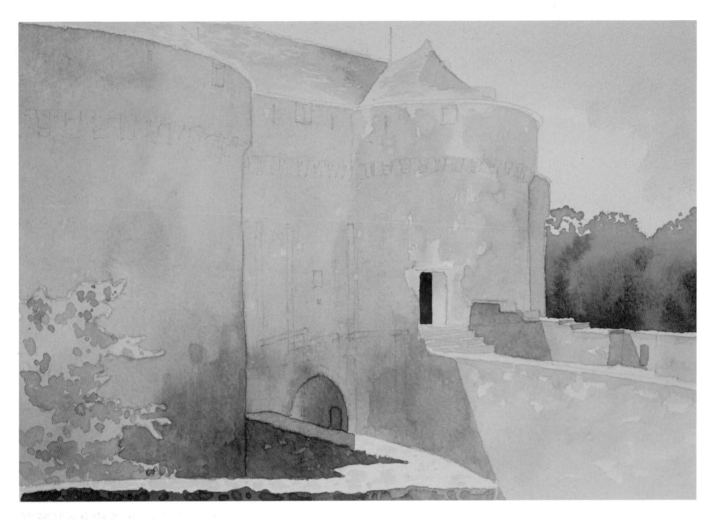

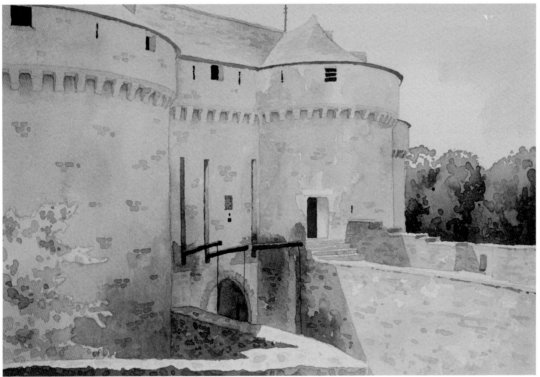

ABOVE: **French chateau, stage 2.**
I washed in areas of shade to define the shapes of the curving walls, parapets and so on. I scumbled some of the washes, especially on the far tower, in order to generate some texture on the stonework.

LEFT: *French chateau*, 30.5 x 21cm (12 x 8¹/₄in). The darkest darks and finer details are added last. Notice how the inclusion of the dark tone makes the lighter areas appear bright and fresh.

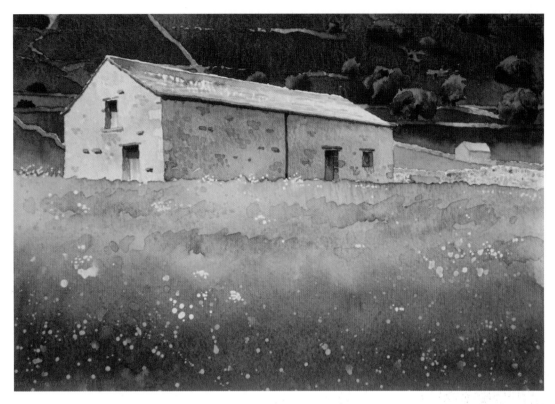

Hay meadow, Kettlewell,
33 x 23cm (13 x 9in).
**The viewpoint is from
below the building and
therefore the eye level is
lower too. All radiating
perspective lines will
meet on the eye level,
making any horizontals
of the structure slope
downwards.**

feature across the face of your building. At least one side of the building may also be in shadow. Shades can be described as those darker areas that separate features, for example the side of a building including a lean-to may be in shadow but within that there may be further shades that define the edges of the lean-to and all its relevant details. Look out for the tonal changes and try to plot where your shadows and shades are before you begin painting. Use a grey mixed with the key colour in your palette, for example you may have used mainly raw sienna (with other colours) for your initial building wash so mix this colour with a grey to form the shadow colour of the building. The strength of your shadow is purely subjective to your scene. If you need a strong shadow use less water and increase the grey. If you need a weak shadow use more water and decrease the amount of grey.

Darks and details last

If you have built up your building successfully in the progressive layers, you should have something that resembles a three-dimensional structure with a certain amount of detail suggestion already present. Add any final darks and details on top of these layers, although I usually find that you can eliminate a lot of the finer detail at this point due to the interest generated by the first two layers of colour and shadow. This also helps to greatly simplify the subject.

Drawing buildings

Drawing buildings can be tricky due to the technicalities of perspective and if you find this subject difficult to understand then keep working on simple exercises until you are fully aware of the basics. An artist does not need to be an accomplished draughtsman in order to place a building successfully into a landscape painting but a grasp of the basics of perspective definitely helps. All that is required is an eye level and the knowledge of vanishing points, as these will determine whether a line slopes upwards or downwards. By working on simple diagram exercises it is possible to gain an understanding of these fundamentals of perspective.

Perspective

To be able to construct a three-dimensional drawing on a piece of paper, you first need to establish an eye level. An eye level is exactly as it sounds – it is the level of your eyes as you look straight ahead from your viewpoint and it is represented on a perspective drawing by a horizontal line drawn across your paper. Look carefully at the shapes and objects within the scene you are viewing and how they relate to your eye level. Are they situated above it, on it, near it or below it? Whatever your position, your eye level is represented as though you were looking straight ahead regardless of where your building is situated in the scene.

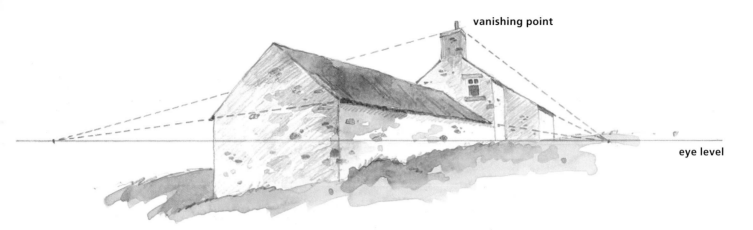

vanishing point

eye level

ABOVE: **In this diagram the majority of the building is above the eye level and therefore the known horizontals such as the gutter lines, chimneystack and windows slope downwards. When viewing a building above you like this, establish the eye level first and construct the drawing above it. The orientation of this building depicts one vanishing point close in and the other slightly further out, depicting our close proximity to the structure.**

BELOW: **In this diagram the building is way below the eye level, therefore depicting our higher viewpoint with the roof line and chimneys sloping upwards. Draw your eye level as though you were looking straight ahead and construct the building underneath. Here the vanishing points are way off the edges of the paper, putting more distance between the viewpoint and the subject.**

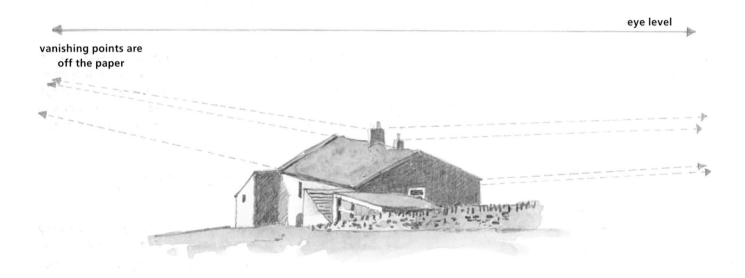

eye level

vanishing points are off the paper

Eye level examples

If you were standing on level ground looking at a building, your eye level would cross the building at approximately normal door height. The majority of the building would be above your eye level.

If you were elevated above the building and you looked down, you would be viewing the top of the roof and chimney. Your eye level however, would still be drawn as though you were looking straight ahead and this line would be established way above the

building in your drawing. When you have established your eye level and its relationship to your scene, you need to create two vanishing points along this line.

Vanishing points

Vanishing points are where the horizontal lines of the sides of an object meet your eye level through perspective. The closer you are to a building, the closer in to that structure the vanishing

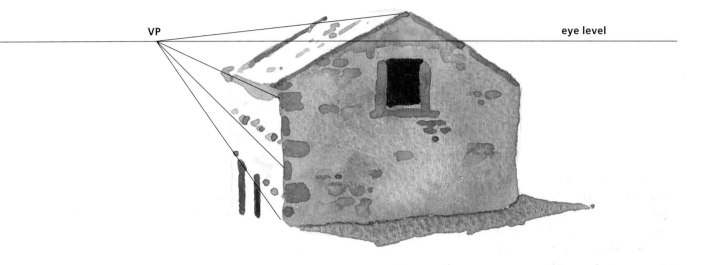

VP eye level

Here the roof lines, some of the stone coursing and door tops have been extended
in pencil to locate the eye level. All the lines will cross over at a single point, which
is actually a vanishing point. A horizontal drawn through the vanishing point will
give you your eye level, shown here just below the point of the gable.

points will be, and hence the angles of the shape will become acute. The further you are from viewing the building, the further away your vanishing points will be. When you are viewing a building where two sides can be seen, then all the known horizontals of the building will radiate to one or the other of the vanishing points. All the verticals can remain vertical. In more complex cases where several buildings are seen at various angles you will still utilize one eye level but with a multitude of different vanishing points to create the different angles of the structures. In most cases it is unnecessary to create technical drawings and instead you can rely on a general judgement to establish your drawing. Understanding the fundamental basics of eye level and vanishing points, though, is paramount to being able to make that judgement in the first place.

Plotting eye levels and vanishing points

Sometimes it can be difficult knowing where to start with a perspective drawing and to help yourself locate your eye level you can take angles and lines directly from your source material. Look at your scene and use the horizontals in a building, for example those that would be horizontal if you were looking straight at it, i.e. window lines, roof lines and so on, to plot the vanishing points. Draw pencil lines along the window tops, win-

dow bottoms and rooflines either on your photograph or on tracing paper placed over your photograph. Where they meet you will have a vanishing point, which will also be on your eye level. Once you have established your eye level in this way, you can begin to construct the drawing properly on your paper.

Breaking buildings down into simple shapes

Complicated-looking buildings with lean-to additions, chimney stacks and dormer windows can be daunting to draw, especially if you only have a tenuous grasp of perspective, but if you break them down into a series of simpler shapes then the application of perspective can seem a little easier. A straightforward building may be broken down into a rectangle with a triangle on top for the roof. A chimney is a rectangle on its end and so on. Practise drawing these kinds of individual shapes so that drawing buildings becomes a matter of assembly of a number of boxes and not a complex mass of geometrical calculations. Not every painting has to contain complex buildings. If you want to paint a particular building but you find perspective too complex to follow, then try painting it from a different angle or from a viewpoint where the perspective might be easier to handle. Some buildings have wonderful facades and here you may

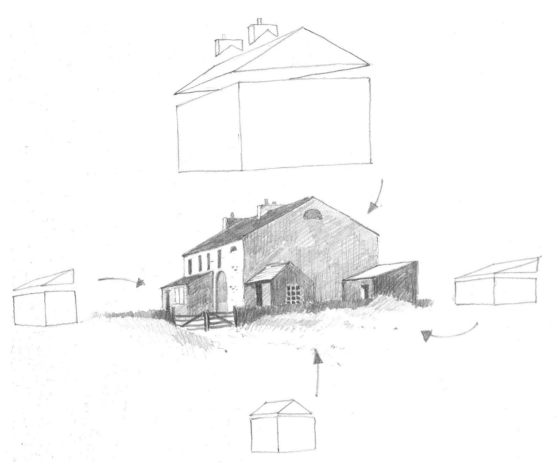

To draw a building such as this with all its additions, build it up as a series of geometrical shapes. The entire structure has one eye level and only two vanishing points so use these as a guide when constructing the rectangles, triangles and so on.

wish to paint a portrait viewed straight on, rather than the building in its surroundings. A building may become a focal point in the far or middle distance and could well be fairly small in the picture. In circumstances like this, in-depth perspective is probably not needed although a road leading up to the building will need to conform to eye level and vanishing points. A grasp of the basic laws of perspective will certainly help you build up better drawings in general and it will also help when looking, gauging and drawing things freehand. If your building looks wrong, then there may be something wrong with a perspective line and an understanding of the subject will enable you to put it right.

Perspective recap

Always establish your eye level first. Remember that vanishing points may be way off your paper and in this instance you will have to guess at their location. When seen in perspective, for example you can see two sides of the building, any horizontal above your eye level will come down to it and any horizontal below your eye level will go up to it. Vanishing points close to the building will create acute perspective lines and those further away will make the structure appear more level.

Water

Water in all its forms has an evocative charm in a painting. Although watercolour is ideally suited to capturing the various effects and states of water, it remains a difficult concept for many to master. One only has to think of the lazy reflections on the surface of a lake to appreciate the perfection of the wash required in order to capture such an instance. The random motion of a waterfall complete with all the nuances of tone and transparency requires steady technique and a keen observation of negative shapes. The rolling pattern of colour, tone and contrast at the base of a waterfall has a mesmeric perpetuation and capturing this motion requires full expression and confidence in brush handling.

Still water

The most important watercolour techniques for capturing the effects of still water are the wet-into-wet technique and a considered wet-on-dry approach. Creating the glassy effect of water relies on the artist being able to paint and control reflections of the required depth of tone and necessary shape. Soft blurry reflections can be stated in one application using a carefully

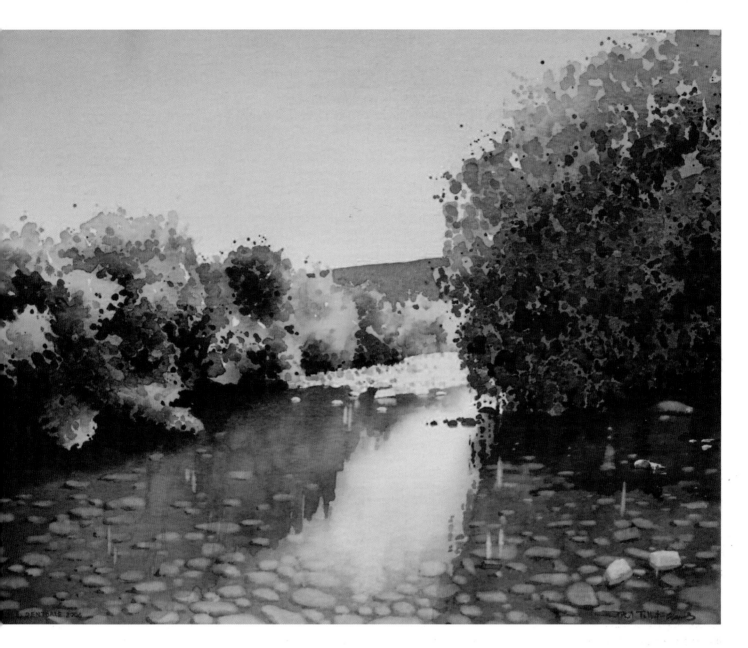

River Dee, Dentdale, 46 x 36cm (18 x 14in).
Clean deliberate washes reflect the light and the trees, with the
pebbles showing the shallow level of the water. A complicated
series of techniques was used to depict this water scene.

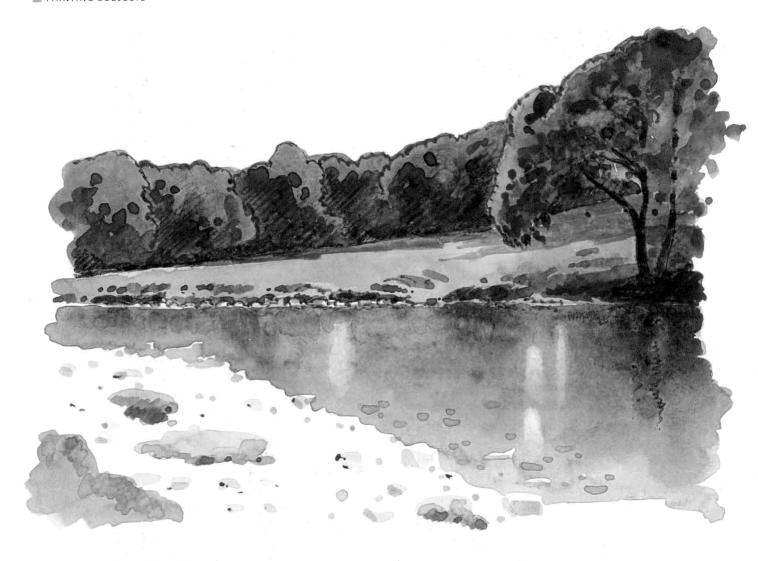

A watercolour sketch of a still section of river depicting reflected colours and tones painted wet-into-wet.

planned wet-into-wet technique. Wetting the paper sufficiently is paramount for achieving a successful result and a liberal amount of water should be brushed into the paper surface and allowed to settle before a second layer is added.

Once the wet sheen is of an even, satin finish then the painting process can begin. Reflections will mirror shapes, colours, tones and angles and these must be observed before a brush is brought anywhere near the paper as a clean deliberate approach works best. I often begin with a pale tint of the sky colour across the entire body of water and this helps to tone down any of the lighter reflections, making them look more realistic. Next, I brush in the colours and tones, working from the lightest areas through to the darkest using slightly less paint than if I were painting wet-on-dry. This prevents any definite reflected shapes from totally dissipating into the wetted paper. The whole process requires one eye on the painting action and the other on the wetness of the paper.

As soon as this begins to show any signs of drying, the painting progression must stop. It really pays to try and stay calm, aiming for the main shapes, colour and blocks of tones rather

than any fiddly details. It does not matter too much about achieving perfection so long as the main shape of the reflection has been captured. Creating soft reflections in this way invokes a sense of calm on a painting and for this reason I often paint lakes as still-water reflections.

A similar approach can be utilized using a wet-on-dry method and the tentative artist who wishes to exert a little more control over his or her subject can adopt this. Again, I usually begin with a pale wash of the sky colour but when painting reflections this way I allow this wash to dry first. Next, I use fluid paint to describe the reflections as wet-on-dry. If any reflected areas overlap, such as where two mountains meet, I usually allow one shape to dry before applying the next. The end results are similar to the soft wet-into-wet approach, however this technique produces hard edges and as a consequence it sometimes pays to add a gentle waviness to the boundaries of the reflections as

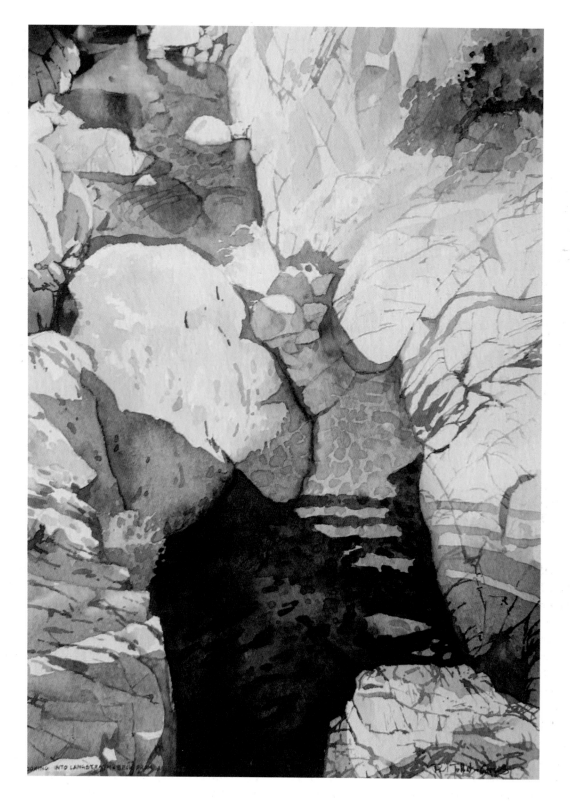

Looking into Langstrath Beck from a bridge,
26.5 x 38cm (10¹/₂ x 15in).
In this painting an almost abstract view is created by
looking into the beck from above. The reflections in the
water were painted as wet-on-dry and this is evident in
their harder edges.

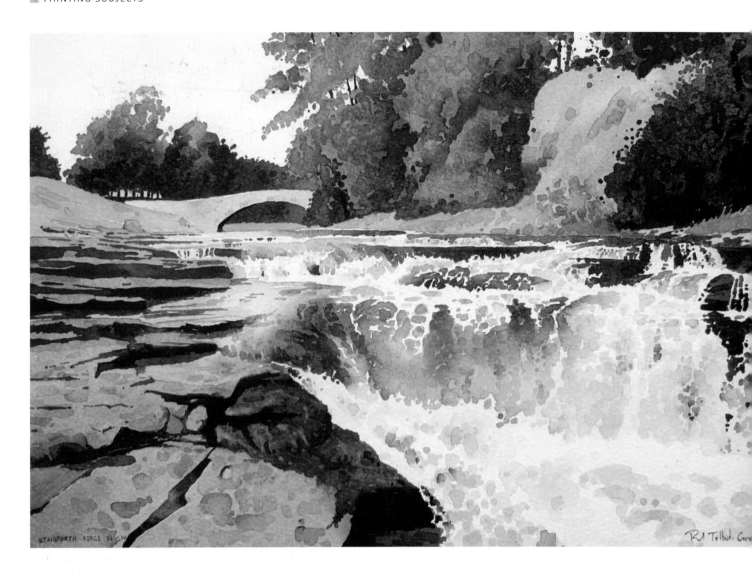

Stainforth Force in spate, 45 x 30.5cm (17^3/$_4$ x 12in).
In this painting the waterfall dominates and I chose it as a strong focal point.
The effects of the falling and churning water were built up as a series of simple
stippling techniques, which are more evident the closer you look at the painting.

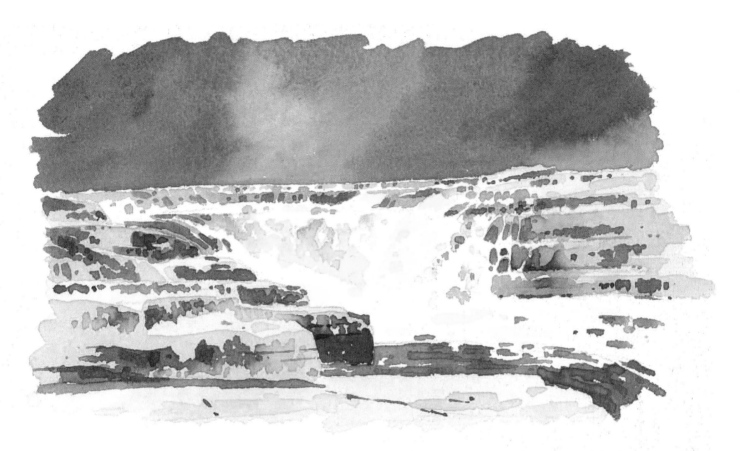

you paint them. Both these methods can be combined in a painting, for example wet-into-wet reflections used in the far and middle distance, with more detailed and sharper reflections painted in the foreground as wet-on-dry. There are no hard and fast rules over which method should be used where and the decision really rests on the individual's style and approach.

Falling water

Waterfalls essentially form a series of shapes and patterns where darker bits of rock are seen constantly appearing and disappearing through the broken cascades. Sometimes the dark shapes are visible at full strength, other times they become a half-tone value when seen through the falling water. To imitate these effects I use a stippling technique, wet-on-dry, in a controlled and constructive way, beginning with pale colours for the shadows and shade seen within the falling water itself. It is important to start pale and work towards the darker sections where it is equally important to try and achieve the appropriate tones in a single application. This avoids having to repaint any delicate areas and as a consequence it helps to keep the image crisp and fresh. I work my way towards the darker, more negative shapes that surround the falls, allowing each layer to dry before continuing with the technique. Painting water in this way demands a fine balance between allowing the white of the

paper to suggest the transparency and foam associated with the subject, and applying enough detail without overdoing the effect. I often find a blunt, round brush (that is simply a round brush that has lost its point through years of use) works very well at achieving the rounded negative shapes that describe the splashing water.

A great deal of softening of some of the shapes with clean water helps to create a delicate transparency throughout the image. This is achieved by applying a limited amount of the dark tone in a small area using the stippling technique, and continuing the same stippling action with clean water, pulling the colour out of the wet paint. A waterfall can be built up in this way, over-layering a number of delicate washes and creating a crisp finish to the feature. Depending on the location of the waterfall in your painting, you may be able to get away with a simple dry brushstroke or a couple of directional marks with the brush, especially if the falls are situated in the distance. Reserve the detailed approach for the foreground area only. Utilizing a lazy scratching or hopeful scrubbing action with a brush will not be sufficient to describe a waterfall in detail and will more probably produce messy results.

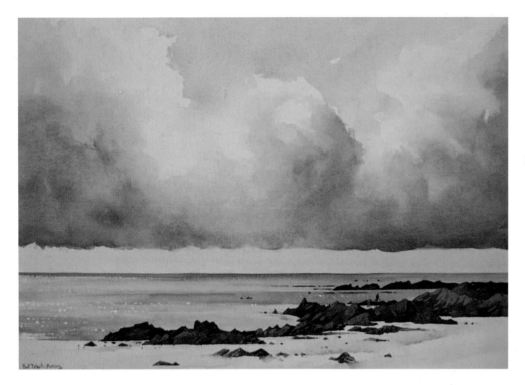

Looking for shells on a Uist beach,
46 x 30.5cm (18 x 12in).
**The figures add a sense of scale
as well as a visual story to
the scene.**

Painting the Sea

Painting the sea involves many challenges and depending on the actual scene, may involve many different watercolour techniques. Rarely will you need to employ still-water reflections within the main body of the ocean, instead relying chiefly on the general techniques for creating movement and splashes. At its base level, an ocean can be painted as a mass of tone and colour, with a few directional brushstrokes describing the general pattern of the waves added as a second layer, wet-on-dry. Leaving one or two white areas of paper to suggest breakers is often useful and these will need planning before the painting is begun. It is possible however to add these in the final stages using white gouache. Painting the more in-depth elements of the ocean requires the use of expressive and descriptive brushwork such as utilizing brushstrokes in the direction or angle of particular features, for example the haphazard formations of crashing waves and breakers.

Look out for the transparency of the water, especially on the crest of waves where the light and colour can become intensified. Many of the techniques associated with waterfalls can be employed for crashing waves, sea surf and spray. Where the waves crash into rocks creating finer spray, a simple removal of paint using a sponge is often enough to describe the action. Generally the distant horizon will be level no matter how stormy the sea is, for which a ruler can be exploited to create the necessary straight line. There is no need for the artist to take into account the curvature of the earth and a sloping or undulating horizon will definitely look wrong!

Where the sea laps at the beach in a gentle washing action the wet area will need to look reflective and shiny and here the techniques for painting still-water reflections can be used. Depending on the lighting, angle of viewpoint and so on there may be features reflected into the wet sand or just an area of reflected light and this could affect how you approach the subject. Sometimes the colour of the sand can be painted over the area and the reflections painted on top of this, other times the sand may be darker in tone than the lighter, reflective water, and in these circumstances the two areas will need to be treated separately. Watch out for and make good use of any contrast between dark rocks and white foaming water.

Coastal subjects

Seascapes make a great alternative to landscapes and there are many varieties of subject that can be gleaned from the coast. Wide, expanding views out to sea can include big atmospheric skies whilst other studies can be sought from cliffs, boats, bays, figures and sea life. If you find seascapes difficult to paint in general, start with a simple format of distant sea, dark rocky shore and maybe some middle distant cliffs. The emphasis of the painting can be based around a big atmospheric sky and to some extent this will mask your initial inhibitions. You do not always have to paint a whole series of complex wave patterns, in fact closing in on a single wave or breaker can make a subject itself. You might consider painting a sea bird at close quarters

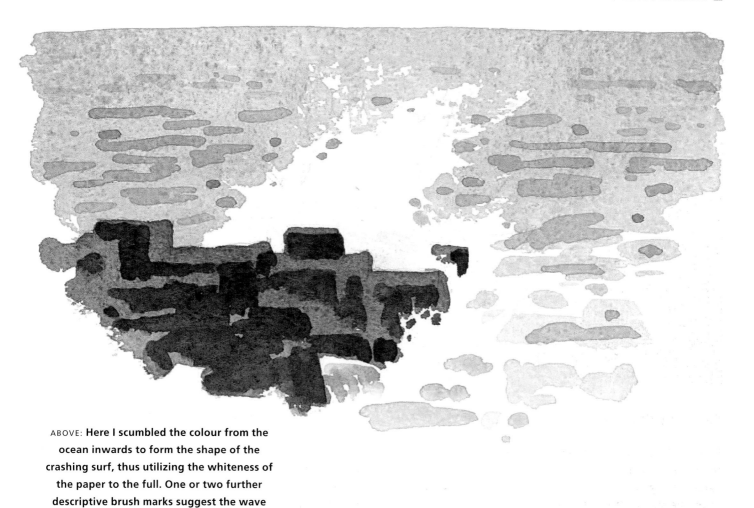

ABOVE: **Here I scumbled the colour from the ocean inwards to form the shape of the crashing surf, thus utilizing the whiteness of the paper to the full. One or two further descriptive brush marks suggest the wave movements of the remaining sea.**

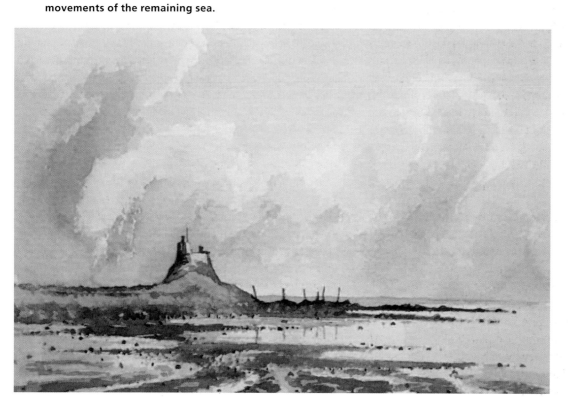

Lindisfarne Castle, 20 x 13cm (8 x 5in). The scene is one of romantic charm and in this painting I have drawn full attention to the structure by drawing the eye into it with the patterns of seaweed in the foreground and the careful use of cloud shapes. The still water left by the tide provided an opportunity to add gentle reflections.

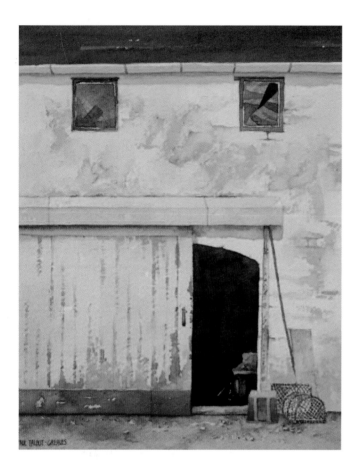

The boat shed, Port Askaig, 13 x 21cm (5 x 8¹/₄ in).
A different coastal subject, concentrating on the colours and textures of the fascia of the building.

This boat was moored to a pier at low tide and provided a lovely painting subject in the bright sunlight.

and use a blurry background of cliffs to provide contrast. Alternatively, studies of rock pools can make fantastic paintings with an abstract element. Tumbledown boathouses make different subjects and these can be painted with just a hint of the sea in the background or even as close-up studies with no background at all. Indulge your creative initiative in the colours and textures to make the painting interesting. To draw attention to part of your coastal scene or subject, look towards including brightly coloured buoys or fishing nets, as a splash of colour especially in a grey atmosphere can really liven things up. Figures, whether lone fishermen, strollers or children hunting for seashells, make useful focal points within coastal scenes so really concentrate on the subjects that surround you when visiting the coast.

Boats

One subject that is synonymous with coastal scenes is that of boats and these can either make or break a painting depending on how they have been interpreted into the scene as well as how competently they have been drawn in the first place. Boats make

excellent subjects, whether used as a focal point out at sea or simply as a study on the shore. The gaze of the viewer will always follow the direction that something is looking or pointing towards and in this respect the eye will follow the line of the boat from the stern to the bow. Point your boat into your painting and not out of it, so a boat pointing left needs to be situated at the right-hand side of the picture and a boat pointing right placed on the left. Boats on shore can make strong focal points, especially if they are brightly coloured or maybe even in a derelict state. You can use the sea or cliffs as a backdrop to the study of a boat.

Boats at sea

Boats reflect the sea conditions that they are in, so upright masts and level keels will convey a sense of calm, flat water. In similar circumstances a restful, horizontal sky such as a sunset or sunrise can be complemented with a vertical line such as the mast of a boat. Stormy seas and high swell will toss a boat in all directions and if you are bringing over an atmosphere then try to illustrate this kind of discord within your picture. Turner's seascapes are full of drama in this way and he usually included a number of boats with masts at all different angles to really exaggerate the drama of the scene.

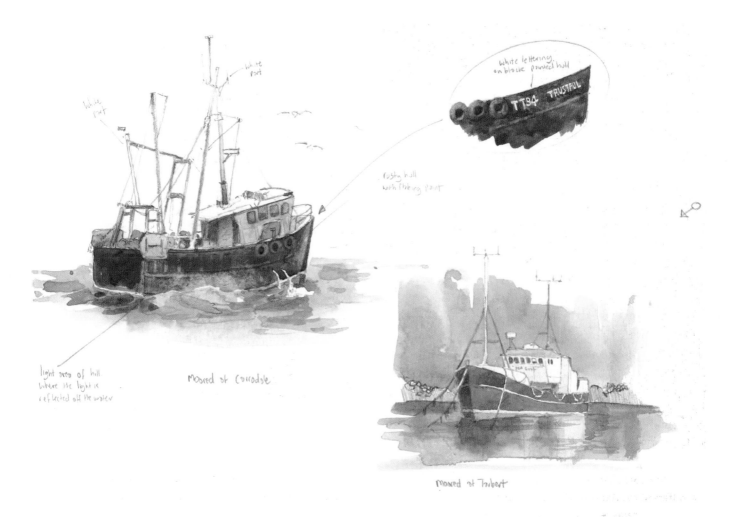

white lettering on black painted hull

TT94 TRUSTFUL

White mast

White mast

rusty hull with flaking paint

light area of hull where the light is reflected off the water

Moored at Corrodale

Moored at Tarbert

ABOVE: **A couple of sketches of boats at sea. The trawler set off as I began to sketch but I managed to chase it out to sea through binoculars, capturing the essence of the situation.**

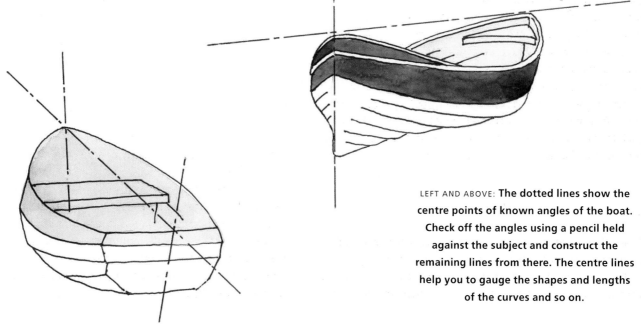

LEFT AND ABOVE: **The dotted lines show the centre points of known angles of the boat. Check off the angles using a pencil held against the subject and construct the remaining lines from there. The centre lines help you to gauge the shapes and lengths of the curves and so on.**

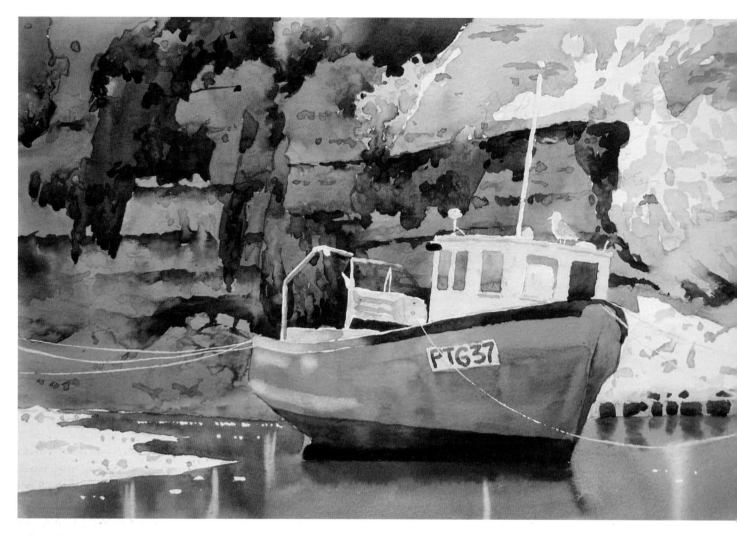

Drawing boats

Boats are notoriously difficult to draw unless they are either viewed side on or from a distance. Because designs of boats vary, there is no one set formula for drawing them. However, they do usually have some similarities in that they are generally higher at the bow than at the stern. The shape of a boat causes havoc with rules of perspective, especially if the boat is on shore and resting on its keel, which is why they are so difficult to get right. I usually take a few sensible plot lines from the image and construct the rest of the shape by eye from there. The plot lines involve a straight line drawn through the points or centres of the bow and the stern. Also, look for any areas that may be level when the boat is afloat such as decking, planks or even the flat-topped stern of a rowing boat. Draw lines through these to give you the angle or tilt of the boat, using a ruler if necessary. If you can see the prow of the boat draw a centre line through this too, if possible. These lines become your skeletal construction lines around which you build up the shape of the boat. However there is no easy substitute for thorough observation and careful drawing.

Waiting for the tide, 43 x 29cm (17 x 11½in).
This painting was done as a demonstration piece for an art group. The red of the boat is an instant attraction but it did take some time to get the drawing correct. The top part of the boat was masked out in order to freely paint the background.

Painting boats

Yachts out at sea can be simply suggested with a coloured triangle for the sails and a mark underneath for the boat. Closer up, the painting needs to be a little more technical. Create the colours required for the boat and do not forget to mix grey with the colours for the shaded areas. Any light reflecting off a shiny boat can be taken out with a damp brush after the washes have dried to create a soft highlight. Use any of the brush techniques to assist you in capturing textures such as worn woodwork or flaky paint.

A summer tree painted in a variety of warm bright greens and cool shaded greens will give it a realistic appearance. The initial washes are overlaid with a stippling layer to create form and texture.

Trees

As trees are part of the landscape, they cannot be avoided in landscape painting. They can be utilized as focal points usually in their own right, for throwing shadows across a painting or for creating a support or backdrop to an alternative focus within the picture. Winter woodland creates an illusion of height due to the mass of bare tree trunks and the addition of a small figure or animal can really add scale. Summer trees often present artists with no end of difficulty due to the mass of greenery and the bulk of the general shape. Leaves are translucent and a summer tree seen in full sunlight will shimmer with delicate light. Creating this effect without making the tree look solid and heavy can be tricky but by following a few simple techniques the overall result can be achieved.

Summer trees

Firstly, any light areas must be painted with thin colour so that a lot of the white paper is allowed to shine through the wash. Many people tend to use bright colour, such as lemon yellow, daubing it on thickly with the impression that the area will appear bright. If this procedure is followed, the area in question will actually lose its translucency and therefore will appear dull even though the colour used may be bright. Brightness comes

with contrast and the shady area of the tree will suffice to make the lighter parts appear light. Here darker, greyer greens should be used to give the tree depth and body. A few dotted leaves around the edge of the tree often help to break up the general shape of the canopy. Also, areas of sky showing through the mass of foliage help to give the tree a delicate appearance, that is of course if there are gaps visible in the tree you are painting. Another advantage when painting trees is to know a little about colour theory. Bright greens require fresh pure colours but I often see people using muted colours to create their foliage colour mixes. One example of this is when mixing together French ultramarine and cadmium yellow. Although they are popular colours, they do not create bright greens and a quick look at colour theory will show why. French ultramarine is technically a blue-violet and cadmium yellow is a yellow-orange. When compared to a colour wheel of pure colours, these paints are almost opposite each other and are sure to create a grey-green, as they are nearly complementary colours. By replacing the French ultramarine with a more pure blue such as phthalo blue or the cadmium yellow with a more pure yellow such as lemon yellow, the resulting colour mix will be a much more vibrant green (*see* Colour mixing, page 117). A recommended formula for dealing with green is to use a tube green such as sap green as a base colour and add other colours to it. For example, sap green can be mixed with a bright yellow to create vibrant greens or it can be mixed with blue to create cool greens. The

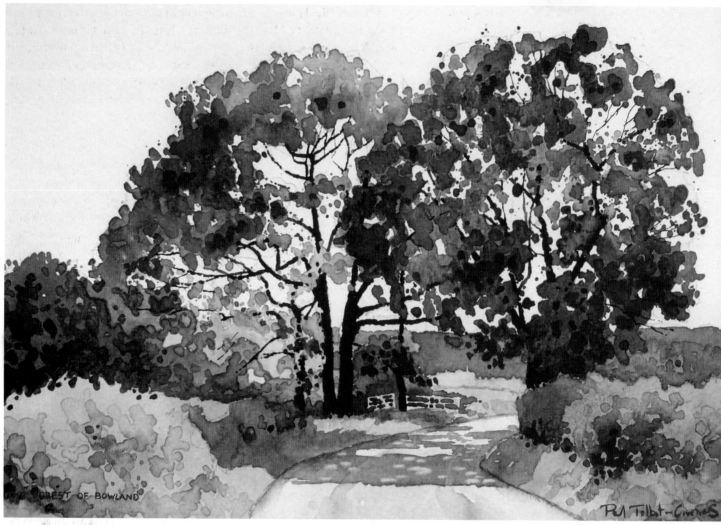

The Forest of Bowland, 26.5 x 19cm (10¹/₂ x 7¹/₂ in).
These trees have a delicate feel due to the intricate shapes seen between the foliage. The darker parts of the shadows actually help by making the lighter areas appear sunlit. The majority of the tree shapes were created by spattering and stippling with paint to create the random leaf coverage.

addition of a grey creates a neutral green and so on. I usually paint summer trees in three stages, the first being the colour wash reflecting the brighter colours, cooler colours and shades, the second being a shadow wash picking out the deeper shadows and at the same time forming some of the leaf structures. The final wash is the addition of the intense darks. By keeping the process simple and creating as much interest as possible with each wash, I am able to keep the subject clean, fresh and translucent.

Winter trees

Winter trees are wonderful for exposing and understanding the skeletal structure of trees in general and for that reason they make great practice studies. They also require a fair amount of dexterity and control of the brush to paint them and therefore they provide a good discipline of handling and controlling the pressure applied to the tip of the brush. For me, the tree needs to incorporate a certain amount of realism and proportion but

beyond that I enjoy the freedom of expression and creativity. It would be foolish to attempt to stringently copy every branch and every twig but on the other hand the character of the tree needs to be captured. Trees flow with energy and the brushwork needs to reflect this. I usually map out the general structure of the tree using a round brush for the trunk and main branches, carefully controlling the movement and tapering the line as I paint. A pencil line indicating the outline of the canopy helps to guide the build up of the twigs, which I paint using a small rigger brush or ruling pen, employing the freedom of my imagination rather than reproducing exactly what I see. This helps to give the tree a fresh, spontaneous and natural feel.

Winter trees seen at a distance can be simply suggested using the side of a small brush, scrubbing the paint onto the texture of the paper surface in order to create a ragged finish. The addition of a trunk and one or two branches usually finishes the feature nicely.

Spring trees

When both summer and winter trees can be described efficiently by the artist, it is not a huge leap to be able to paint spring and autumn trees. Spring trees usually require fewer leaves, with a large part of the skeleton structure showing through the gradually emerging foliage. The freshness of the leaves at this time of year can be breathtaking and it is great to be able to put the lighter tones of the bright greenery against darker tones of the

A line of trees, 28 x 18cm (11 x 7in).
The line of winter trees was painted from left to right and each tree was treated differently to mirror its individual characteristics. The twigs were finished neatly along the canopy line.

trunks and branches in order to create maximum contrast and interest within the picture. If you are painting bright, sunlit, spring foliage then a lot of water must be used in the paint mix to create thin translucent washes and again a consideration of colour theory will be of benefit in order to generate the fresh green. The leaves will appear lighter when stronger tones are placed elsewhere in the picture.

Autumn trees

Autumn time can display trees in full leaf or in a similar way to spring, partially leaved with many branches showing between the foliage. Here one can enjoy using a warmer palette of red, ochre, brown, yellow and bright green. To create the autumnal tints within the structure of the tree requires careful expression with wash techniques. I tend to mix the colours loosely on the paper, allowing them to softly blend where they meet and for this it is essential to use fluid paint as part of a variegated wash technique. Again, contrast is the key and the bright foliage colours can be distinguished against darker branches or shadows cast by low autumnal light.

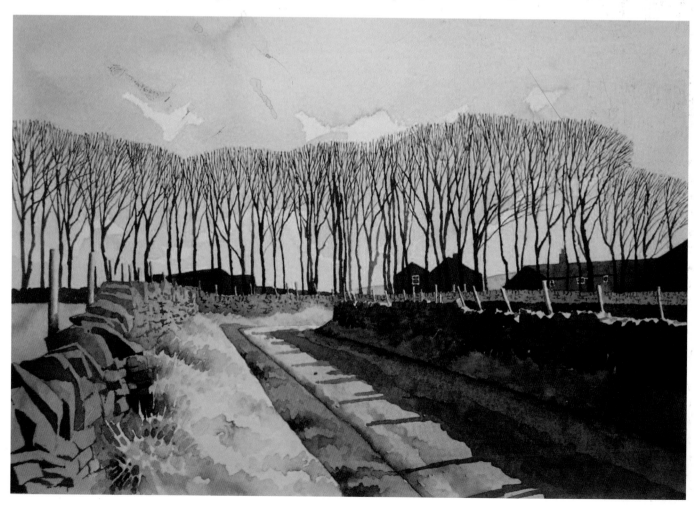

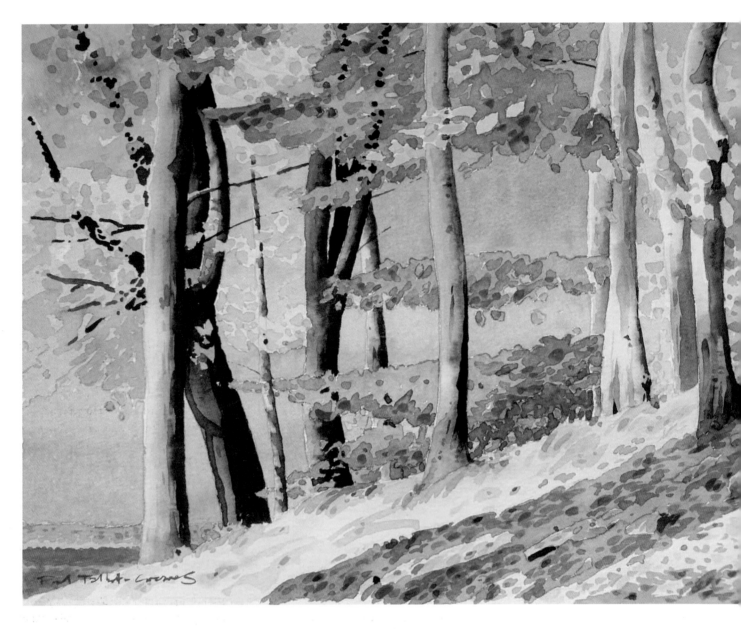

Autumn woods, Jerusalem Farm,
38 x 29cm (15 x 11¹/₂in).
In this painting I used lots of burnt sienna and
aureolin to generate the warm glow of the
autumn leaves. As with summer trees, I used a
loose stippling technique to create the effect
of the foliage.

This pack pony made an interesting pencil study. Although I worked it from a photograph, the feature itself could easily be incorporated into a painting.

Sheep, **16 x 16cm (6¹/₂ x 6¹/₂in).**
Whilst out walking one rainy day I passed a farmyard where these very wet sheep were huddling together. The rain had made the farmer's dye on their backs run, causing their fleeces to turn a shade of blue and I could not resist a few photographs, out of which I created this almost abstract composition.

Animals

Animals sometimes make useful props in a landscape painting, either by way of subjects themselves or as visual blocks or pointers. In the distance, an animal can be painted as a simple brushstroke but further in the foreground it will need some detail and a fairly accurate depiction. Like everything else it is down to studying features and shapes and working on your eye-to-hand coordination in order to get the correct proportions and likeness. Usually, studying animals by way of sketching throws up a few problems, in that they tend to move as soon as you put pencil to paper! Sketch rapidly and if the animal changes position start another drawing immediately and come back to the first sketch if it resumes that pose again.

To make life a little more controlled, you could take a number of photographs and practise your drawing from those until you feel more comfortable to be able to sketch them in their environment. Animals are not always necessary in a painting and if you find yours tend to look more like boulders then do not put them into a picture until you have undertaken enough practice to make them look more realistic. If you can draw reasonable renditions of various animals to scale, then using them in paintings has a number of benefits. Use them as visual pointers to direct the gaze of the viewer by placing them strategically from the foreground to the focal point. The eye will naturally follow the gaze of an animal or figure so use them wisely by subtly pointing them in the right direction.

You could base a painting around an animal or animals, for example cattle feeding in a field or down at the water's edge where reflections might be utilized to make the painting more interesting. The positive and negative elements of black-and-white cattle stand out in a colourful surrounding landscape and in this instance they would create a strong focal point. Similarly animals such as cows, sheep or horses contrast well in a snow scene – the winter element adding mood and feeling to the image. Animals can also be used to add scale such as sheep or goats standing on a mountain rock outcrop or cattle against a vast open plain.

Around Malham Tarn, 30.5 x 21cm (12 x 8¹/₄in).
In this painting I have employed a combination of careful
washes, stippling techniques and paint removal to generate the
shimmering feel of the sunlight and shade. I do not try to paint
things too accurately, opting instead for simple techniques to
depict my landscapes.

USEFUL PAINTING TECHNIQUES

Painting is all about freedom of expression – the artist putting down on paper his or her thoughts, emotions or inspirations for other people to interpret using their own perceptions or thought processes. For the artist concerned, that freedom of expression needs to flow without interruptions or disturbances and equally the involvement of painting should come almost as second nature without the individual having to learn a particular technique or method halfway through the progress of a watercolour. The successful application of paint evolves through constant practice and time spent dedicated to the craft of putting colour on paper. Expressive brushwork conveys into the picture a lively input full of personality, spontaneity and movement, lending the finished piece a painterly and exciting finish. Overlaboured, careful and intricate painting can lose some of that lively feel in a finished work and instead produce a flatter, deadened image. This is especially epitomized in watercolour where a spontaneous slant reigns supreme.

Common techniques

There are numerous approaches to painting certain effects or features found within the landscape, many of which utilize simple brush techniques to suggest particular details, rather than stating the obvious. Using these or similar techniques can add that extra flavour to a painting.

Dry brush

A heavily textured foreground such as a stony track or a pebbled beach can be suggested with a few dry strokes of the brush across the rough surface of the paper, catching the raised parts of the paper's texture and leaving behind an entirely random set of blobs, bobbles and marks. This is best done over the top of an initial coloured wash that has been allowed to dry. The resulting effect is far looser and much livelier than if the artist were to paint each individual pebble and stone in detail with a tiny brush. The technique is also useful for creating the random sparkle effect seen on choppy or rough water.

Spattering

Spattering can be employed as an alternative to dry brush. By filling a brush with paint and gently tapping the ferrule, a random selection of dots and spattered paint can be built up over the required area. I find that this technique works extremely well for creating heavily textured ground and it is especially useful for painting summer trees. Instead of painting the tree canopy in an entirely solid mass, I spatter paint into the required parts and wash some of the dots together, leaving gaps between areas in order to depict the natural spaces seen between the leaves and so on. To tidy up any portions of the tree, I physically stipple the brush point down on the paper in a controlled but spontaneous manner so that the style of approach to painting the tree is kept relatively constant. Alternatively, a controlled spattering technique can be employed on a wet wash to create speckles, textures and runbacks. This is a way of creating texture en masse such as where the various textures seen across a large pebbled beach need to be mainly suggested. Apply the colours as a fluid wash and allow them to almost dry before flicking clean water onto the painting, either from a paintbrush or from a stiff bristled brush such as an old toothbrush.

Scumbling

A similarly useful technique to that of dry brush is a scumbling technique, where once again the side of the brush is utilized against the texture of the paper. This method involves scrubbing the brush in different directions in order to generate a random series of marks. The use of such a technique and how it is employed in a landscape painting is entirely down to the

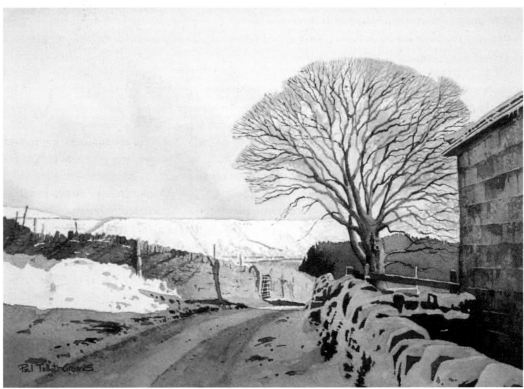

Low light on the Pennine moors, 33.5 x 24cm (13¼ x 9½in). In this painting the scumbling technique is evident in limited but effective placements. The textures on the distant hill were dragged downwards in the direction of the slope, as were the subtle textures on the surface of the track. I scumbled pale burnt sienna throughout the canopy of the winter tree before painting the branches and twigs, and the grit stone blocks of the barn wall were scumbled with a small brush.

LEFT: *Derwent Water*, 33 x 23cm (13 x 9in).
Here I utilized a rough surface paper in order to create the dry brushstrokes that suggest the broken surface of the lake. Fluid paint was brushed onto the left-hand side and brushed out towards the right using the belly of a fat sable brush. The wet-into-wet reflections were then quickly added to the still-water section of the scene.

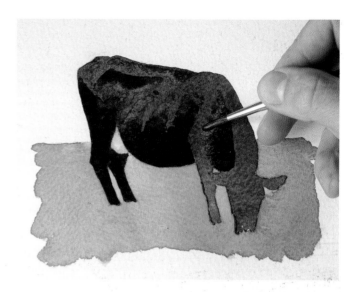

I applied an overall base wash on the animal and allowed it to dry before adding further tone to describe the various forms within the body. I applied stronger tone in the relevant areas and immediately softened the edges away with clean water.

individual artist. Scumbling can be suggestive of many various textures and details and as with the dry brushstrokes it is best employed over the top of a previously dried under-wash or colour. Foregrounds containing masses of long grass can be easily described using a scumbling method. A simple but varied wash of the general colours seen in the picture is allowed to dry and followed by a slightly shadowed variant applied in a scumbling manner. This is far more productive and much easier on the eye than a painting containing a brush mark for every single blade of grass. Rocks, walls and buildings also benefit from a little texture added in this way. The same technique can be used in skies to create broken-edged clouds or even as a way of suggesting the textured structures of cumulonimbus clouds over a landscape.

Softening

Many of these examples benefit from a little softening in places, as do grades of tone found within the landscape. Nature is made up of hard and soft edges and the replication of this general effect creates a very realistic impression. When softening a tone or an edge, rinse the brush out thoroughly and, whilst the painted area is still wet, apply clean water, working from the paint outwards. It is imperative to use the same wetness on the brush as the wash on the paper, otherwise pooling and runbacks will result. To make certain that you have a correct amount of water on the brush, it is wise to wipe a little off on the edge of the water pot before you apply it to the paper. Do not use a tissue or a rag to wipe the water off the brush as this will dry it out completely. Do not apply too much pressure to the brush when softening otherwise you will end up disturbing paint instead of gently blending it. Allow the brush to softly glide on the paper surface, keeping your eye on the wash to make sure you are not over-wetting it.

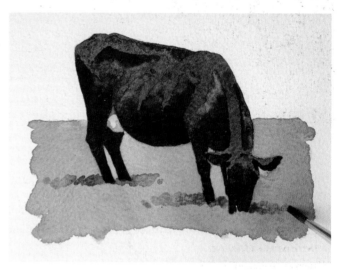

The various hard- and soft-edged shapes in the grass are treated in the same way.

of conventional painting and this can often be healthy and inspiring. Experiment first with any new idea or technique before you apply it to a painting. I usually use the traditional approach of brush, paint and paper but every now and again I find a use for an alternative technique. Consider how effective they might be when used in your own work.

Other techniques

There are many alternative ways of achieving different watercolour effects in your work, apart from using a brush and paper. Some special effects may require you to stray from the confines

Resists

A resist is quite simply a substance that does not mix with water. You could try various kitchen items to discover your own

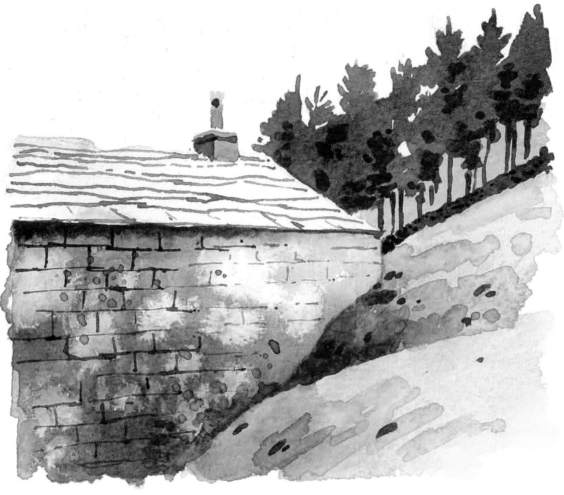

Here I spattered masking fluid into a wet wash and allowed it to spread wet-into-wet. After drying, I rubbed off the residue and built up the additional textures and detail, which resulted in a weathered stone effect.

techniques but do not just concentrate on the effects alone. Think of how a product might affect your painting over time. Corrosive material should be avoided for obvious reasons as should anything that will attract moulds and fungus or even insects! Some products create fantastic effects with watercolour and are worth knowing. For a start, dropping wet masking fluid into a wet wash will create random starry shapes, which can be used to suggest texture, especially the effects of moss and lichen on rocks, trees, walls and so on. Apply a wash and, whilst it is still wet, drip masking fluid into it either from a brush or pipette. The masking fluid will immediately resist forming a starburst in the colour. Leave the wash to dry and then rub over the entire area with a soft rubber or a dry finger to remove the masking fluid. Some of the effects will be more pronounced than others, creating a realistic impression of lichen. The painting can be continued conventionally by adding stone shapes if necessary.

Using a candle as a resist by rubbing it on your paper first can be another way of suggesting texture, for example on a rock or for creating the impression of sparkle on water. The wax will remain permanent on the paper so be sure it is the right thing to do because if it looks wrong there is not much you can do to correct it.

Pure alcohol or a product containing alcohol such as surgical spirit or aftershave will disperse the paint when it is dropped into a wet wash. The effects range from large, rounded bubble shapes to small flecks within the finish of the wash. The application of these techniques is purely subjective to what you are painting and the kind of effects you want to achieve. Try not to overdo the techniques in a single picture but occasionally you might find a use for at least one of them.

Presses

A press is where an item is forcibly compressed into a wash over a period of time. A weight such as a large book can be used to keep the pressure applied whilst your wash dries. There are many things that you can use to press into your wet wash, from plastic bags to tin foil. Removing the press at varying times of drying will create a variety of different results. For a heavily textured effect such as foliage for example, apply a wash on a flat surface and whilst it is still wet, place a screwed-up plastic bag or piece of cellophane food wrap on top. Weight the plastic down with a large book or something fairly heavy and

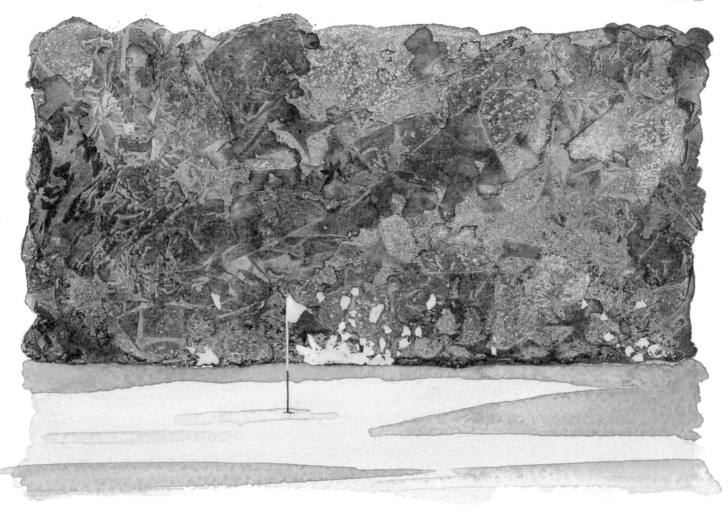

ABOVE: **Pressing some cellophane wrap into a variegated wash provided an ideal generalization of the tree-covered background to this golf green.**

BELOW: **Salt dropped into the wet washes exaggerates the extra icy feel in this winter scene.**

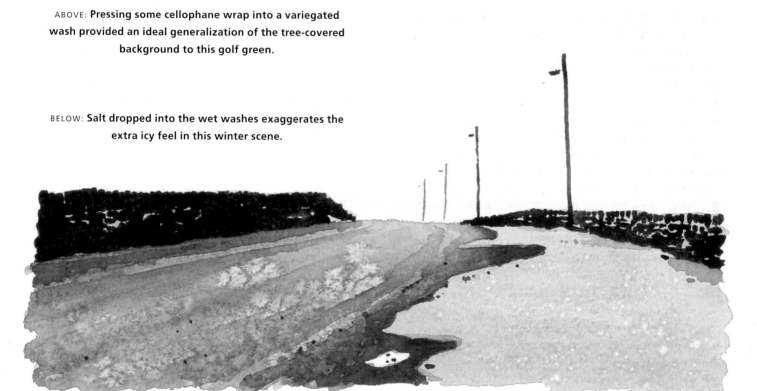

Bluebell woods (masking).
I spattered masking fluid loosely onto the areas of the paper where I wanted to
paint the bluebells. I also applied it to some of the foliage where I needed a
definite crisp shape against a darker feature.

leave it to dry for at least twenty minutes. Different grades of plastic will create different effects so experiment with thin and thick polythene. Once the area is dry, the plastic can be removed and the painting continued in a conventional manner. Using tin foil in a similar way will give slightly different results to plastic. Try folding the foil for more angular or specific shapes. For various other textures sand or sandpaper can be used to put a grainy texture into a wash, or press a sponge into a wash and leave it to dry in the same manner. This latter technique could be used to suggest rock texture, pebbles and so on.

Additives

An additive can be classified as a substance that will dissolve or readily mix with watercolour in order to change its properties or handling. By dropping other substances into wet paint or mixing them with the paint, you can create a whole host of further effects. Mixing soap with your paint creates a thick creamy, almost impasto-like medium. Left to settle on its own, the bubbles leave interesting patterns as the paint dries but alternatively you could scribe lines or detail into the thickened paint with a blunt instrument. Take care with this approach as the soap can linger in brushes and having soap in your paint when you do not want it can be very annoying! A commonly used alternative technique is that of dropping salt into a drying wash to create starry effects. These are suitable for suggesting many different textures such as ice, rock surfaces and lichens. There are now a number of different additive mediums available for the watercolourist to purchase and these have been developed to either create a particular effect or to increase the flow or handling of paint on paper.

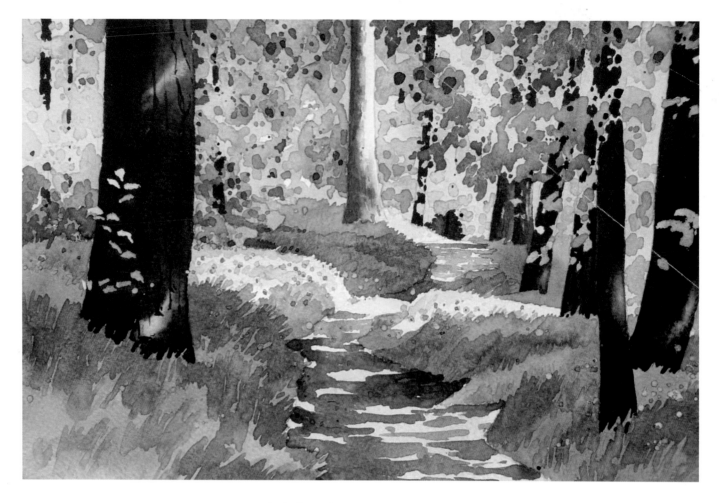

Bluebell woods, 31 x 21cm (12$^{1}/_{4}$ x 8$^{1}/_{4}$in).

I painted the foliage first and built up the washes describing the soft spring grass. When all the elements of the painting were finished, I peeled off the masking fluid and carefully tinted the shapes to suggest the bluebells. By reserving the areas as white paper, I achieved a brighter finish to the flowers.

Masking mediums

For most applications of watercolour painting, reserving the lighter parts of a painting is done as a means of negative painting, putting in the darks to highlight the lights. This is straightforward watercolour technique, which often utilizes a spontaneous approach but it can be risky. If you accidentally paint over the area that you intended to keep as light, you may have to reconsider or re-plan your painting! Masking is a safe way of reserving areas of a painting, leaving you free to concentrate on the rest of the picture. There are various forms and sorts of masking mediums as well as the range of effects that can be achieved by using them, the most common being masking fluid. The majority of painters I meet have masking fluid as part of their painting kit but they either rarely use it or have never used it. It is a useful addition to watercolour and knowing how it behaves will help you to decide when, where and why

you should use it. As a rule of thumb, I generally use masking mediums when it would be too complicated to paint around a shape and control the surrounding wash at the same time. For most of the time if I can avoid using masks I will, purely because negative painting produces a much livelier feel to a picture.

Masking fluid

Most watercolour painters are familiar with masking fluid and you may have used it too with varying degrees of success. A liquid latex solution, masking fluid can be painted onto bare paper or even painted sections before applying any subsequent washes. Some soft papers tear easily when masking fluid is peeled off so it is worth testing a small area first before you use it in a painting. The fluid should be thin and easily paintable, with a flow not dissimilar to watercolour itself. Masking fluid

does go off over time, especially if it has been standing still for a long period or subjected to sunlight and heat on a daily basis. If your bottle contains a thick sludgy liquid or the fluid is congealing into lumps, throw it away and buy some more. It can be thinned with water to increase its flow if it is a little on the thick side or if you just need that extra flow capability. Applying it thickly to watercolour paper will almost inevitably result in the paper tearing when the masking fluid is removed so make sure you achieve a thin, even coverage to the required area. Most people apply it with a brush, sometimes in a very slapdash fashion, probably in the knowledge that it is drying fast. Wet your brush with water first so that the masking fluid does not have chance to stick to the brush hairs. Apply a little at a time and keep rinsing your brush regularly to avoid clogging it with drying masking fluid. If a simple area needs masking, such as the round shape of the sun, the brush handle is ideal for applying the fluid as it wipes off easily with no fuss. If a more complicated area needs masking then you must be careful not to leave any gaps or holes or clumsily overlap your pencil guidelines. Masking fluid leaves definite hard edges and if you distort your masked shape through ham-fisted brushwork it will definitely show when the fluid has been removed! Use an old synthetic brush or similar cheap tool to apply the solution as a brush is easily ruined once the fluid has dried in it. However a brush gummed up with dried masking fluid may sometimes be rescued using dry-cleaning fluid. Other ways of applying masking fluid are with shaper brushes (a rubber-headed brush) or, for fine detail work, a dip pen.

Make sure your masking fluid has dried thoroughly before you begin to paint and similarly make sure your paper is totally dry before you apply masking fluid. When it is time to remove your masking fluid, peel it from your paper, drawing short lengths of the rubbery skin towards you using the point of your finger. Avoid peeling it off in one great length as this is more likely to tear and damage the paper surface. Finally, do not leave your masking fluid on the paper for more than a few days otherwise it can become very difficult to remove successfully.

Masking tape

Ordinary decorator's masking tape is a useful addition to the watercolourist's kit. Apart from holding a piece of paper in place, it can be used to achieve a straight edge in a painting, for example when painting to a waterline or the edge of a building. For a clean presentation to your work, use masking tape around the perimeter of your painting before you begin. If your masking tape is very tacky, a few passes over your clothing will help to reduce its adherence. Better still, use a hairdryer to heat the tape as you peel it off the paper. The heat will soften the tack of the tape and this will avoid it tearing the paper surface.

Here a strip of masking tape is being used to gain a straight waterline to the base of the mountains.

Masking tape does not have to be reserved only for straight lines. Try tearing a piece of tape in order to paint up to ragged edges, for instance when painting rock shapes, boulders and trees.

Masking film

Masking film is a product that was used extensively in graphic design and illustration until the advent of computers and, although it is still available, it can be difficult to find. Masking film is a low-tack clear film available in various widths. It can be marked with a pen or pencil and in a watercolour context it is ideal for masking large areas of a painting, for example in a snow scene where white mountain edges meet an atmospheric sky. The scene is drawn out as normal, then a piece of masking film is laid over the top. The drawing can be seen through the film even with the adhesive backing in place. The outline of the shape to be masked is then traced onto the surface of the film. The film is then removed from the drawing and the shape cut out carefully with a scalpel. The shape is peeled from its backing and stuck to the paper exactly where it needs to be. Care must be taken not to allow paint to flood underneath the film and this is especially problematic when used in conjunction with a rough surface paper. To counter this, I usually run a line of masking fluid along the edge of the film in order to seal it against paint seepage.

Brush handling

Applying these techniques is one thing but physically controlling the brush is another. The brush should become an extension of your senses, so much so that it is almost possible to feel the applied pressure to the end of it. To do this, hold the brush around the area where the ferrule joins the shaft and when

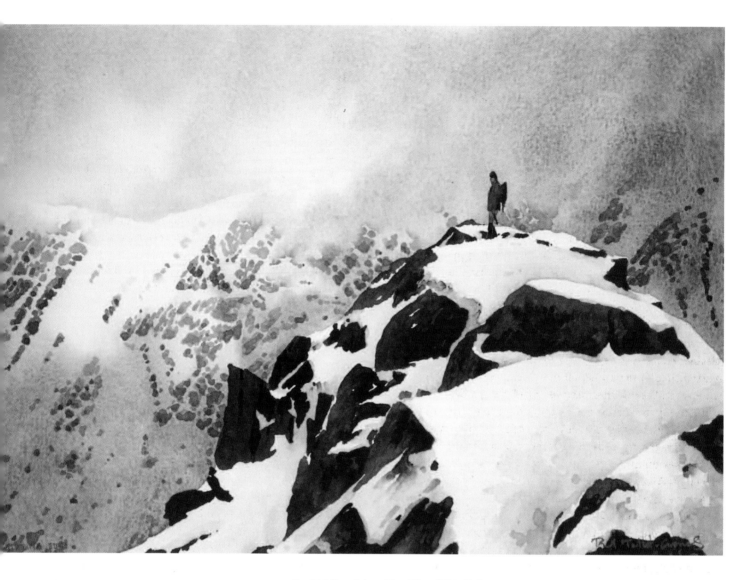

On Striding Edge, 33 x 23cm (13 x 9in).
The clean-cut shape of the foreground mountain arête was masked out with a sheet of masking film, allowing me to freely brush the wet-into-wet sky all around the background area. When the washes and background detail were complete, I removed the film and built up the detail in the foreground.

This small study of a tractor was painted directly onto the paper with no preliminary drawing or guidelines. I worked with free expression, using controlled pressure to create the various array of marks.

Another free painting, worked up without any pencil lines. Exercises like this really help your brushwork and creative expression as they force you to draw with your brush instead of following carefully executed pencilled outlines.

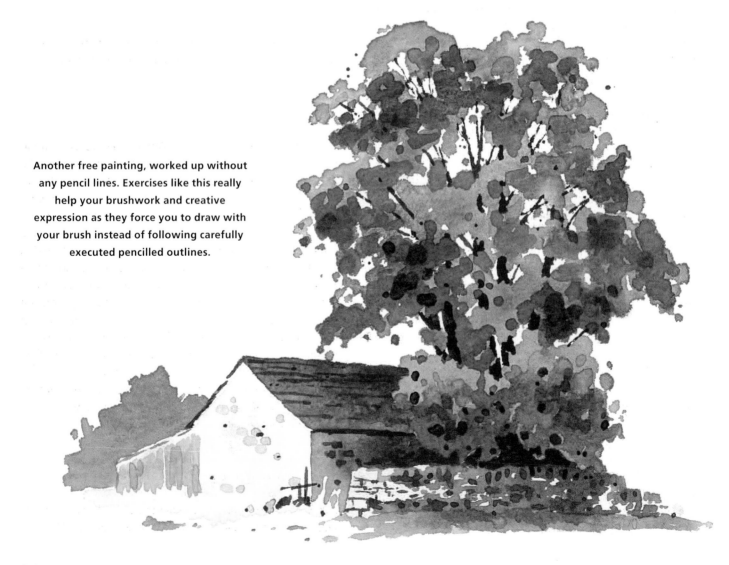

gripped correctly it will balance nicely in the hand. The wrist should be locked and the full flow of movement carried right through the whole arm. This is important in controlling the smooth flow of paint and generating those important expressive marks. At the same time, part of the hand should be placed in gentle contact with the paper. Whether this is the side of the hand or an extended little finger, the placement is entirely down to what is deemed as comfortable for the individual. However the hand is placed, the contact with the paper ensures that full control of pressure applied to the tip of the brush can be felt. Any applied pressure to the brush in this way is controlled through the extended movement of the thumb and forefinger. With time and practice, you should be able to apply various amounts of pressure in one brushstroke in order to create a variety of marks, from gentle dots and thin lines to heavy broad strokes and sweeps. Brush control and mark-making can be exercised on scrap pieces of paper and even a ten-minute session will help with further control in a painting, so these exercises should be incorporated into any improvement routine.

One particular brush that really demands steady control is the rigger. A long-haired, fine-pointed brush, the rigger is intended for painting fine and intricate details in a watercolour such as the random gaps and spaces between the masonry of a dry stone wall or the fine filigree of twigs on a winter tree. The brush should not be overloaded with paint to avoid it blobbing colour onto the paper and creating unintentional thick lines. The hold on the brush is exactly the same as for any conventional brush, but it needs to be kept more upright if the point is to be utilized to its maximum potential. The control and feel of the rigger brush is more important than other brush holds because of the sensitivity of the long, thin brush head, which can flick, twist and buckle out of control if the user is not careful. It is also possible to use this style of brush in a scumbling way to create a more controlled but limited texture effect on the paper.

Try writing your signature with this brush in the same free manner as you would write with a pen. Although you will lose some control due to the difference between the rigid pen and the soft rigger, you should still be able to achieve a reasonable result, which will indicate the level of brush control you currently have.

Bigger brushwork can be executed a little more freely, such as when applying skies or large under-washes, using a mop type or flat brush. I generally favour a sable flat brush which is as firmly held as any other brush except sometimes the hand cannot be placed in contact with the paper if a large area has to be filled quickly or a wet-into-wet technique is being employed. Instead, it is better to stand over the work so that the arm remains balanced and the full flow of movement can then still be executed. Use the flat brush across its corner as this maximizes the amount of paint being applied to the paper. However, be careful not to

Foliage effects applied with a sponge in several layers.

drag the sharp angle of the ferrule across the surface, as this will create a scored line, which will be impossible to remove.

Other tools

There are a number of different painting tools available on the market, some of which are useful and others that can only be regarded as gimmicks. Sponges are great for a number of different uses. Natural sponge has a surface that can be used for stippling or stamping paint onto a watercolour in order to create texture effects or more commonly the foliage of a summer tree. If you use it for the latter, try to avoid making every tree look the same. A shaped sponge on a brush handle makes a cheaper and useful alternative to a wash brush and these can be bought from art stores. If you find a rigger brush too difficult to control when painting fine lines, try using a dip pen or ruling pen. These can be loaded with paint, usually by mixing the required colour and tone in the palette, and then wiping the loaded brush across the nib of the pen to transfer the mix to the pen. Care must be taken to avoid sudden blobbing when using a dip pen and for this reason it is best not to overload it with colour.

Common brushwork problems

If your brushwork throws up consistent problems, then you need to take stock and practise your holds and handling. Try

St Sunday Crag, 32 x 22.5cm (12¹/₂ x 8³/₄in).
In this painting a whole host of brush techniques has been used, from big flowing washes requiring a lot of arm space to smaller, controlled and expressive marks.

holding a pen or pencil in the same manner as your brush so that you become accustomed to the general grip and feel of the implement as you write on a day-to-day basis. Sometimes artists can become tense while painting and this is especially common at the start of a piece of work. Since this can stifle your brush-work, try to relax so that you gain free flow of your brushes. If you find that your washes are turning out full of prominent brush marks, even though you thought you had used enough fluid paint, the problem may lie in the application of too much pressure to the brush when painting. Try to gain a feel for the end of the brush and allow it to skate delicately across the paper rather than pushing it into the surface as though you were

swabbing the deck of a ship. If you notice your washes curve away from you at one side, especially the straight lines, then you may not be sitting properly at your worktable or easel. Make sure you are comfortable, with plenty of free space around you so that you are able to move your arms freely. Sit over your work centrally and try not to lean too far either side or tilt your head too much as this will distort your perspective and line of vision. If your straight lines are not straight or your painted shapes are not too steady, then make sure you are maintaining some sort of contact with the paper, either with your little finger or the side of your hand. If it works, try an oil painter's mahl stick on which to rest your painting hand.

Brush control exercises

Although some exercises may seem basic, it is good practice even for professionals and experienced artists to employ them

from time to time in order to freshen up their style and approach. If you have not painted for a while or you find yourself stuck in a rut with your work, then these typical exercises are an ideal way of being back in control of things. First, try holding the brush rigid whilst painting a single straight line across the paper. Once the feel of the control is achieved and you are used to having a contact with the paper surface move on to the next exercise.

Create a similar stroke but this time incorporate some applied pressure through the movement of your thumb and forefinger as you draw the brush across the paper. This is much harder to achieve than it actually sounds and looks but the exercise will definitely increase your dexterity with the brush. The line should gently graduate from a thin line through to a heavier line and back again. Before this exercise is attempted, the flow of your arm complete with a locked wrist should be perfected to an extent that you do not have to concentrate on doing it.

The exercise can now be increased in difficulty by creating an up-and-down movement with the brush whilst at the same time applying more and less pressure together with creating the full-flowing line across the paper. This uses all the control issues of locked wrist, full flow of the arm and control of the brush through the thumb and forefinger. Some of the techniques here may be harder to achieve than others but if your brushwork is in need of improvement, then there is no excuse but to keep on practising. After all, the brush is the tool with which you express yourself in paint and so full control in this area is paramount to success.

Creating expressive marks

Expression in a painting comes from the freedom of brush use and control. If pencil lines are rigidly followed then the painting can sometimes look over-controlled. Try using a round brush as a sketching tool and practise drawing features or still-life arrangements in paint only, using just the brush and no preliminary pencil work. This exercise ensures that you use the brush with freedom and creative expression, and, because the marks you make are not intended to be erased, you will think more about the placement and importance of each and every line you make.

Negative painting

The world of watercolour revolves around negative painting and any desired improvement in the medium should be directed towards this practice. As negative painting involves placing the darks to bring out the lights, watercolour painters need to train

The side of the hand is in contact with the paper and a gentle pressure is applied to the brush as it is drawn across in a straight line.

The pressure is gradually released to create the varying thickness in a steady manner.

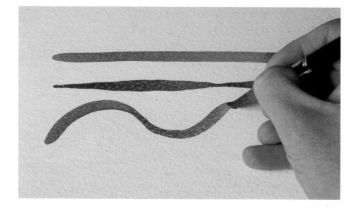

The arm flows across the paper in a straight line, leaving the thumb and finger to apply more and less pressure while creating the undulating line. The dexterity employed here will increase your brush-handling capabilities and bring an increased expression into your watercolour painting in general.

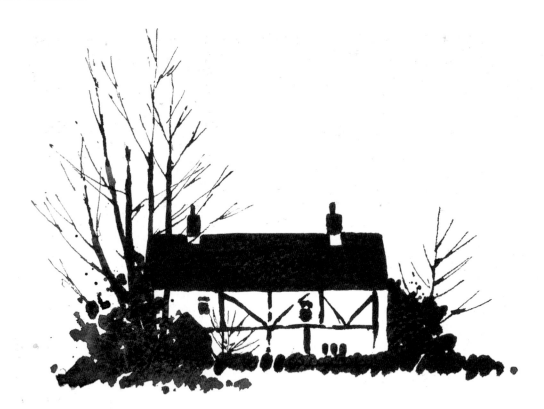

Here the building and its surrounding features were painted
directly using Payne's grey. The building stands out because
of the negative tones surrounding it.

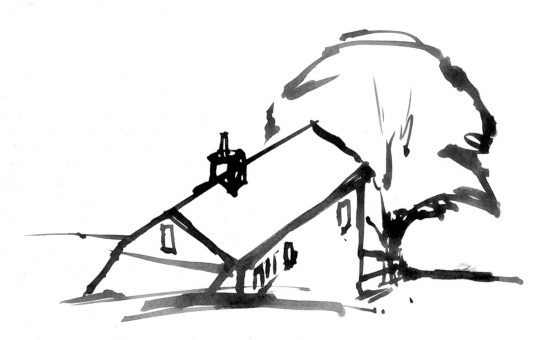

A quick sketch conducted with a round brush, using Payne's grey. Look at
the expression in the lines – some are thick and others are thin where
I have used more and less pressure on the brush.

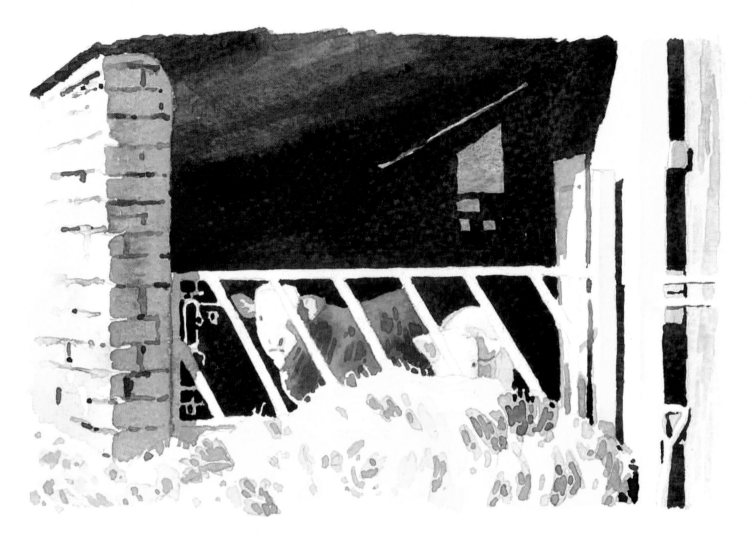

The dark interior of the barn forms negative shapes around the cattle and the gate. The cattle also form negative shapes against the straw piled in the foreground. Always look for darker tones that make lighter ones stand out.

themselves to literally think backwards. Some people find this terribly difficult to undertake and only constant practice will improve an understanding of the entire process. It is often better to carry out practical learning sessions on small studies rather than leaving it to chance in the middle of a large involved panoramic watercolour. Simple studies make refreshing schooling and can be very beneficial in the whole psychological battle between painter and painting. Use a single dark colour such as black or Payne's grey and select a landscape feature to study for maybe an hour or so. Try to paint the image without using any preliminary drawing, concentrating only on the contrasting tones of light, medium and dark. In this way, you will build up the appropriate format of transposing a scene into watercolour, working in the traditional manner from light to dark. Exercises using only the extreme ends of the tonal scale are incredibly use-

ful for learning how and when to separate shapes. By using black paint and the white of the paper, the task involves pictorially describing the feature or scene as clearly as possible. This may involve altering some tones in order for others to stand out but essentially the exercise is once again training the brain to read tones and separate shapes. It is often useful to check tones against each other, using a tonal scale held against the area. Sometimes a piece of black card or, conversely, white paper can be used to compare and highlight the darkest and lightest tones within the picture.

Pencil work is directly related to studying and practising the use of negative shapes and this is one reason why sketching is an important activity towards the improvement of one's watercolour abilities. With ordinary graphite pencils, it is possible to take more time over a study than if watercolour was being employed. Essentially the process is the same, working from light to dark and placing negative shapes that bring out the lighter ones. Small studies conducted a few times a week will really help you to understand the concept of shapes and how one feature stands out from another.

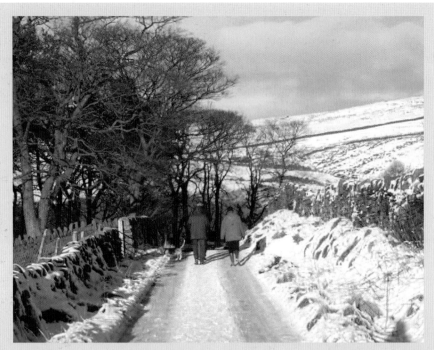

NEGATIVE PAINTING EXERCISE 1

Look at the photograph and ask yourself what do you immediately see? As a watercolour painter you should be looking beyond the obvious recognizable shapes and more at the tonal interplay within and around them. Look first at the darker negative shapes that make the lighter ones stand out. Tones are so important and you should be studying the image, looking for further variations that make one feature stand out from another. Negative shapes do not always have to be black against white, they can be very subtle, too, involving closely related tones. It all depends on the image you are painting and the variation of tone within it.

In the photograph the white of the snow is brought about by the surrounding darker tones. The left-hand wall and the right-hand bank are made up of negative shapes and these in turn describe the patterns of the settled snow. The tree trunks are also lighter than the mass of twigs, again described through negative shapes. Every landscape you look at will contain negative shapes in various forms and layouts.

Snow scenes make great exercises for understanding how negative shapes relate to each other because of the high contrast of tones. Here each feature plays its part in describing edges, lines and contours of the scene. Paint the photograph of the snow scene or a section of it, concentrating hard where you place the negative shapes.

Inter-layering of negative shapes

A negative shape does not necessarily mean that it is just a solid block of tone. It is all relative to the feature you are painting. For instance, a window with a dark interior to the house may be constructed of solid blocks of tone for the panes of glass, and these in turn may make the surrounding window frame stand out as a lighter tone. A farm gate on the other hand may stand out as a lighter feature set against some darker long grasses behind it. The negative shapes that make the gate visible may contain further negative shapes, which describe layers of dark grasses behind lighter ones and so on. All the changing angles, tones and shapes of the grasses and gate crisscross each other in a complex pattern of negative shapes.

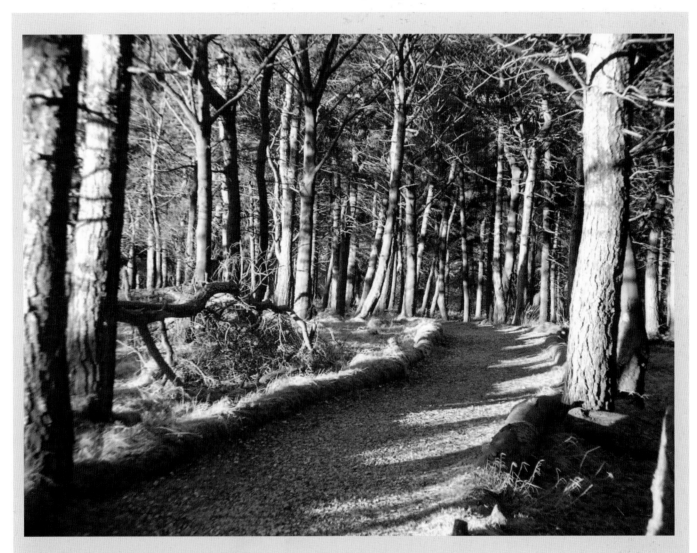

NEGATIVE PAINTING EXERCISE 2

Now look at the more complex photograph involving the lit tree trunks, branches and twigs creating criss-cross patterns of varied shapes seen light against dark. Here negative shapes can be seen within negative shapes, and for the watercolour painter the complexity of the pattern needs to be carefully studied and the appropriate moves planned before the brush is brought anywhere near the paper.

Watercolour paintings should be thoughtfully considered in this way and it is quite normal to sometimes spend more time planning a painting than physically painting it! Start with the lightest tones in the scene, working your way towards the darkest through a number of carefully considered wash stages.

Wet-into-wet technique

The wet-into-wet technique is probably one of the most versatile watercolour-painting techniques that can be employed in a picture and yet it is just about the most difficult to master. Even professionals who paint every day can frequently find themselves battling their way out of a half-wet, half-dry situation, watching in sheer frustration as runbacks appear in the middle of their wash. Since there are so many factors that can affect the success of wet-into-wet, it is worth going into in some detail here.

Why wet-into-wet?

Wet-into-wet is the description given to wet paint applied to wet paper. Wet paper can mean either wetted with clean water or already wet with colour from the application of a fluid wash. Usually, the wet-into-wet technique is instigated by wetting the watercolour paper evenly, using plenty of clean water. The effects achieved are soft-edged and fluid, which makes this approach ideal for painting skies and atmospheric effects or for laying down a broad under-colour onto which further layers of watercolour would be subsequently added as wet-on-dry. Many people, especially beginners, become confused about which approach to take – wet-into-wet or wet-on-dry? The answer is fairly straightforward – if you want to create soft-edged shapes and blends of colour, then use wet-into-wet and if hard-edged, crisp shapes are required, then a wet-on-dry approach should be utilized.

Controlling wet-into-wet

Wet-into-wet is like a juggling act – on the one hand, you are controlling the colours and tones and on the other, you are watching the wash to make sure it is not drying too soon. The first consideration is in the choice of paper. Thin paper such as 190gsm (90lb) will only be able to absorb a small amount of water whereas a thicker paper such as 425gsm (200lb) will be able to absorb more. The better the absorption rate of the paper, the greater the time you will have to apply your paint. The surface texture of the paper affects the technique too. Rough papers have bigger and deeper pits in the paper surface than those of cold-pressed (NOT) surface papers and this helps to keep the surface sheen evenly wet, which is a very important consideration.

To avoid cockling and buckling of the paper whilst you are painting, it is best to pre-stretch anything under about 425gsm (200lb) in weight.

When applying the water to the paper make sure it is spread evenly across the surface, using a large brush and leaving no areas of pooling and no areas of drying. The surface can be checked against the light in order to maintain an even satin sheen to the finish. Apply a layer of water and allow this to soak into the fibres of the paper, which should take a few minutes, after which the surface will have taken on a matt appearance. Now apply a second layer of water in exactly the same manner as the first application. The paper should still display an evenly wetted satin sheen and it is now ready for adding paint.

Adding paint

When the paper is ready for paint, the area should be tackled fairly quickly and efficiently. Big areas of paint should be applied with a large brush and perfection should not be an issue. Aim for your ideas and intentions but do not expect perfect results. Instead, wet-into-wet should be acknowledged as a give-and-take relationship, in other words you aim for the effect you want but in most cases you have to accept what you get. This should be embraced as a positive step and it is what gives the wet-into-wet technique its exciting edge over other paint applications. The paint applied should not be too fluid, especially when the paper is already wet, so some of the paint can be taken off the brush by wiping it on the edge of the palette before applying the colour. Use a gentle pressure to apply the paint and keep the brush in constant contact with the paper, pushing the colour to where you want it to be. Use the side of the brush to apply the paint and to achieve an even application of colour. Layer after layer of colour and tone can be applied to a wet area up until the point that the sheen starts to disappear. This is when you should stop and it is usually this point that catches out many painters, with runbacks, streaks and so on. Never try to adjust a wash as it is drying, as this will almost certainly invite unwanted marks that will spread more and more as you try to cover them. Discipline is the key and especially with wet-into-wet it is a good idea to lay the wash down and leave the room until it has dried. Remember, if you do not quite achieve your goal you can always re-wet the area after it has dried and apply the wash again as a second layer.

Problems with the technique

Most initial problems with wet-into-wet arise from either not wetting the paper thoroughly enough or through over-wetting. Having a wash dry halfway into the process indicates that the paper has not been sufficiently wetted and this is usually down to applying one meagre layer of water before adding paint. The appearance of visible brush marks, streaks or runbacks is a tell-tale sign of an uneven drying process associated with poor

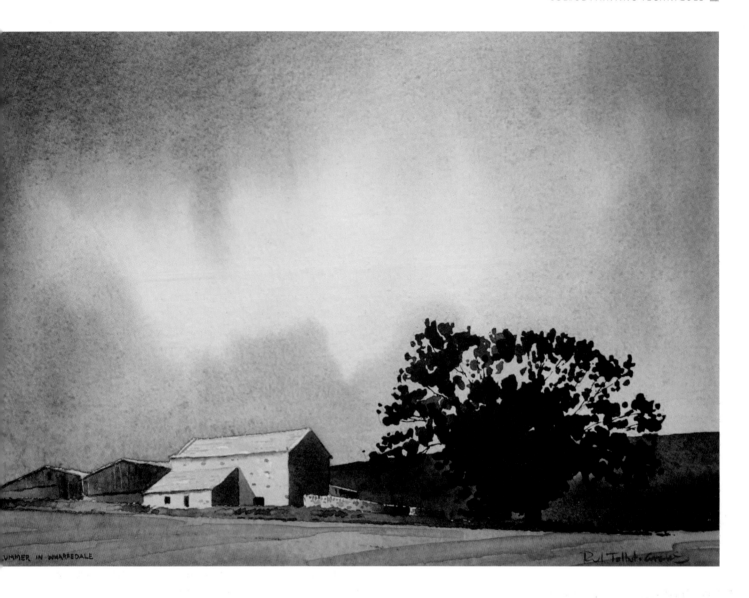

Late summer in Wharfedale, 28 x 20cm (11 x 8in).
The passing rainstorm was achieved by employing
a wet-into-wet technique to create the soft tones
within the sky. The fingers of rain formed as the
board was tilted at a steep angle.

**A classic runback where the colour has been
applied as the paper is drying. Here intense violet
was brushed into cobalt blue at the wrong time.**

preparation of the paper. Even when the paper has been properly prepared, if drying is an issue then it may be down to the artist working too slowly. Answering the telephone or a knock at the door whilst you are in the process of a wet-into-wet wash is usually the kiss of death for a successful result. Preparation is the key to everything and the appropriate colours and mixes should be ready before you begin painting. Usually, I apply the first layer of water and then prepare my paints whilst this is soaking into the fibres. Runbacks in the washes are caused by uneven drying rates and this can be a result of either an unevenly wetted piece of paper or inconsistency in the amount of paint applied over the area. Other factors governing the success or demise of the technique may be the angle of the painting board, the temperature within the painting area (hot weather dries watercolour very quickly), brush sizes, the type or make of paper and of course timing!

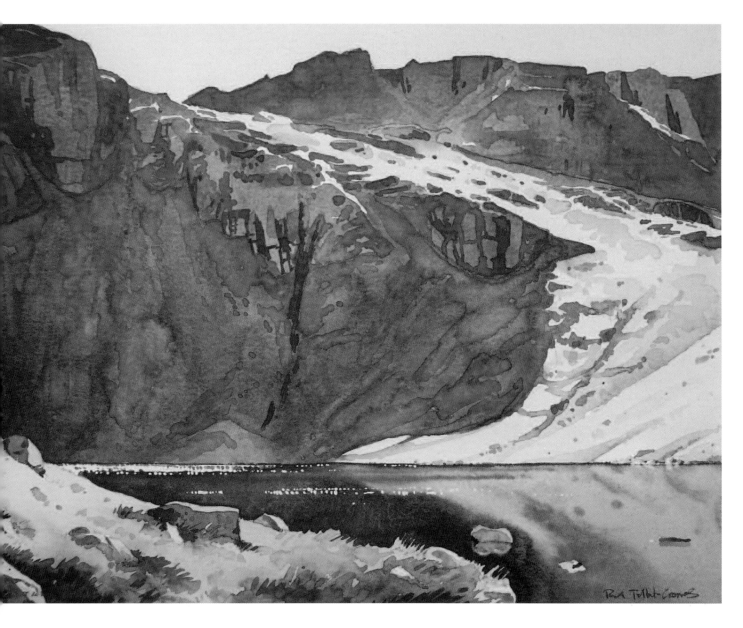

Angle Tarn, 43 x 33cm (17 x 13in).
Here I used a wet-into-wet technique to create the soft blurry
reflections in the tarn.

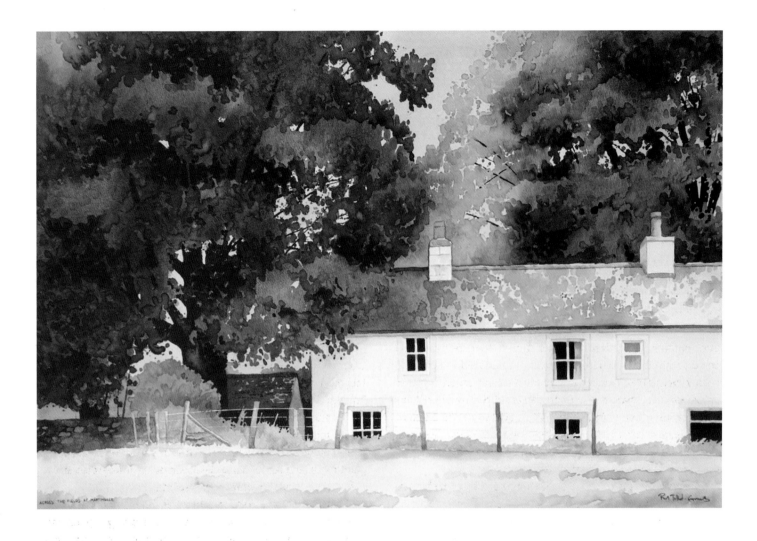

Across the fields at Martindale,
70 x 48cm (27¹/₂ x 19in).
**The variety of greens within this
painting commanded a full
understanding of colour mixing and
colour theory.**

WORKING WITH COLOUR

Colour mixing is the bane of painters' lives. I know this because it is one of the most discussed subjects that I come across in my watercolour classes and workshops. People readily admit that they find colour mixing hard to understand and that is no surprise when you look at the basic mixing possibilities. If three pure primaries are mixed together they will create three new colours, making six different colours in total. Add a darkening colour such as black and create five tonal shades of each of those colours and you have suddenly arrived at thirty different colours and shades. Intermixing them with each other in different combinations will create an infinite range of colour variants. Increase the number of tones within the colour ranges and the figure multiplies beyond comprehension.

However, the results of one's colour choices or mixing are entirely personal and it makes up a portion of our individual style and interpretation of subjects. Colours do not always have to match up exactly with the features of the landscape and in any case it is what is happening on the paper that counts, not whether you have achieved the precise shade of green for the trees in your painting, for example. Colour mixing incorporates basic physics but your approach does not have to be scientific. I often compare colour mixing to cooking. Following recipes is fine but now and again it is incredibly liberating to add your own guesswork over the quantities and amounts of ingredients to be added. Do not measure out the cooking wine in a jug – just slosh it in! Things usually still work out in the end.

Colour mixing is the same. I often slosh colours into a wash and if I run out of a colour I quickly mix more but I never spend time trying to match it exactly with what is already on the paper. In fact, if it is a slightly different hue then all the better, for it will give the overall colour wash variety and interest. Colour mixing need not be difficult, especially if you adopt a constructive approach to creating the colours you want. However, it is wise, first of all, to look at the basics.

Parent colours

The painter's basic parent colours, otherwise known as primary colours, consist of red, yellow and blue. It is important at this stage to recognize that not every red, yellow and blue in the palette is a pure primary colour. Some blues, for example French ultramarine, contain a hint of red and therefore they should be technically classed as blue-violet and not strictly primary blue. This variance of primary colour is quite common in all three of the primary labels so if you are intending to experiment with colour theory then you should ensure that you obtain pure primary colours and not just any old red, yellow or blue. Some paint manufacturers actually class their pure primary colours on their colour charts or information leaflets.

The pure primary colours should be bright and fresh and when mixed with each other they will create orange, green and violet, thus completing the basic spectrum of colours that you paint with. As a suggestion, three pure primaries are sometimes labelled, but not always, as permanent rose, lemon yellow and phthalo blue. The colours may change slightly depending on the manufacturer of the paint.

Every colour that you use from your palette is directly related to these three pure primaries. With a little time and patience, it is possible to recreate the majority of known palette colours by intermixing the primaries. Similarly, computer printers use the same primary colours in ink, generally known as magenta, yellow and cyan. These colours are digitally intermixed in exactly the same way in order to create colour photographs.

The computer printer also uses black in order to create darker, more neutral shades of colour mixes and the watercolour painter can follow the same example. On the colour wheel, the outer segments resemble pure colour whilst the inner segments contain grades of black added to the colour in order to create darker shades.

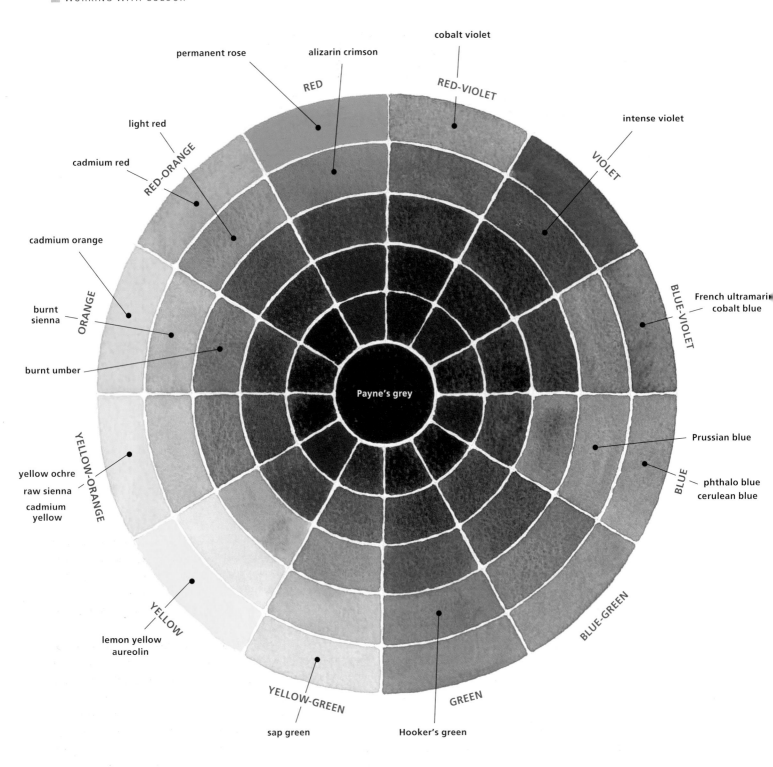

permanent rose

alizarin crimson

cobalt violet

RED

RED-VIOLET

intense violet

light red

cadmium red

RED-ORANGE

VIOLET

cadmium orange

French ultramarine
cobalt blue

BLUE-VIOLET

burnt
sienna

ORANGE

burnt umber

Payne's grey

Prussian blue

BLUE

phthalo blue
cerulean blue

YELLOW-ORANGE

yellow ochre
raw sienna
cadmium
yellow

BLUE-GREEN

YELLOW

lemon yellow
aureolin

YELLOW-GREEN

GREEN

sap green

Hooker's green

A colour wheel, showing around the outer edge the primary colours of
red, yellow and blue and the secondary colours of violet, green and
orange. Tertiary colours are mixtures of primary and secondary forming
red-violet, blue-violet, blue-green, yellow-green, yellow-orange and
red-orange. In the centre is black (or in this case, Payne's grey), which
is mixed with each colour in increments to create the various darker
tones. Included in this diagram are the approximate placements of
my palette colours.

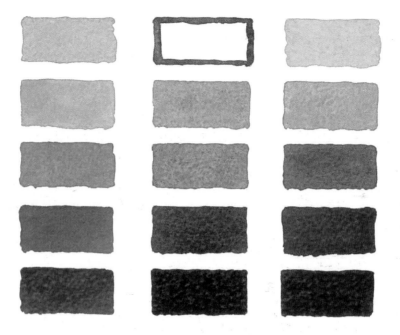

LEFT: **Phthalo blue is increased in strength and although the tone becomes progressively stronger, the colour intensity remains the same.**
MIDDLE: **Payne's grey is graded, creating a full range of tones.**
RIGHT: **This is a mixture of the two colours, which creates a more natural darker shade of the blue. As the strength of the blue is increased so is the Payne's grey, creating gradually darker and shaded tones.**

Creating darker shades

To create a shade of a particular colour it is important to create the key colour first. This could be a mixture of colours or a single ready-to-use palette colour, for example alizarin crimson. To shade the colour requires a certain amount of judgement regarding the tonal strength of the paint mix. Initially the colours are lighter at the top end of the tonal scale and so more of the white of the paper is utilized. The first tone therefore contains a majority of water, allowing more of the white paper to show through as in this example, above, which uses phthalo blue with an amount of water added. As the colour progresses down the tonal scale and into darker shades, it must become stronger and darker, so more colour and less water is used in the mix. The colour is also mixed with grey or black in order to darken it, in this case Payne's grey. The amount of Payne's grey added to the colour is increased in the mix as the colour becomes increasingly darker until the final intense dark is reached. When creating shades of a colour, it is important to keep the mix on the bias of the key colour, for example when shading phthalo blue the shades must be blue-grey and not just grey. Too much grey in a mix will lose the key colour and the resulting shade will look wrong.

Colour mixing

Colour mixing begins with a dominant or key colour, which can be pulled in two further colour directions either side of its placement on the colour wheel. Firstly, the painter needs to identify the key colour of the required mix, for example is it mainly green, red, yellow, blue, orange or violet? The key colour will fit the categories of one of the six basic colours.

Next, identify the variant of the key colour if applicable, for example if the colour is green then is it a tertiary cool blue-green or warmer yellow-green? Look at the colour wheel to see how the green can only be pulled in one or the other of these directions. The same applies to the other colours, for example red can become increasingly violet or increasingly orange. If you are not sure which tertiary variant the key colour is taking, a quick swatch of both possibilities will usually help you to decide.

Finally, the colour then needs to be identified as either a bright colour or a shaded colour. I usually take the view that a colour seen in the landscape is either in the light or in the shade. If it is in the light, then it is generally a pure, bright colour used fresh from the tube. If it is in the shade, then the colour has to be darkened to a certain degree with black or Payne's grey. Payne's grey differs in colour between manufacturers, some creating a very blue grey and others a more neutral grey, which is the paint that

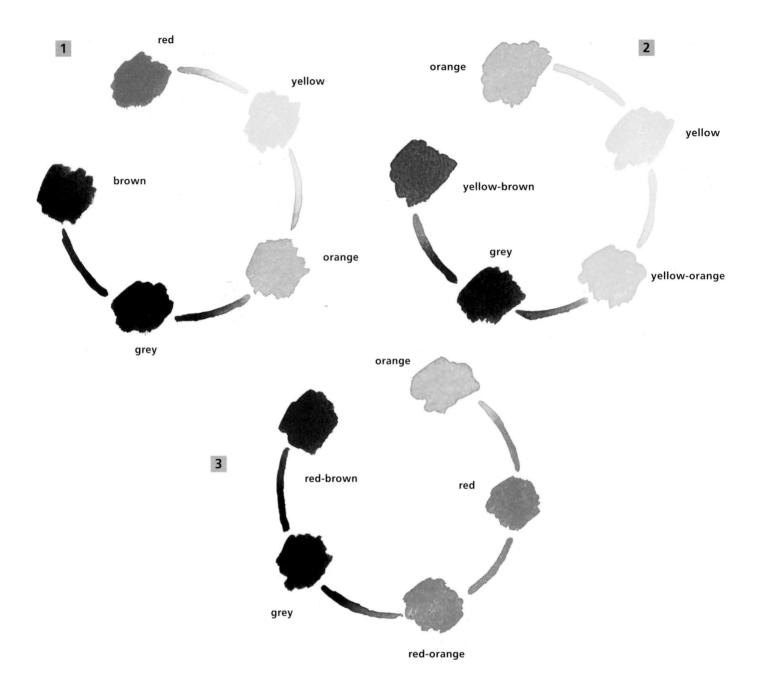

1. **Red + yellow = orange**
Orange + grey = brown such as burnt sienna and burnt umber.

2. **Orange + yellow = yellow-orange**
Yellow-orange + grey = yellow-brown such as yellow ochre.

3. **Orange + red = red-orange**
Red-orange + grey = red-brown such as light red.

I generally use. The amount of grey added to the colour is dependent on how shaded the actual colour is in reality. Let us have a look at this theory in action.

Brown

Brown is a shaded variant of orange, which is created from mixtures of red, yellow and grey. Depending on the overall hue of the colour, you might involve more red or more yellow in the mix to create redder browns or yellow-browns as shown in the examples above.

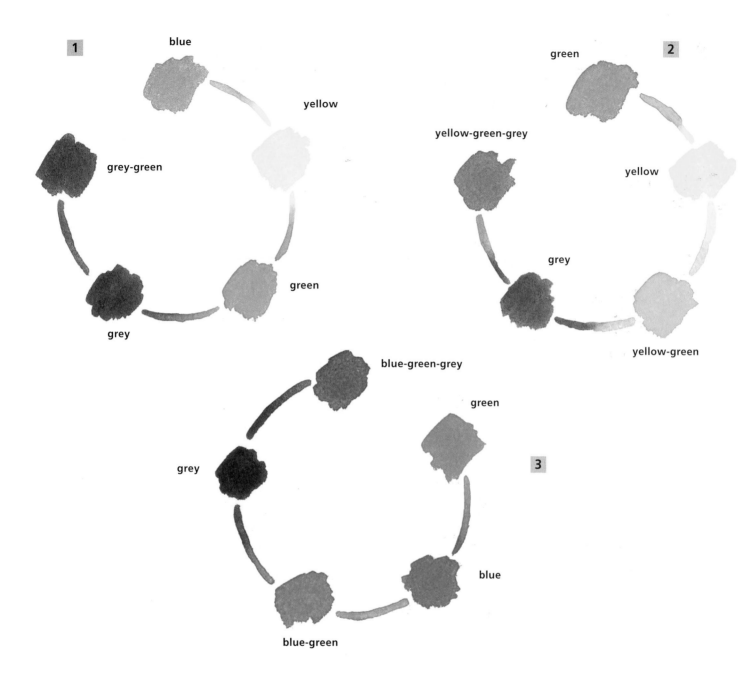

1
blue
grey-green
grey
yellow
green

2
green
yellow-green-grey
yellow
grey
yellow-green

3
blue-green-grey
grey
green
blue
blue-green

Green

Mixing blue and yellow together creates a bright green. This can be manipulated through adjusting each portion of the mix to create yellow-green and blue-green. Further shaded variants can be formed with the addition of Payne's grey, as in the examples above.

By experimenting in this way using three pure primaries and grey, you can really begin to understand how to create all the colours you want in a proactive manner. You will also realize that some of these colours are already familiar, such as the results of the brown mixes. The yellow-orange brown looks similar to

1. Blue + yellow = green, ideal for bright summer trees.
Green + grey = grey-green, the perfect shadow counterpart for bright summer trees.
2. Green + yellow = yellow-green, ideal for brighter grasses or spring trees.
Yellow-green + grey = yellow-green-grey, the perfect shadow counterpart for brighter grasses or spring trees.
3. Green + blue = blue-green, perfect for cooler background hills or trees.
Blue-green + grey = blue-green-grey, the ideal shadow counterpart for cooler background hills or trees.

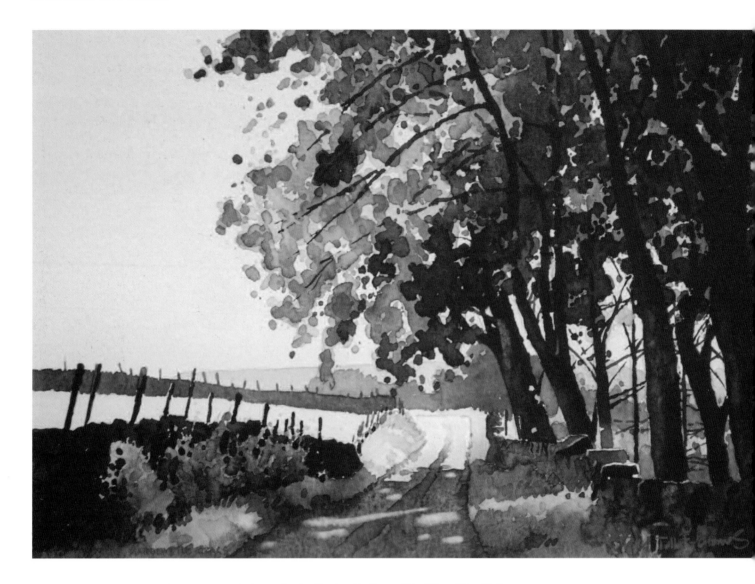

Autumn shade, Hardcastle Crags, 28 x 20cm (11 x 8in).
**I used burnt sienna, lemon yellow, sap green, French ultramarine and light
red, intermixing them to create further colours and shading them with
Payne's grey to create darker shades.**

burnt sienna and the red-orange brown has a similar appearance to light red. This is because the primary colours directly relate to all the readily available palette colours. Palette colours are simply the paints that artists work with such as burnt sienna, cadmium yellow and Hooker's green. As a result of primary-colour mixing, it is possible to recreate these known palette colours fairly accurately and this is extremely useful for understanding their individual colour properties. Consequently you should not look upon your paints as a random collection of different colours, they are simply shortcuts to popular primary mixes. Knowing the properties of each colour will enrich your ability to accurately mix palette colours together with confidence.

How palette colours relate to each other

To work out how the palette colours relate to each other, it is necessary to conduct some analysis of their colour compositions. Each individual palette colour can be carefully recreated from pure primary colours and grey in order to calculate the proportions of primary (and grey if applicable) elements within the final colour. For example, French ultramarine can be recreated with approximately 67 per cent primary blue mixed with 33 per cent primary red, which places it as a blue-violet on the colour wheel. Some palette colour properties are obvious whilst others are a little more difficult to trace, such as the browns.

Here are some examples of a number of popular colours that I have analysed, the results of which are specific to the brand of paints that I use because colours do differ between manufacturers. The composition of each palette colour can be clearly seen in the pie charts alongside each swatch and this helps to place the colours accurately on the colour wheel. Having this knowledge about your colours also helps with mixing and selecting colours to use in paintings, for example the difference between sap green and Hooker's green is more blue and grey in Hooker's green. Therefore, Hooker's green is a cooler, greyer green ideal for backgrounds and shady areas of a green landscape whereas sap green is brighter and fresher, ideal for spring scenes and so on. These colours, and more, can be seen in their respective positions on the colour wheel on page 116.

The approximate composition of each of these colours is as follows:

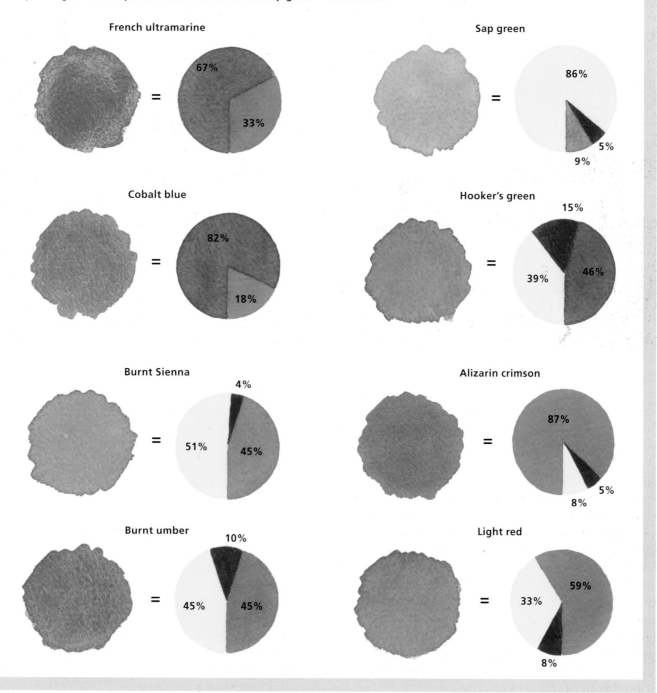

French ultramarine = 67% / 33%

Sap green = 86% / 5% / 9%

Cobalt blue = 82% / 18%

Hooker's green = 15% / 46% / 39%

Burnt Sienna = 4% / 51% / 45%

Alizarin crimson = 87% / 5% / 8%

Burnt umber = 10% / 45% / 45%

Light red = 59% / 33% / 8%

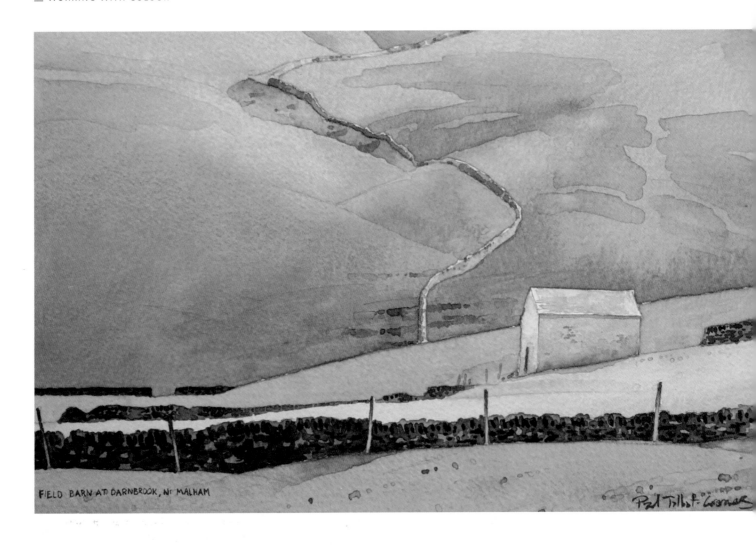

FIELD BARN AT DARNBROOK, Nr MALHAM

Field barn at Danbrook near Malham, 26.5 x 18cm (10^1/$_2$ x 7in).
**The greens in this painting were kept fresh and bright
by using a palette green as a base colour and mixing
this with yellows and blues to create the various subtle
colour changes.**

As I have previously illustrated, browns already contain an element of grey and these would be placed further into the centre of the colour wheel within their respective orange and red segments. Each palette colour can be analysed in this way and placed in its appropriate position on the colour wheel. However, it is only when you have pure primary colours with which to compare the palette colours that their true differences can be seen. Non-pure primary colours will create false results and subsequently the palette colours may end up in the wrong place on the colour wheel.

When you are familiar with the primary properties of each palette colour, you can instantly begin to sort out your colours

into their respective categories – cobalt blue, French ultramarine and cerulean into blues, blue-violets and blue-greens; raw sienna, cadmium yellow and lemon yellow into yellows, yellow-oranges and yellow-greens; alizarin crimson, permanent rose and light red into reds, red-violets and red-oranges. When all of your palette colours have been sorted into their respective categories on the colour wheel, it is possible to predict what colours they will make when mixed together, for instance cobalt blue and alizarin crimson will create violet. French ultramarine and alizarin crimson will also make violet but this will be slightly different from the cobalt blue mix because of the difference in the composition of the two blues.

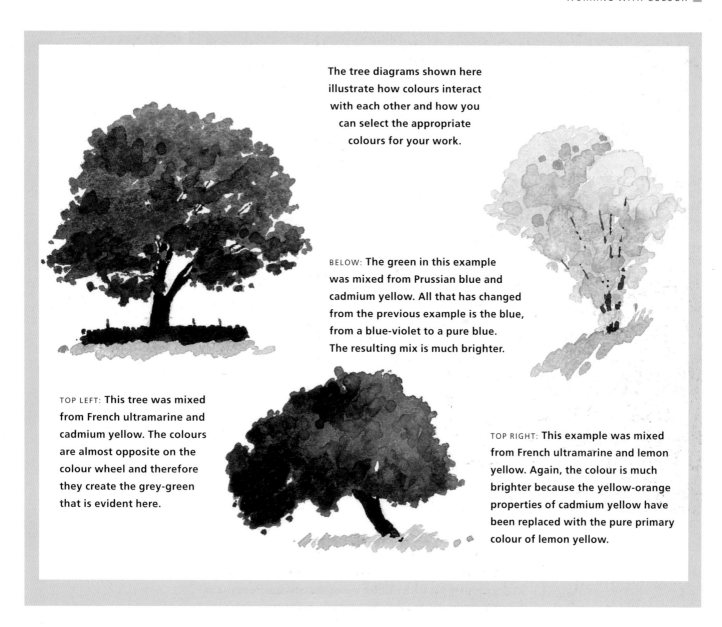

The tree diagrams shown here illustrate how colours interact with each other and how you can select the appropriate colours for your work.

BELOW: **The green in this example was mixed from Prussian blue and cadmium yellow. All that has changed from the previous example is the blue, from a blue-violet to a pure blue. The resulting mix is much brighter.**

TOP LEFT: **This tree was mixed from French ultramarine and cadmium yellow. The colours are almost opposite on the colour wheel and therefore they create the grey-green that is evident here.**

TOP RIGHT: **This example was mixed from French ultramarine and lemon yellow. Again, the colour is much brighter because the yellow-orange properties of cadmium yellow have been replaced with the pure primary colour of lemon yellow.**

Complementary colours

Complementary colours are those opposite each other on the colour wheel which, when mixed together, will neutralize themselves to create grey, so for example red and green or blue and orange. Purist colour mixing involves the use of complementaries for creating neutral shades and although the theory does work, the technique requires labour intensive colour matching to get the final mixes right. The use of black or grey replaces the need for this theory, although it is worth some study for it can predict or explain what will happen with certain colour mixes. For example the combination of French ultramarine and burnt sienna will create a dark, neutral grey colour, which can be expected due to the positions of these colours on the colour wheel – virtually opposite. A popular trap is when an artist uses French ultramarine and cadmium yellow as a combination for the bright greens of high summer. What actually happens is that the resulting mix becomes the drab green of a dull grey day. The colour wheel explains this, as French ultramarine and cadmium yellow are actually blue-violet and yellow-orange and as a consequence are nearly opposite each other, so a grey green is an obvious outcome. To rectify the situation either the yellow or the blue can be substituted for a brighter, more primary colour, such as lemon yellow with French ultramarine or Prussian blue with cadmium yellow. By placing palette colours on the colour wheel in their respective places, a coherent understanding of how they work together can be formed. My colour wheel is made up of one particular brand of watercolours; however, as I have previously indicated some colours differ between manufacturers so you should try to analyse your own palette in order to maintain accuracy with the theory.

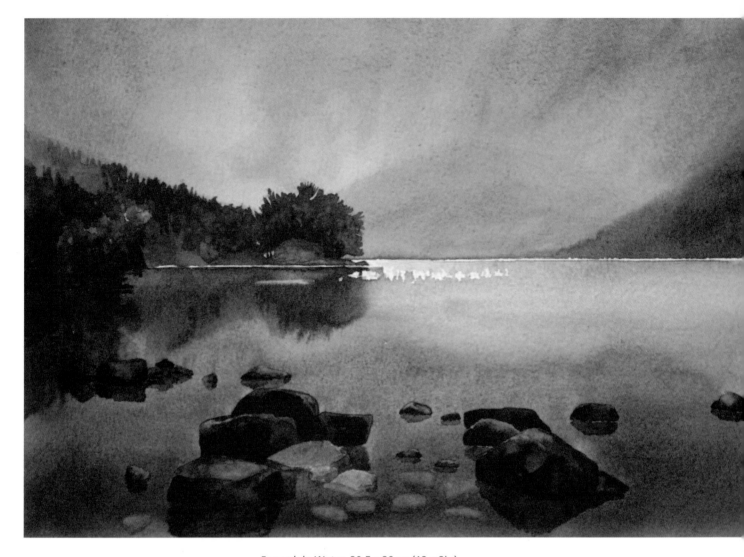

Ennerdale Water, 30.5 x 20cm (12 x 8in).
**In this painting the dark sinister atmosphere was echoed in the
land and the water by adding various amounts of grey to each
of the basic colour mixes.**

How to mix palette colours

Colour mixing should be methodical but it does not have to be an exact science. It does not matter if your mix fails to be a precise match to that in the image you are working from, so long as you know how you have arrived at your colour. The following simple rules will help you mix your colours better:

Only mix two colours together at any one time. In a three-colour mix, mix two together first to create a new colour and then mix this new colour with a third colour to arrive at your selected shade.

Try not to use more than three colours in a palette mix at any one time.

For darker shades create the base colour first, for example green, then add grey or use a complementary colour (opposite on the colour wheel).

Keep your palette clean and remember to rinse your brush out between colours when mixing on the paper.

For thin paint, put the required amount of water in your palette first and add paint to it until the necessary tone is reached.

For thick, heavy tones, put paint out first and add small amounts of water at a time to it until the required strength is attained.

To create the colour you want, first categorize it into its general selection on the colour wheel in exactly the same way

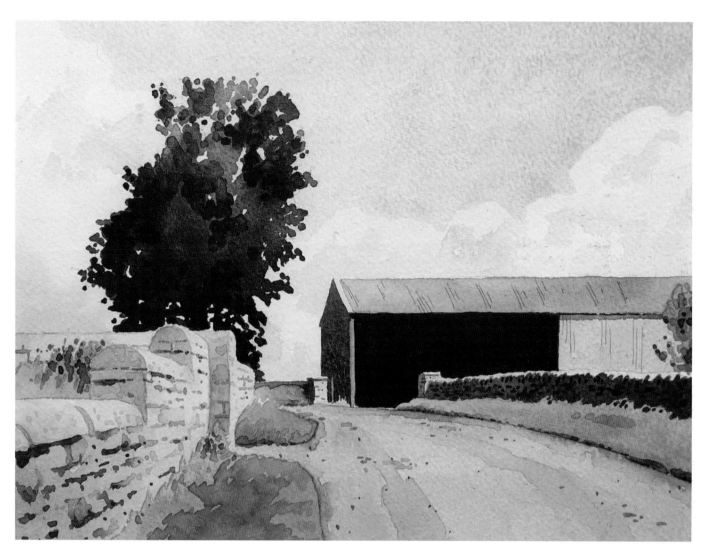

Northumbrian barn, 28 x 21cm (11 x 8¼in).
I kept the sky bright using cerulean blue, and for the greens
I used sap green as a base colour throughout. Along the grass
verges I mixed this with raw sienna on the paper but to create
the warm grey-greens of the main tree I mixed the two
together in the palette and added Payne's grey. I used cobalt
blue and burnt sienna for the shadowed wall on the right, with
Payne's grey added in the darkest parts. The dark of the barn
interior involved cobalt blue and Payne's grey. Even in the
darkest tones, you can create subtle colour variation.

The winter grasses here were painted in a fluid wash of raw sienna, burnt sienna and Payne's grey, all mixed loosely on the paper. A few subsequent marks when the washes dried suggest the details.

as for dealing with primary colours, for example identify whether it is a red, green or yellow. Next, try to work out if the colour you want is a bright pure colour or if it is a neutral shade. This will indicate whether or not you need to add grey to the mix. When you have made your assumptions, you can work out from your colour wheel which palette colours you might use in order to create the new colour. For example if you want a cool, grey-green, then you would initially categorize the colour as a green. You could either mix a green from any blue and yellow or you could make life easier and your painting clearer by selecting a basic palette green such as Hooker's green or sap green. For the cool portion add some blue and for the grey portion just add some grey (Payne's grey or black). You will need to create the green first and then add the grey.

You can use any combination of blues and greens, which will obviously alter the hue of your resulting mix but essentially there are many ways of arriving at the same resulting colour. Take cadmium yellow for example. Although it is predominantly yellow, there is an element of orange in it. You can recreate cadmium yellow by mixing lemon yellow and cadmium red. Alternatively, you could use raw sienna with slightly less red added or add a palette orange. All the possible combinations in this instance would use the bright colours of red or orange and yellow situated on the external perimeter of the colour wheel.

With darker greys and browns the colour mixing possibilities are opened up even further with the addition of a neutral element – grey. For a dark, warm grey two complementaries

can be mixed together such as French ultramarine and burnt sienna. Alternatively, the French ultramarine could be substituted with cobalt blue or the burnt sienna with burnt umber. The results will be very similar with only subtle differences in the resulting colour mix. Alternatively, a little burnt sienna or burnt umber could be added to some Payne's grey.

Liven up your washes

A wash of a single colour will flatten a picture, so liven up your paintings by mixing colours on the paper as well as in the palette. I generally create a base mix, which becomes the key colour of the area, for example a violet. As I paint with the violet, I also loosely mix on the paper elements of its colour properties such as red and blue, as well as not forgetting to include any necessary grey shades. Breaking the colours up in this way is especially useful for generating interest within darker areas, such as a dark-toned rocky shore of a seascape. To paint

I used French ultramarine and light red to create this
painting, making the washes paler and cooler in the
distance (more French ultramarine blue) and warmer and
stronger in the foreground (more light red). The limited
palette creates a strong, subtle atmosphere.

the area as a single, flat neutral colour would deaden the
feature. In an instance such as this, I would use two colours, for
example French ultramarine and burnt sienna, and whilst brush-
ing on the resulting grey mix I would also add them in their pure
form so that bits of each colour show throughout the area. This
really helps to add life, colour and realism to an otherwise drab
area of the painting.

Using a limited palette

When a full comprehension of the relationships of palette
colours has been made and colour mixing becomes a straight-
forward process, then it can become extremely enjoyable to
experiment using a limited palette. Using a very limited palette,
such as narrowing your choice of colours down to two, forces
you to be creative, inventive and imaginative. Certain colours
have to be substituted to fit your limited colour scheme but it is
a great way of becoming more familiar with individual colours,
how they behave and interact with other colours. Limiting a
palette to two colours offers you the choice of being inventive

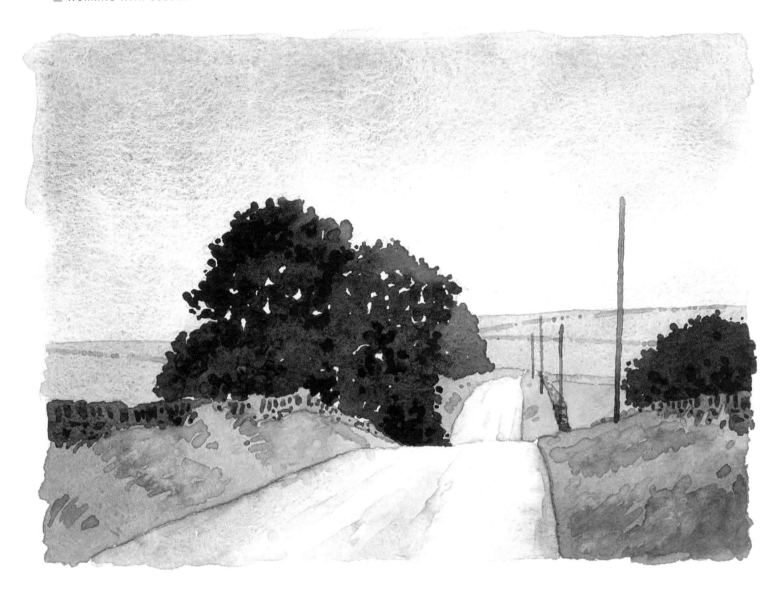

Here I used French ultramarine, light red and sap green. The addition of sap green has opened the colour scheme into a new dimension as I am able to create cool and warm greens, shaded greens as well as brown mixed from sap green and light red. If you have never tried working with a limited palette, it can really teach you how to intermix your colours wisely.

with distance in a painting and of course the range of colour is narrowed down to such an extent that this method can help to exaggerate strong atmosphere. By choosing a blue and a brown, it is possible to create warm greys, cool greys and strong darker greys. By making the areas of the foreground warmer and stronger, and the background cooler and paler, distance can be interweaved into a scene. The limited colour scheme also pulls all the elements of a painting into a simple visual delight. If grey is the dominant colour in the scene such as when the day is misty or rainy, then the choice of colours will also help to bring over the mood. As an example, cobalt blue and burnt sienna will create a slate grey, whereas replacing the burnt sienna with light red will result in a subtle grey-violet. A slightly brighter red might be employed instead, such as alizarin crimson and this in turn will create a much brighter violet. The behaviour of the colours used can be predicted by referring to the colour wheel. When selecting two colours for a limited-palette painting, it is also important to ensure they will be capable of creating a dark tone, otherwise your picture may look washed out.

Three-colour paintings

Adding a third colour to a limited palette opens up even more capabilities. The third colour could be a neutral such as grey or it could be any other colour from the colour wheel. Again, choice and selection of colour can be assisted by referring to the colour wheel and predicting how the colours will interact with each other. Various moods and atmospheres can be created using three colours.

Primary-based paintings

There is no better way of learning about colours than to create paintings using the three pure primaries and a grey. By using a basic colour wheel, it is possible to predict the precise outcome of mixes and this is the base level of colour mixing in general. Use the grey to neutralize the colours. You will of course notice a slight difference to the finish of the watercolour and this is down to the staining properties of the pure primary pigments. Some palette colours granulate on the paper, leaving a characteristic grainy finish to a watercolour and this can be especially useful for suggesting texture.

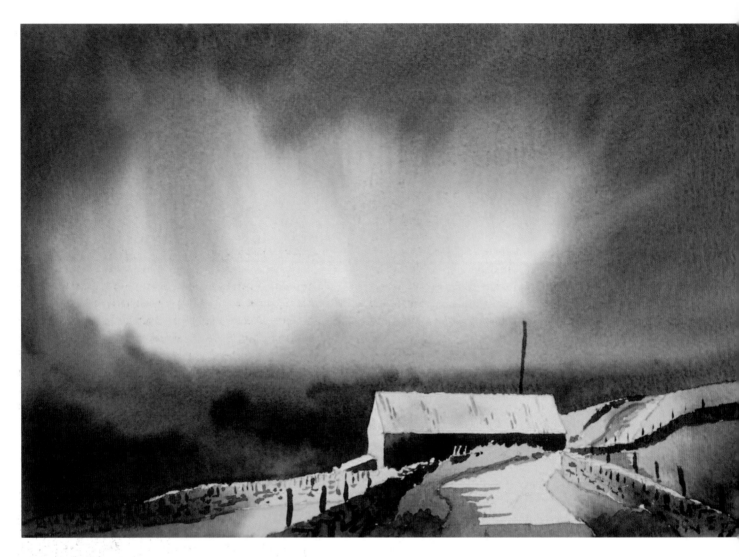

A summer storm, 34 x 24cm (13^1/$_2$ x 9^1/$_2$ in).
I exaggerated the sky and increased the
contrast of the lighting to create a painting
with impact and mood. Techniques like this
can be employed in any landscape scene.

ATMOSPHERE AND THE LANDSCAPE

Atmosphere conveys a strong sentiment within us all. There is something about an atmospheric sky that captures the imagination, whether it is a feeling of self-security, for example looking at a picture of a storm and imagining the lashing rain or the stinging snow whilst enjoying the comfort of a warm dry room, or maybe it is the sheer awe and respect of the forces of nature. Whatever our feelings, watercolour is the ideal medium for capturing the effects of atmosphere because the painter can rely on the transparent veils of pigment to run and gradate on the paper in the same manner as atmosphere does in nature. Watercolour is spontaneous and responsive and with these kinds of qualities it is fairly straightforward to suggest stormy skies and different moods with a few techniques.

Practise painting atmosphere

Watercolour is a partnership between the artist and the medium. You aim to achieve what you have in mind but you must always be prepared to accept what you get instead. This is so true to painting atmosphere, especially when you are aiming to lay down a soft wet-into-wet sky. One or two ill-considered pokes of a brush can ruin the whole effect so it pays to have in mind what you wish to achieve as well as accepting something slightly different. Put the paint on quickly and efficiently and allow the effects to do their own thing. It is invaluable to practise painting the atmosphere as you see it in the landscape, whether you are out in the open air or just viewing it from a

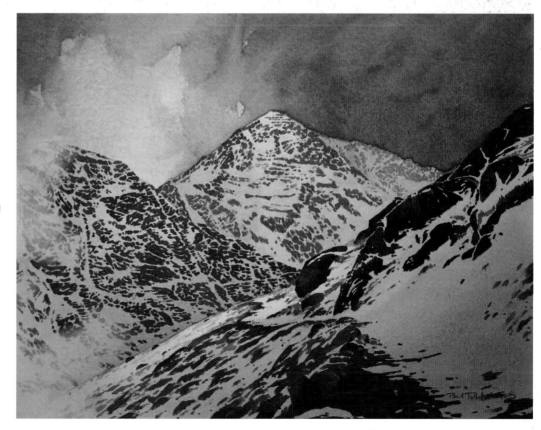

Fleeting light on the approach to Snowdon, 45 x 35cm (17^3/$_4$ x 13^3/$_4$in). **A flash of light passes over the mountain slopes in this sombre atmosphere, adding a splash of colour and a focus to the painting.**

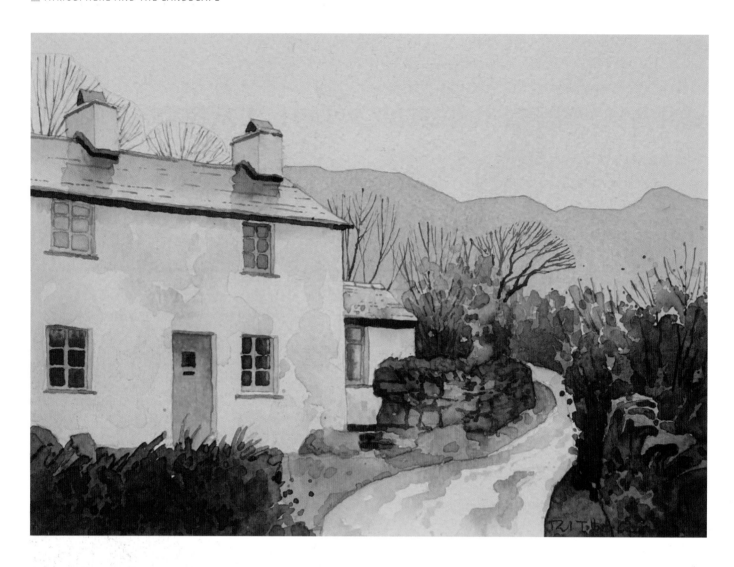

A wet day at Little Langdale, 24 x 18cm (9½ x 7in).
Watercolour is ideal for capturing subtle moods.
Here I used grey shades, reflections and watery washes to
bring across the feel of the damp day.

window. Often, moods and skies can change quickly and this forces you to concentrate only on the elements that count. Sketch what you see using watercolour, preferably on cartridge paper so that the washes dry quickly, allowing you to build up the colours and tones in rapid succession. Working outdoors brings with it the excitement of absorbing the atmosphere first hand. I have certainly absorbed my fair share of atmosphere over the years, in some instances more than others! On one occasion whilst sketching on high ground I was unfortunate to be caught in the centre of a violent thunderstorm. Crouched low on my rucksack, I kept my head down as lightning randomly struck the ground around me and the roars of thunder nearly shook me to my feet. If that was not frightening enough, the torrent of hailstones stung my back in a torturous barrage of icy missiles.

Luckily I survived and the resulting painting definitely had an emotional edge to it that I am sure it would have otherwise lacked had I not experienced that situation.

On other occasions I have had my painting freeze as I have painted winter sunsets from mountain peaks. Drizzle causes speckles to appear in washes and rain makes sketching an interesting proposition. I extract an immense feeling of self-satisfaction after returning from a sketching trip, my books and equipment drying by the log fire as I retrace my route on the map. After a while, atmosphere becomes part of your life and you certainly gain an understanding and respect for nature through sketching weather and mood first hand. I can really empathize with Turner's idea of being strapped to a ship's mast whilst riding out a storm at sea. Experiences of this kind work their way into your soul and I'm sure he must have discovered a new mental understanding and approach to painting seascapes. In many respects the whole experience induces inspiration, if nothing else.

LEFT: **This photograph of Stonehenge was taken on a clear summer's day but I thought the subject demanded a stronger atmosphere.**

BELOW: *Amongst the stones*,
68 x 51cm (26³/₄ x 20in).
I used the photograph for detail reference but completely changed the sky, the season and the mood. Applying your own creative intervention on a picture in such a way is incredibly exciting.

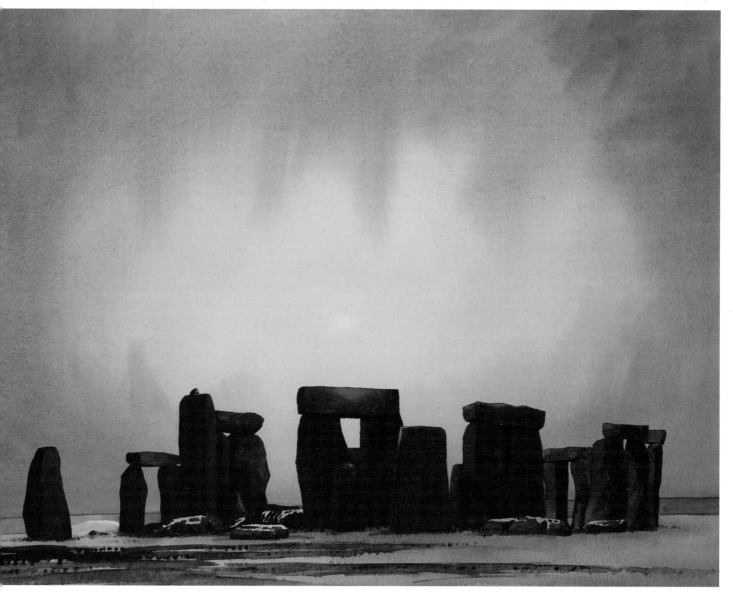

Atmospheric effects

Atmosphere can be a mere change of light or weather upon the landscape, which can have a profound effect upon the appearance of a scene and, in turn, the senses of those viewing it. These effects are very often fleeting changes and it is those changes that can really make a painting stand out as something special. By bringing an atmospheric appearance into a scene the artist conveys his or her very own emotions and experiences to the viewer. By exaggerating the atmosphere, the mood and therefore the overall impact of the painting will be magnified. It is rather like an expanded fisherman's tale except you are creating your own fabricated evidence on a piece of watercolour paper for all to see. Using sky to your own creative advantage can be extremely exciting. Try changing the sky in your scene by using one from another photograph or even from your imagination. The wet-into-wet technique can be extremely useful here for creating a whole array of atmospheric effects, especially where you intend to use more sky than land. Try to create shape in the sky to complement your composition or use atmosphere to obliterate parts of the landscape that you do not wish to include in the picture. Success of the wet-into-wet technique relies on good preparation but there are other factors that can help make a sky interesting too. When you are painting a strong atmospheric scene, it is important to bring across the whole mood within the picture. If you have a grey sky, you can use the same grey to darken other colours in the scene and this will unify the atmosphere, mood and lighting to a certain extent.

Skies

The sky obviously has a direct relationship to the atmosphere you wish to convey and so you should begin by giving some thought to the overall content of your scene. In many cases you may be working from a photograph that has a dull, shapeless sky or even a flat blue summer sky. Changing the atmosphere can really lift a subject out of the ordinary and project it into a whole different league. You can paint any kind of sky onto your picture but before you begin painting it is important to decide if you want to convey rain, mist, snow or perhaps dark, ominous storm clouds overhead. You can use your sky as a strong element of your composition and there are a number of ways of doing this. Two thirds sky to one third land is a good proportion to use, but with over half of the picture as sky, how can you create interest? One large flat wash will probably make the painting look a little empty so consider using changes in tone, colour and shape. Shapes used innovatively must direct your eye to a particular part of your painting, ideally your focal point. To do this, you will probably have to use some creative initiative, either by

A STEP-BY-STEP APPROACH

ON THE NORTH YORKSHIRE MOORS

TOP LEFT: **I used Payne's grey and cobalt blue brushed wet-into-wet over the sky area and into the land to create soft weather patterns. By tipping my board steeply I induced some of the paint to run, which is suggestive of distant rain.**

TOP RIGHT: **Using the same colours I brushed in the shapes of the background hills.**

BELOW LEFT: **I applied raw sienna to the track and then used sap green, burnt umber and Payne's grey to describe the mass of moorland colours.**

BELOW RIGHT: *On the North Yorkshire Moors,* **32 x 23cm (12¹/₂ x 9in). Finally, I added some harder-edged shadows in-between the clumps of heather and softened them in places with clean water. Using sap green mixed with a little Payne's grey, I painted the grassy section in the middle and sides of the track, adding the post, which is the only vertical in the picture, last. This is placed off-centre and creates a subtle focal point, which is enhanced by the lighting through a number of carefully considered wash stages.**

inventing shape and direction within your sky or by selecting a photograph of a sky that fits with your idea. Heavy clouds whether dark or light can be used in a deliberate manner in this way. Tone can also be effective, either by creating strong contrast around the focus or by guiding the eye into the painting from the edges. Light breaks in a stormy sky can be used to highlight patches of land, low clouds on the horizon will provide a backdrop to a scene, which is ideal for creating distance or supporting shapes to a focus, and directional brushstrokes will suggest windswept weather such as rainy days and stormy moods. I find that mood is greatly enhanced if you have strong lighting on the landscape so with this in mind it is often beneficial to work from source material with good directional lighting rather than dull or flat light. Low light from one side will throw shadows across the scene, visually enhancing your moody painting. Your atmospheric scene will not always have strong light though, for example in a foggy scene or in other low lighting conditions, so consider all the elements and maybe even practise a few ideas before you begin painting the finished picture.

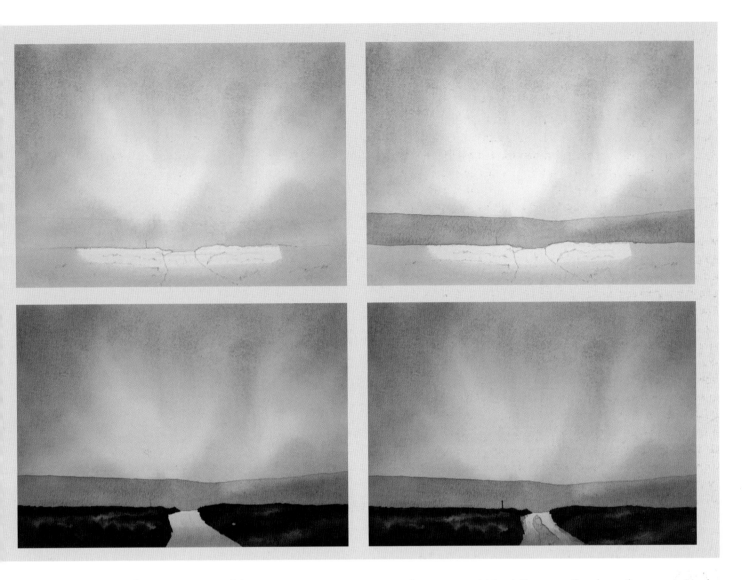

Techniques for painting skies

The atmosphere is made up of moisture and in direct comparison watercolour is too. The wet-into-wet technique is therefore predominantly the most appropriate start with a sky painting, unless of course the sky is one flat colour where a simple wash may be more appropriate. Wet-into-wet creates soft blends of tone and colour, shapes and movement, all of which are key elements of an atmospheric sky. Skies can be painted in one stage using the wet-into-wet technique and although this is generally enough to suffice there may be circumstances where more detail is required, for example where harder-edged clouds are present or in a larger painting where a little more shape may be needed to fill the bigger space. When applying colour, begin with the palest and gradually build up the tones by adding darker colour, allowing each layer to softly blend with the previous one. If you are using yellow to bring warmth or light into a sky break, make sure you only place the yellow where it is needed and use it thinly. Bring the other colours up to the edge of the

yellow area and blend them gently where they meet. Naples yellow is a safe bet because, being opaque, it will not readily mix with other colours and as a consequence it may be used to avoid green or muddy skies! To create soft shapes, whether they are landscape features seen through a misty veil or cloud shapes fleeting across the landscape, I keep my board flat down on the table and use a half-loaded brush, keeping it in constant contact with the paper. I push the paint into the general shapes that I have in mind and I leave the area to avoid over-working the emerging effects. To suggest veils of falling rain, the board can be tilted at a steep angle. As soon as the desired effect has been achieved the board is once again placed either flat down or at a shallow angle and is left to its own devices. For very realistic and finely graded effects within a wet-into-wet sky, use staining pigments as opposed to grainy ones, for example Prussian blue (staining pigment) settles more finely on the paper than French ultramarine (grainy pigment). You can build up some wonderful depth, soft tone and incredibly fine tonal variations in a sky using staining colours.

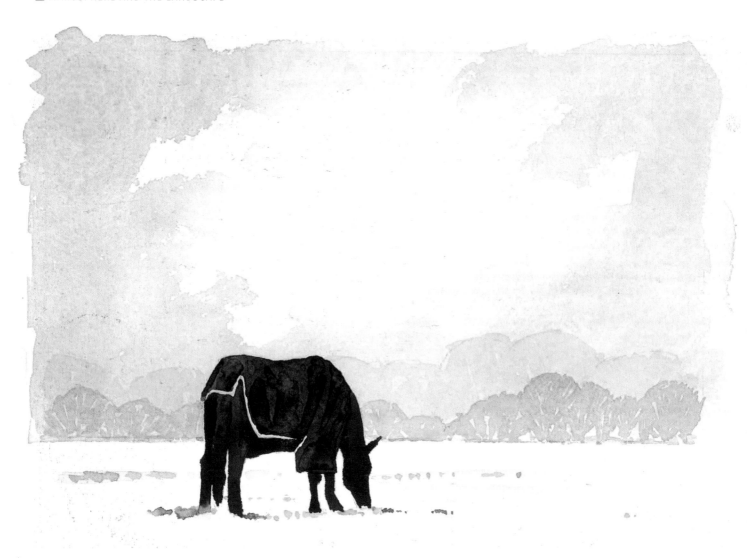

Two-step skies

Two-step skies require a little more confidence. I usually begin with a wet-into-wet wash, brushing in the general colours, tones and shapes and allowing it to dry before adding anything further. Once the paper is ready again, I add paint wet-on-dry and form any cloud shapes or tones on top. This works especially well for layers of cloud. Strong directional brushstrokes can also be used to infuse movement or action into the atmosphere and this works especially well on top of a coloured ground where flecks of the under-wash are left showing here and there.

Skies do not always have to be approached from a wet-into-wet angle. A wet-onto-dry method will give you the opportunity of working with the white of the paper where hard cloud edges can be left. When working in this manner, you must use plenty of fluid paint in order to keep the wash area uniformly wet otherwise runbacks will become a big issue. Soften some of the harder shapes with clean water to avoid the clouds looking as though they have been cut out and stuck on. Some excellent effects can be achieved by taking paint off, either whilst the

Out in the cold, 23 x 16cm (9 x 6¼in).
Here I painted a soft wet-into-wet sky of yellow and grey-violet, allowing it to dry before adding a second layer of the violet wet-on-dry. The harder edges of this second layer give the sky some depth and movement.

initial wash is still wet or after it has dried. Apply a wash of fluid colour and take out some hard-edged cloud shapes using a piece of dry screwed-up tissue. Keep turning the tissue so that you are working cleanly and use a combination of heavy and gentle pressure to vary the delicacy of the shape you are creating. Alternatively, create some soft-edged clouds by taking paint out using a slightly damp brush. If the wash is dry a similar approach can be made with a damp sponge, dabbing and scrubbing gently to loosen the paint and mopping up any excess with paper towels.

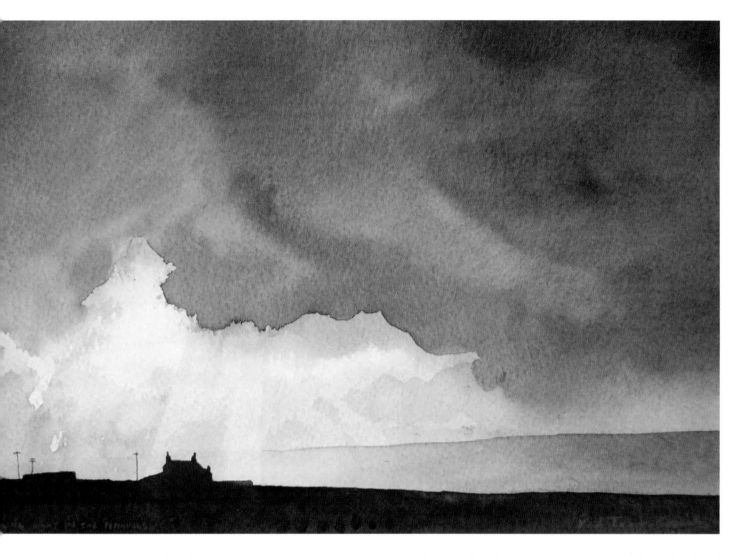

Changing light in the Pennines, 25.5 x 17cm (10 x 6³/₄in).
In this painting I have used a two-step sky to bring over the dark brooding atmosphere and to add shape and movement in the top two thirds of the picture.

When to use a big sky

Use a big sky on a scene that either cries out for atmosphere or where there is very little in the way of subject matter, for instance a lone building on a moor or a mountain peak. In these circumstances, use at least two thirds of the paper for the sky area and try to make the sky interesting. If so much attention is given to a sky then it must have some depth and interest to it in order to balance the lack of detail in the land.

When to use a simple sky

Paint a simple sky, for example a pale wash of blue, on a scene where there is a lot of landscape detail or where the land takes up at least two thirds of the picture space. Always remember it is a matter of balance. All too often I see paintings where there may only be a corner of the sky showing but the artist has crammed it with clouds, thinking that it will make the picture more interesting. It just stifles the overall image.

Plain skies

For plain skies, use a simple blue such as French ultramarine or cobalt blue mixed with plenty of water. Do not make the blue too strong or it may overpower your picture. For cool winter skies with a hint of warmth, use cobalt blue mixed with Naples yellow. Naples yellow is an opaque colour (just off-white) and will not create a green providing you do not put too much of it in the mix. Alternatively, to create an opaque, cool winter sky, mix cobalt blue with white gouache. This is the only occasion in which I would use either Naples yellow or white as a mixing colour. You can either mix the colours in the palette or allow them to fuse together on the paper.

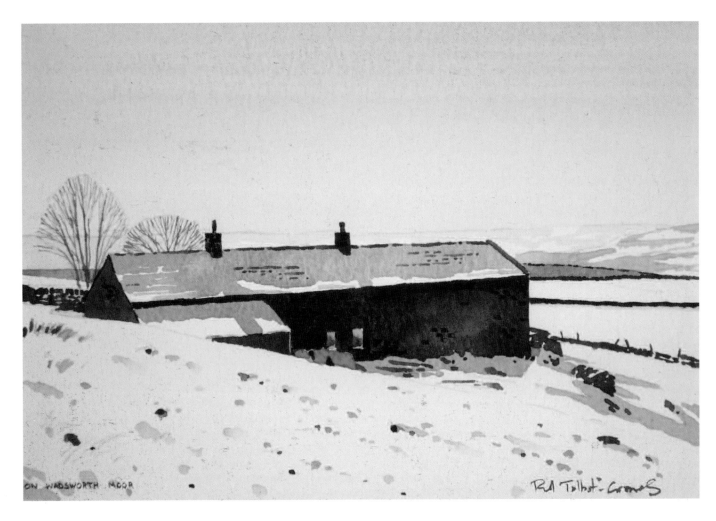

On Wadsworth Moor, 21 x15cm (8¹/₄ x 6in).
**The plain sky here complements the brightness of the day
and keeps one third of the painting simple. I used cobalt
blue graduated into Naples yellow, finishing the wash at
the horizon line.**

Sunsets

Sunsets convey a sense of calm and relaxation due to the warm underlying colours and the horizontal nature of the sky shapes and clouds. I usually begin with an overall colour wash of red and yellow, allowing them to wash right over the landscape. This provides a colour unity throughout the painting, which reflects the strong colour influence of this particular atmosphere. Care must be taken when using yellow and red as these paints possess very strong colour intensities and it is all too easy to make them too thick, overpowering the sky and resulting in an unrealistic sunset. The landscape washes and clouds are then built up on this under-colour, which glows through the subsequent layers of paint. The sun is the brightest element of the sky and as a consequence this must be left as white paper, either by painting around it or masking it out with masking fluid prior to

any applied washes. When the colours have dried, a wet-on-dry approach can be employed to paint any thin bands of cloud. Usually at this time of day the cloud forms long horizontal strips near to the horizon and this can be extremely aesthetic when used in a painting. Look out for any subtle changes of colour, especially where a cloud crosses near the sun as it may take on a pale orange hue due to the light intensity in that area. This may also apply to an area of the landscape below the sun. Essentially, the colour imitates lens flare (either on the eye or from a photograph) but it is very effective in a painting and can really enhance the light effect. To create a glow to the light source, a limited amount of paint may be lifted from around the sun prior to removing the masking fluid. Looking west into a sunset is a delight but looking east is equally appealing. This is where you can find violets, reds and pinks intermingled with shades of dark blue clouds, in other words the cooler side of the spectrum. These colour schemes can be just as attractive as a directly observed sunset so do not dismiss looking east just because it does not contain the sun.

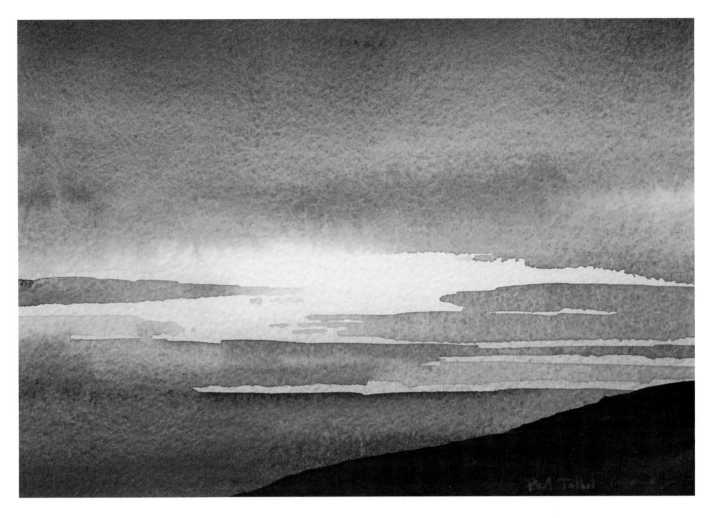

Evening glow, 22 x 15cm (8¹/₂ x 6in).
The subtle background colours glow through the over-layered washes of the clouds. The dark section of landscape provides contrast, making the light area appear bright.

Sunrises

Sunrise is pretty much the same as sunset except the light is more delicate and the colours tend to be fresher. Here you might experience warm yellows, oranges and pinks and these can be contrasted with stronger, darker landscape elements to give the painting a striking feel. Although the sun may appear to be orange, painting it as such will have a negative effect on the light in your painting so keep the sun as white paper wherever you can. Sometimes you might catch the sunrise in combination with early morning mist and this can make for a really evocative painting, especially if you have a good strong focal point such as a boat, figure or rock feature.

Snow scenes

Snow scenes lend themselves to exaggeration and mood-enhancing skies. They also make excellent studies of the landscape, in particular where shadow and form are concerned. A cloak of white really shows the shadows that would be present but are difficult to see in other seasons. Snow scenes deal with contrast, shadow and negative painting, all of which are important elements within any landscape scene so the opportunity of studying and painting snow scenes should not be passed. They are the bare bones of landscape painting.

In general, white reflects ultraviolet and this explains why shadows in a snowy landscape are often depicted as blue or violet. The selection of blue from the colour wheel will enhance either the coolness of the scene or with a little colour mixing may even add slight warmth, depending on how you interpret it. Bright light may cast a warm glow into a shadow area and this can be depicted by laying down a wash of blue, for instance cobalt blue, and whilst it is still wet, brushing some pale raw sienna into part of it. For the brightest effect, work on a brilliant white paper such as a Bockingford paper as this will provide you with maximum contrast between the lights and the darks. The

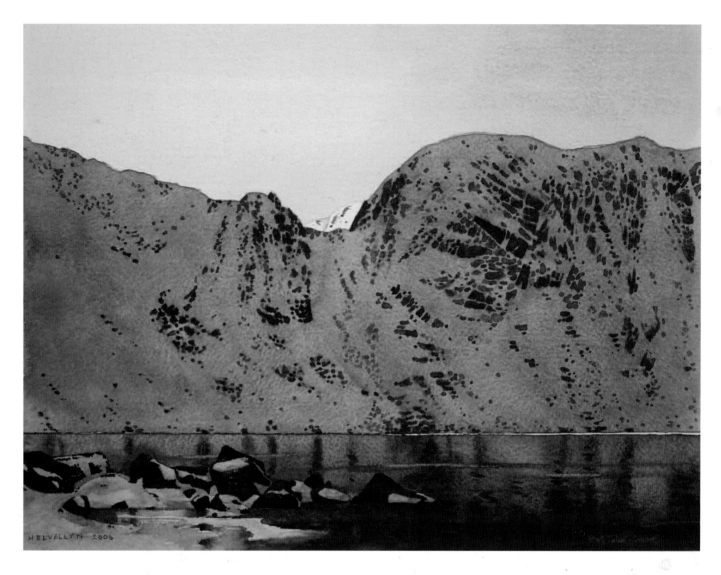

Helvellyn, 44 x 33.5cm (17¼ x 13¼in).
**Here the whole mountainside lies in shadow, with only
a flicker of light showing on the uppermost slopes of
Nethermost Pike in the distance. The dark rocks complete
the full tonal scale, giving depth and body to the mid-tone
sections of the painting.**

white of the paper depicts the colour of the snow and the rest
of the scene is built up applying shadows first, with darks and
details added after. Choose a scene with the extremes of con-
trast for maximum visual impact.

Negative shapes in a snow scene

The art of negative painting is one that requires constant prac-
tice as it appears in many different circumstances. It is used
extensively in watercolour painting because of the very nature
of working from light to dark with the medium. Negative paint-

ing can be described as putting in the darks to bring out the
lights and it features highly in snow scenes due to the tonal
extremes found within the picture. An instance of negative
painting within a snow scene is where a dry stone wall is
covered with snow but bits of the stonework show through,
leaving small ledges and shapes of white in the joins and cracks.
Similarly, mountain scenes illustrate the same kind of effect
where rock shapes and forms show through a covering of snow.
Usually a few dabs with a dark tone on a brush is all that is need-
ed to suggest this level of detail. One has to be careful with the
construction of a snow scene as it is important to layer the
colours in the right sequence in order to avoid muddying or
blurring stronger details. Apply shadows first, making sure they
describe any contours and shapes and ensure that they are of
the correct strength before progressing with any details. In a
mountain scene where dark rocks show against lighter snow, it
is imperative to map in the shadows first. If the order is reversed
and the shadow is layered over the top instead, the mass of rock
detail will lose its clarity.

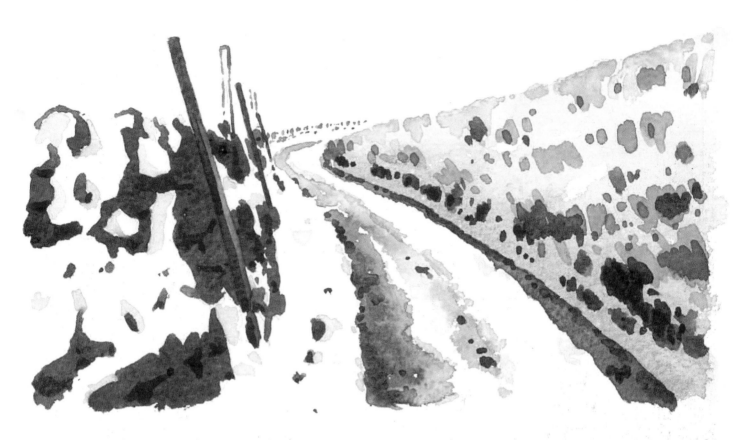

The various dark blobs and shapes painted loosely suggest
the patterns of the snow-covered features.

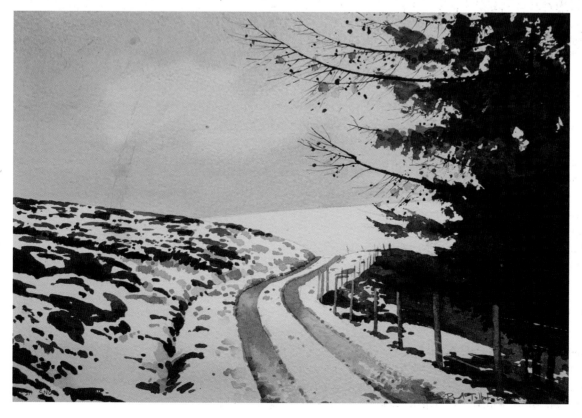

Fresh snow near Widdop, 36.5 x 25cm (14$^{1}/_{2}$ x 9$^{3}/_{4}$ in).
In this scene the shapes of moorland heather were painted with the contours of the landscape to describe the hit-and-miss effect of the fallen snow. Notice how each darker tone plays its part in the picture, forming new shapes or changes in the lie of the land.

141

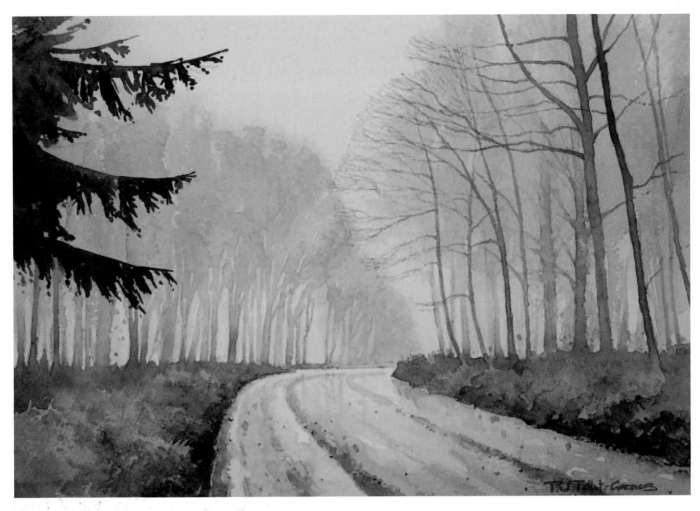

A wet day in the Howardian Hills, 34 x 24cm (13¹/₂ x 9¹/₂in).
I used a wet-into-wet technique to describe much of the background, gradually increasing the detail and strength of the washes as the trees neared the foreground. I kept the washes as subtle shades of grey to enhance the atmosphere and added reflections in the road for supporting effect.

To paint falling snow I usually use white gouache at the end of the painting and blob it all over the image. This technique requires a little confidence, especially if you are happy with the painting prior to flecking it with irremovable white paint! I use a loaded, medium-sized round brush and tap it to offload gentle blobs of paint, making sure they are falling in various sizes to create a feeling of recession. This technique is fine for gently falling snow but for blizzards and wilder weather it may be better to spatter on some directional marks using a stiff brush such as an old toothbrush. These approaches work best against a darker background such as trees or a dark sky. Do not water down your gouache too much or it may disappear as it dries.

Mist

Misty atmospheres, low cloud or fog are very useful to the landscape artist as they can be used for generating ethereal atmospheres as well as for hiding unwanted parts of the background scenery. I was once given a commission to paint a scene of the canal in my local town. The image was to be of a set of lock gates

where the canal terminated into a basin before entering a stretch of river. The subject itself was interesting enough with lots of lovely colours and textures in the wooden gates and the stonework, as well as some nice deep reflections in the water. However, right behind the scene was a modern supermarket building on one side and an old mill building on the other. Neither structure did anything to enhance the scene but to omit them completely would be changing the identity of the picture beyond recognition. After some careful consideration and a little study I painted a heavy mist right over the background so that the buildings were barely visible. This had a twofold effect, in the first instance it simplified the scene and gave the focus much more emphasis and in the second it added an ethereal atmosphere, which actually enhanced the subject. The finished

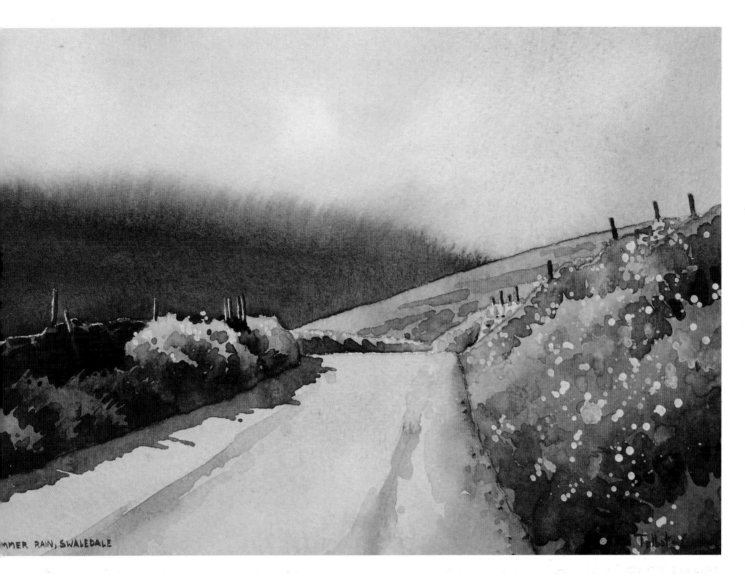

Summer rain, Swaledale, 26.5 x 19cm (10$^{1}/_{2}$ x 7$^{1}/_{2}$in).
**I washed in the sky and whilst it was still wet I brushed
strong paint on the left-hand hill allowing it to blur,
creating the effect of low cloud.**

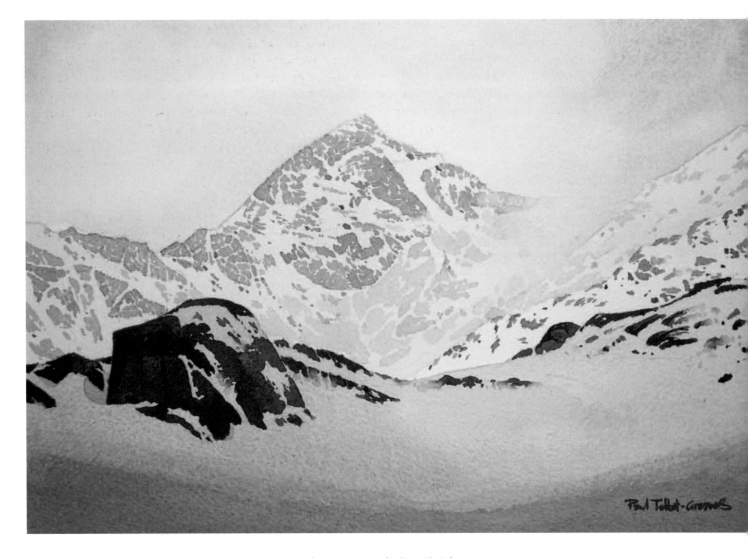

Snowdon, 34 x 24cm (13¹/₂ x 9¹/₂ in).
Here the rocks throughout the scene were of a similar tone and
colour but I exaggerated the aerial perspective by painting
them cooler and paler in the distance, slightly stronger
in the middle ground and much stronger and warmer
in the foreground.

painting turned out well and it now hangs in a local bar. Heavy mist tends to condense aerial recession and this effect can be exploited in a watercolour, especially if you are changing an atmosphere from a clear day to a misty day. Features in the middle distance need to be treated as though they were in the far distance with strong detail reserved for the immediate foreground only. A limited palette can be used for a misty scene, as a low number of colours will actually emphasize the atmosphere. The use of a blue and a brown will create a range of warm and cool greys as well as strong tones for the foreground area.

Techniques for painting mist

The soft shapes seen within a misty atmosphere can be painted in a number of different ways, all of which are equally viable. The most obvious choice is a wet-into-wet approach, where a thick consistency of paint is applied to wet paper in order to retain soft, blurry shapes. Keep the painting flat down so that the shapes do not run and distort. Alternatively, a shape, such as a building, can be painted first and allowed to dry before the misty sky wash is brought over the top. This approach will soften the pre-painted shape and in some cases it may lose too much clarity, however it works well on an absorbent paper such

as Saunders Waterford paper. On some papers, the image may wash off altogether when the sky is applied so it is worth trying out this kind of effect before you use it in a finished picture. In some circumstances only parts of a feature may be soft, such as in a mountain scene where rising patches of cloud soften the horizon in places, and this can be achieved by wetting out some of the paint with a clean damp brush as it is applied. Rising mist or cloud may also be taken out of a wet wash using screwed-up tissue. Alternatively, a similar effect can be achieved by removing dry paint from an area with a damp sponge.

Distance

Aerial perspective is the distance we see in a scene. Due to the interference of light, weather and moisture in the atmosphere, distant objects generally appear much paler and cooler in colour temperature. Compare the distant colours and tones to those in the foreground and you will notice that those nearer are stronger and less blue. To achieve this effect in your paintings, mix distant colours with a cool blue such as cobalt blue and use much stronger tones in the middle distance and foreground. For maximum effect, use a simple blue-violet with no detail for the distance. Use a little detail in the mid ground, and stronger tone using warmer colours in the foreground. Whether your subject matter actually conforms to this theory or not, it is worth exercising a little exaggeration in order to create depth and distance in your painting. Incorporating atmosphere makes the process a little easier but in any case you should not discount utilizing a single wash for the background for instance, even if the picture you are working from contains lots of detail.

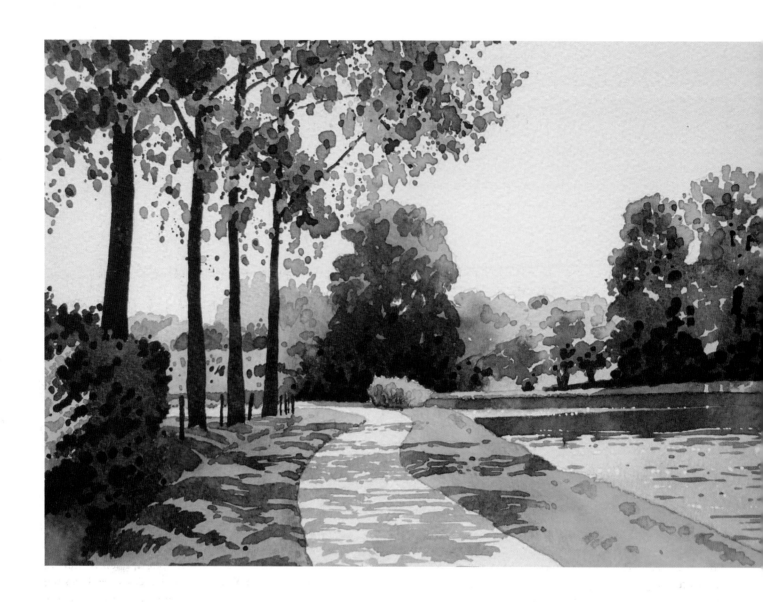

Lassay-les-Châteaux, 31 x 21cm (12¼ x 8¼in).
In this scene, the crisp French light illuminated
the whole landscape in clean colours and
translucent shadows.

PAINTING LIGHT

I once had an artist bring me one of his paintings depicting a building surrounded by trees. He said he thought it looked washed out and was going to paint it again so how could I suggest he improved on it next time? The painting was competently done and he had applied all the light and mid tones in the picture but no dark. This was why it looked washed out. I took a strong mix of Payne's grey and burnt sienna and painted a small amount of it into the windows of the building. It was rather like putting a match to a firework. We both stood in amazement as suddenly the painting burst into life. There was depth, light and shade, and the painting looked complete. He thanked me profusely for saving him the job of having to repaint it and I thanked him for making me realize how important dark is to light. We both learned a lot that day.

Light is very often the making of a painting. Some subjects and scenes remain uninteresting or lifeless until bright light and shadows are cast into the picture. I have experienced this on many occasions and people are genuinely surprised at how I can turn a seemingly everyday subject into a beautiful painting. I do not perform the magic though, it is the light that does. Light not only provides interesting shadows for the painter, it creates tonal extremes too. Without dark tones and areas of shade the lighter parts of the picture will not stand out, and similarly without light areas the darker tones have no comparison, so it is very important to consider tone when painting light effects. It is not about how much light you put into a painting – it is how dark you can make your darks. Many watercolour painters are pretty reticent at applying strong, dark tones to a picture but how can you contrast the light if you do not put in the darks? The darker your darks are, the lighter your lights will appear to be and this is all down to controlling tone in a competent manner. The more practice and exercise work you do in this area, the better your paint mixes will become and subsequently, the better your paintings of light will be.

The best times to study light

Although bright light in a painting will generally portray a more exciting image than that of a dull day, there are occasions when light is also fairly uninteresting. When the sun is high in the sky throughout most of the day in high summer the lighting remains flat and constant with very short or little shadow to provide interesting forms and shapes. The best times for painting at this time of year are early morning and late evening when the sun is either rising or setting. The red glow of the sun can add exciting hues to the landscape as well as the appeal of the long cast shadows stretching across the picture. If you are working outdoors, it is also more comfortable to cope with the early morning and late evening temperatures too. Springtime brings fresh bright light and the sun can still be low enough in the sky for most of the day to provide some appealing shadows. Autumn casts low warm light throughout the entire day and this is one of the best times of year for capturing subjects containing long cast shadows. Winter light is pure and if snow is on the ground the light can also be very intense. Again the sun is low in the sky all day long so interesting shadow patterns can be exploited in a subject. As a painter looking for a focus, I tend to concentrate primarily on tonal patterns and fascinating shadows rather than the subject itself and this probably explains why I discover many opportunities for paintings.

Areas of light

Areas of intense light will be bleached to a certain degree. Extreme lighting may be reflected from a surface as white, in which case you can leave an area of white paper to depict this. Sometimes, leaving chinks of white paper within a wash can help to suggest sparkle and shimmering light. Usually it is beneficial to put in some sort of local colour but you must use plenty of water with it so that the colour becomes pale. The paler the tone, the brighter the light will be but only when the

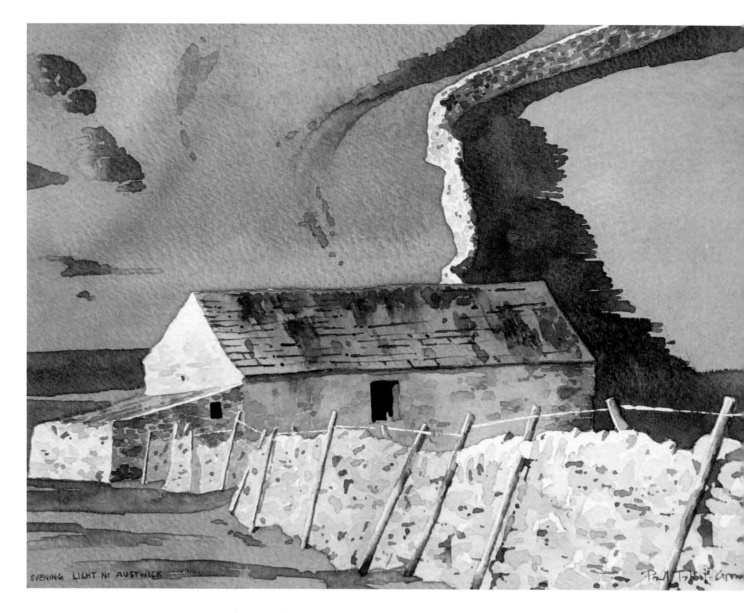

Evening light near Austwick, 28.5 x 21cm (11¹/₄ x 8¹/₄in).
**Here the long cast shadows of low evening light make
the painting interesting, creating new shapes and angles
within the picture.**

darker elements of the painting are added. Do not confuse the brilliance of light with colour intensity and apply the colour as a thick heavy wash. This is a common mistake when using bright yellows, for example in a summer scene or the evening glow of a sunset. If paint is applied thickly, it will appear opaque because the brilliance provided by the white paper has been covered up. In circumstances like this, it would be difficult to really make the area shine, even when darker tones are put into the picture to provide contrast. To counter this problem, add lots of water to the colour before applying it. The more water there is in the mix, the more the white of the paper will show through the colour

and therefore the brighter your area will appear to be. Brightness is formed by contrast between dark tones and light tones, not necessarily by colour intensity.

Areas of dark

The darker tones within a scene are caused by a lack of light, which forms what we know as shadows or shades. Shadow generally refers to a cast shadow across a lit part of the

In this instance the lit side of the shed appears to be fairly intense due to the darker tones surrounding it.

landscape. Shade refers to larger areas of shadow. On a dull day with no light, the entire landscape can be described as being in the shade. The darkest tones in a painting are often the deepest areas of shade where very little light penetrates. Shadows and shades are formed by adding some grey, such as Payne's grey or black, to a paint mix (*see* Colour mixing, page 117). This is because when colours are seen out of direct light they become slightly grey. The further out of the light they are, the greyer they become until ending up virtually black. It is important to recognize the general tonal patterns within a scene before you start painting so that you can mix the colours accordingly as you build it up. Very dark areas adjacent to very light areas will give you maximum contrast and hence maximum visual impact.

Controlling tones

Tone can be especially difficult to control and a certain amount of practice will really help you with your work. Ideally, you only need to work with a maximum of five tones, which are graded from light to mid-light, mid tone, mid-dark and dark. Try to categorize the tones of your painting into these simpler forms. To do this, first identify the lightest and darkest tones within your chosen scene by using a tonal strip or tone finder. Place the strip onto the picture you are working from and compare the tonal strengths directly. When you know which areas are to be the lightest and which areas are to be the darkest, everything else in the picture has to be a tonal grade somewhere in-between. The painting is then constructed in a series of layers and planned applications so as to create a clean and crisp finish. Generally, the process is to work from the lightest tones through to the darkest tones although this is not always the case. Occasionally,

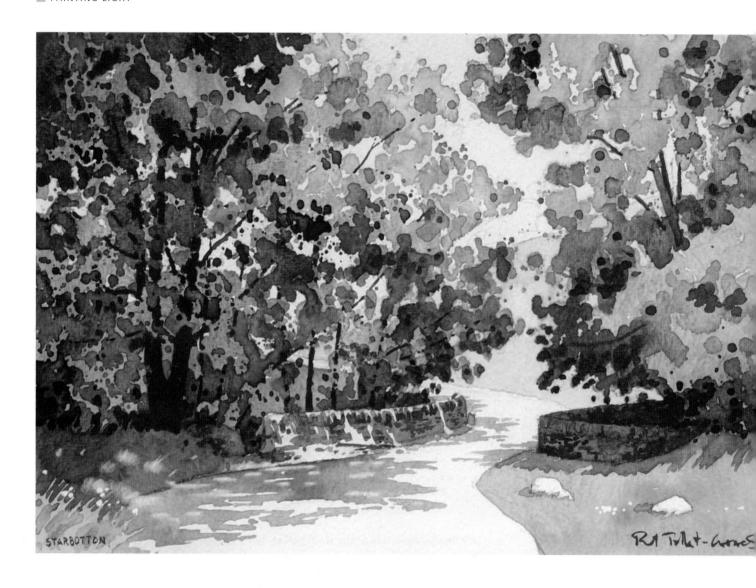

Starbotton, 30 x 20cm (11³/₄ x 8in).
I used raw tube colours for the
brighter areas of the scene, mixing
them together where necessary and
adding Payne's grey to the mixes to
form the shadows and shades.

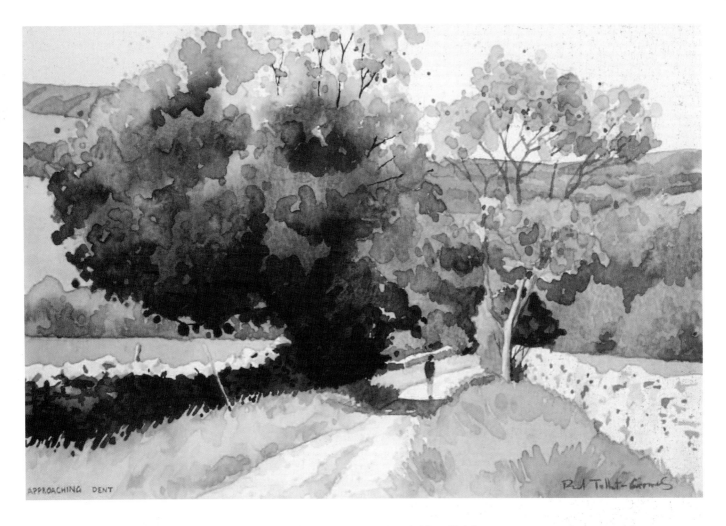

Approaching Dent, 32 x 22cm (12¹/₂ x 8¹/₂in).
**This painting shows the use of a full tonal range, from the light
tones of the right-hand wall to the mid tones of the
background and the darkest tones in the main tree.**

it is beneficial to apply some of the darkest tones in the painting at an early stage so that the lighter and mid-tones can be gauged more easily. There is no definite answer to this and the method is entirely subjective to the scene you are painting. I usually find it is acceptable to paint a darker tone prior to surrounding lighter tones if the dark area will not be disturbed during the application of the lighter washes. Paintings constructed with a five-tone scale are not only much easier to paint but are also much easier on the eye of the viewer.

Practise your tones

Tonal work can be difficult to understand and control but it is an extremely important element of painting. Tones make the layers of the landscape stand out against each other and without some

consideration given to the tonal structure of a painting, the whole image can easily end up looking flat and lifeless. It is therefore worthwhile studying the different tones of your scene before you begin to paint. Identifying the darkest and lightest is fairly straightforward and this will leave you with three remaining tones to use constructively. The amount of different tones and shades that we can see in general is far too many to be handling in paint so a little creative manipulation has to be undertaken. Try to pigeonhole the tones of your scene into the five tone strip, so for example some may be made slightly stronger and others made weaker in order to fall into each tonal category. Painting each of the five tones as an exercise is invaluable work as it gets you accustomed to mixing and recognizing the appropriate strengths.

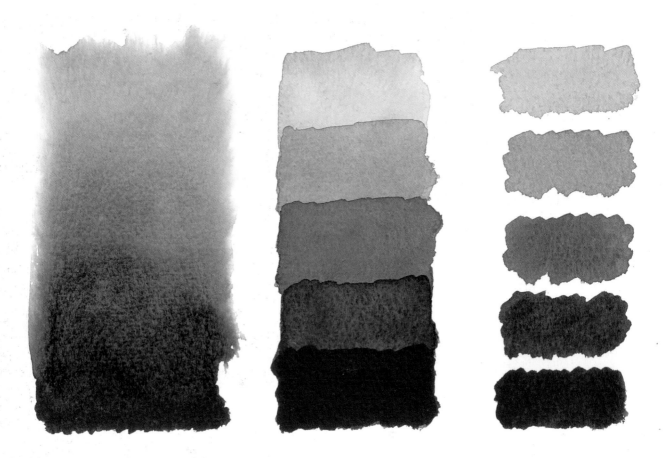

LEFT: **I softly graded the tone wet-into-wet, starting with pure pale colour and ending up with full-strength colour mixed with Payne's grey.**
MIDDLE: **The tones here were built up in layers. A strip of the first tone was painted and allowed to dry before being overlaid with the same strength again from the second tone downwards. This creates the new tone, which is left to dry, then painted over with its own strength to form the third tone and so on.**
RIGHT: **These tones were mixed to their respective strengths in the palette and painted directly onto the paper.**

Tonal scales

There are three key ways of building up gradations of tone in a watercolour painting, all of which are useful for creating different effects and appearances, especially where painting light is concerned. One is where the wet-into-wet technique is employed, starting with a pale tone and gradually adding stronger paint to the wetted area. This can either be instigated on a surface wetted with clean water or added into a wet colour wash. The process is ideal for capturing skies, soft light or soft-edged shadows within a scene. Another technique is to use an over-layering technique, where each wash is allowed to dry before the next is applied on top. As the subsequent washes are applied, the tone becomes another shade darker and consequently this approach is very versatile as you can build up layers of different tones, textures and three-dimensional effects at the same time.

The third way is to paint the shapes and forms of the picture using instant blocks of tone, for example a light block here and a dark block there. This is a great way of achieving instant contrast between light tones and dark tones and hence creating bright light effects. The choice of method to be used is entirely subjective to the scene being painted at the time and the approach and style of the artist. Whichever method you employ, there is no substitute for practising tonal scales in these three different ways and exercise work is a great way of learning how to control the varying tones within a light and shade scenario.

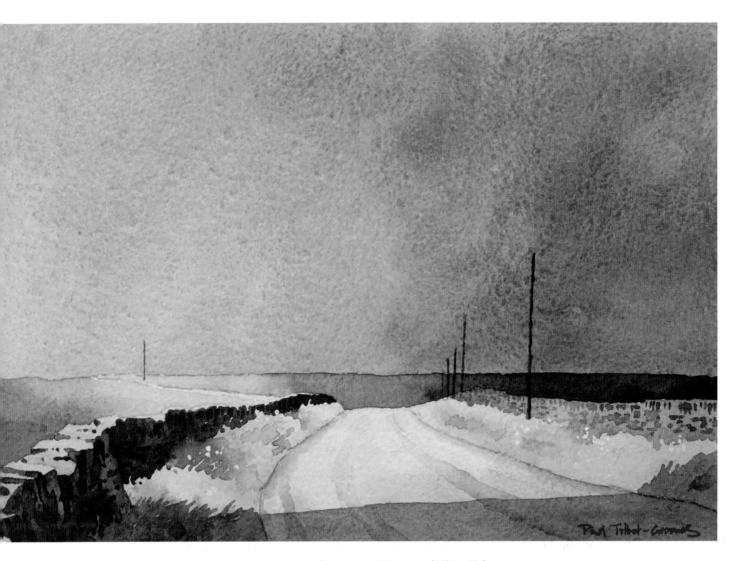

Crossing the moor, 26.5 x 18cm (10¹/₂ x 7in).
**The cast shadow across the foreground changes colour in each feature, for example the
wall, the grass and the road, however the overall tone stays relatively constant.**

Colour

Although tone is the main factor when painting light, colour
adds the dynamics of temperature and reflected light. The
amount of colour seen within a tone depends on the strength of
the light and the location of the colour. Seen in bright sunlight,
the colour may only be a tint but in deep shadow it may be a
dark grey connotation. When adding grey or black to a colour
to create shades, the amount to be mixed depends on the
colour intensity of the area. Although shadow is generally dark-
er and greyer in colour, areas of shade adjacent to brightly
lit parts of the painting may absorb slightly more light, which
will reflect more colour intensity than deeper areas of shade
elsewhere. In these instances, more of the colour should be used
and the amount of grey reduced.

Creating shadows

Shadows are areas of the picture that are out of the light and as
a consequence they take on a greyer, darker hue. The colour
section of this book covers the theory of adding grey or black to
a colour in order to darken it. A shadow across an area of white
will show the colour of ultraviolet such as a blue or a violet. Snow
scenes are a good example of when to use these colours for
shadows. However, in other instances where shadows are cast
across several changes of colour, the process becomes a little
more involved. To create a shadow of a particular colour, you
must first look for the pure version of the colour as seen in direct
light. Colours not seen in direct light become shaded, so you
only ever need to look out for two basic forms – light or shade.
I see many instances at exhibitions where shadows have been

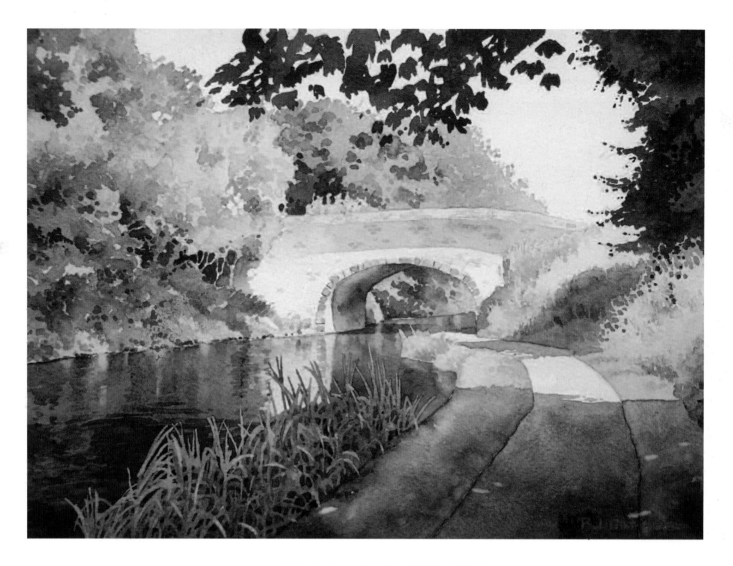

In the shadows, 34 x 24cm (13¹/₂ x 9¹/₂ in).
**The underside of the bridge is in dark shade but light reflecting back
into the area from the water casts a warm glow. Here I brushed raw
sienna into the area wet-into-wet. Notice too how the colours of the
shadows on the towpath are intensified nearest the light.**

glazed across the landscape using blue and although it may appear to work in some cases, more often than not the shadows do not gel with the underlying landscape and instead sit there like unnatural stripes of alien colour.

This is especially noticeable when the shadows are painted darker. A cast shadow will be relative to the colour it falls across. A shadow across a green field will become grey-green. A shadow cast across a variety of different coloured features will change colour appropriately. For example, a shadow cast across a road with grass on either side will change colour according to the colours underneath. The shadow for the grass will be grey-green and, assuming that the tarmac is violet in colour, the area of the road will be grey-violet. The areas must first be coloured if any light is to show elsewhere around the shadows. To paint

the shadows, take the relative key colour for each feature, in this case green and violet and add either grey or black to it. The shadow is then painted as two different stages, one for the grass and the other for the road with drying in between to avoid each section from blurring. The strength of the shadow will be subjective to the light in the picture but in general the darker it is the brighter the lighter areas will appear to be. In theory, the overall tone of the shadow stays constant throughout but the colours change according to the underlying features. If your cast shadow has strikingly disparate tones in each section, it will probably look wrong.

Sometimes shadows are cool in temperature and other times they can be warm. It is possible to alter the temperature of a shadow by mixing other colours into it wet-into-wet, such as

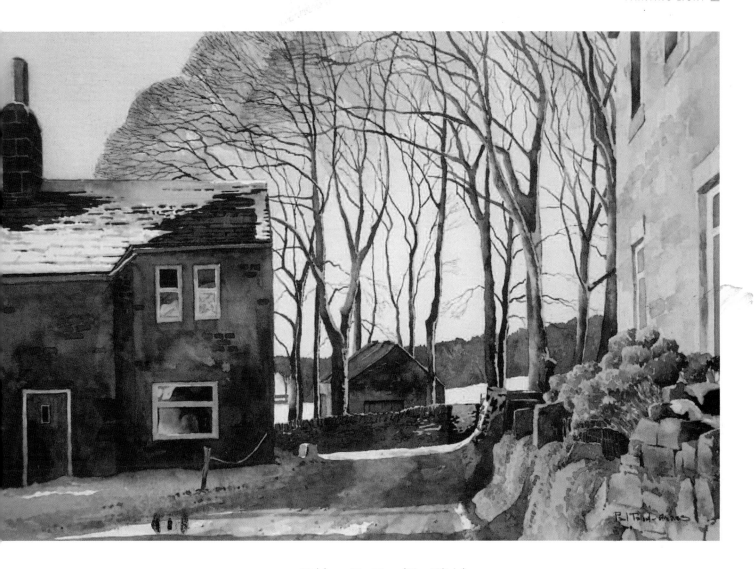

Walshaw, 46 x 31cm (18 x 12¼in).
**The contours of the cast shadows show the slope and
angle of the right-hand wall and their cool colour
helps with the mood of the winter's day.**

cobalt blue for cooler areas and maybe raw sienna for warmer areas. The blue or yellow will influence the shadow in a very subtle way. In instances where a shadow is adjacent to a brightly lit or brightly coloured area, some of the light or colour may be reflected back into the shadow especially at the edge. A limited wet-into-wet technique can be employed to achieve the subtle effect by applying the shadow colour and whilst this is still wet brushing some of the reflected colour into it.

Shadows cast across the landscape follow the contours of the land, for example downhill, uphill, across level areas, up and over walls. Although this sounds obvious, it is relatively easy to forget about these various directions and lines, especially if you are inventing a new light direction within your painting. The line and form of a cast shadow are important elements in livening

up a picture so it is essential to ensure they follow any potential contour changes of the land and landscape features.

Dappled shadows add a further dimension and can really spice up the feeling, mood and temperature of a summer scene. To create dappled shadows, I first ensure that I am working on a paper that will release paint easily, such as a Bockingford paper, and initially paint the shadow area as a solid block of tone. When the area is dry, I take a damp brush and scrub out the dappled shapes, again making sure they follow any contours, angles, slopes and changes of direction. The effect leaves behind soft, rounded lighter marks on the paper and these can be re-tinted using a very pale mix of each underlying colour to create a realistic-looking light effect.

CAST SHADOWS CHECKLIST

When you are tackling cast shadows in your painting, refer to the following summary in order to ensure you have considered everything.

SHAPE
Follow shapes of cast shadows and look especially at the quality of the edges of the shadow. Hard-edged shadows indicate a wet-onto-dry approach whereas soft-edged shadows require a wet-into-wet technique. The quality and crispness of the shadow will be entirely subjective to the picture you are working from.

CONTOURS
Take great care to note how a shadow follows the lie of the land and the corresponding features as the inclusion of strongly described contour shadows in a painting will really make it appear solid and lifelike.

REFLECTED COLOURS
Anything adjacent to a cast shadow that is brightly coloured or lit may well reflect some of its colour into the shadow itself. Watch out for this subtle effect.

REFLECTED LIGHT
Light can be reflected into shadows or recesses, causing some shadow areas to be unexpectedly light or warm in temperature. Look out for varied colour intensity within the shadow itself.

TONAL VARIETY
Take note of any changes in tone within shaded and shadow areas.

TEMPERATURE
Look carefully into the shadow and decide if it has an overall cool or warm hue.

OPPOSITE: **Here hard-edged shadows create crisp shapes, with their contours following the shapes of the walls and the track. The dappled light was removed with a damp brush and the shapes re-tinted.**

ABOVE: **In this example, hard-edged cast shadows are thrown across the scene, with the nearest one following the contour of the land. Notice the whitewashed shed has warm light reflected into it through the addition of raw sienna and this is contrasted with the cooler shade of the nearer building.**

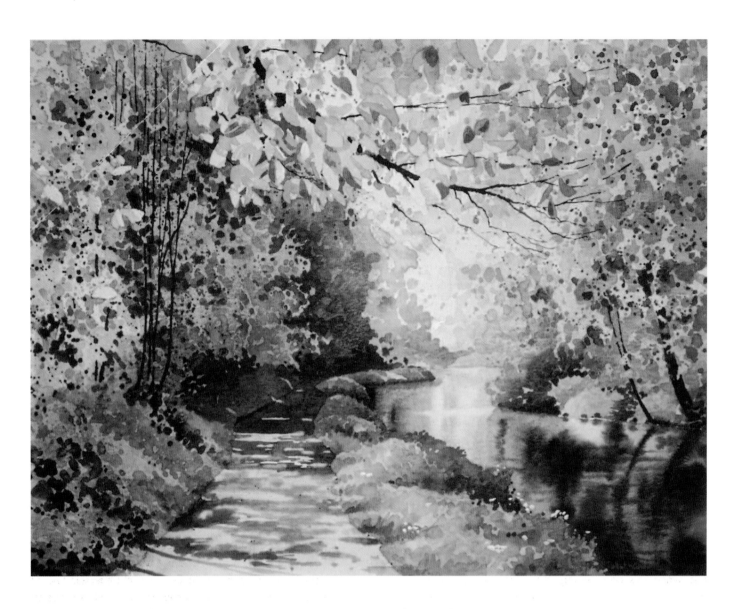

The towpath, 46 x 36cm (18 x 14in).
Built up from a handful of carefully
applied techniques, this painting required
a fair amount of planning and forethought
before I began.

BUILDING TOWARDS A PAINTING

Watercolour painting does not come easily and although it sometimes looks easy there is very often a lot of background study and work gone into the artist's craft. I frequently receive comments at my workshops, courses and demonstrations such as, 'He's painted that in less than an hour!' to which the stock answer is, 'But it has taken me twenty years to get there.' Sometimes you should be realistic about your own abilities and put in independent practice in order to improve further. At other times you may need to put your brushes down and seek out inspiration and ideas from elsewhere. This chapter might just help to give you some further ideas and methods to follow for your own journey of development.

Working with study sheets

In the excitement of creativity, we all strive to paint at our best and when this goes wrong, the next painting becomes our intended best work and so on. In many cases, artists repeatedly let themselves down through their lack of ability in painting a certain landscape feature or in handling a particular watercolour technique. These issues can raise their heads time after time and yet how many painters actually do something about it? If you keep tripping yourself up over the same mistakes you must take stock and practise the elements that you are finding difficult before going any further. Creating study sheets is one of the best ways of learning about an individual subject or technique. There is a lot to take in with landscape painting and complementary study should be a natural supplement to creating paintings. Begin your studies on half or full imperial sheets of watercolour paper. It may seem like a large space but you will soon fill it. Title the sheets, for example, walls, trees or buildings and date them if you wish, as this will provide you with some reference later on. Work on small studies out of context of a full landscape and start in the top left-hand corner of the sheet. Use as much reference as possible, gathering images and pictures from your own photographic collections, books or magazines so that you have a large variety of images of your chosen subject. Begin painting how you would normally paint the topic and analyse why you do not like your results or why you think certain bits look wrong. Look carefully and compare your painted image with the reference you are working from. It is very important to make notes alongside your efforts either in pen or pencil because this has a twofold benefit. Firstly, it provides you with information for a later review of your work and secondly, it engraves the information into your conscious. Do not be dismissive or negative with your notes; instead, write positively. Retreat away from comments such as, 'Don't like this, it's awful and the stones look childlike'. Instead write, 'Wall needs some further study in order to gain a more realistic appearance. The stonework detail needs further study too'. You might also add some notes about the colours you were using or the brushes you had selected at the time. Your initial image will then lead you on to the next study, which in this instance may be several careful examinations of stonework detail. You might try working from different photographs in order to create variety and understanding of your subject seen from various angles. In your next progression of studies, you could try using different brushes, ruling pens and sticks to work out which tool you think works the best for painting this kind of feature. After several small painting exercises you might move towards working on textures, colours and various topographical styles of walls and so on. This work can be just as enjoyable, if not more so, than trying repeatedly to create a finished landscape painting. The advantage of these learning sheets is that you can pick them up and put them down as you wish so you can spread your studies over a number of days or even weeks. As an extension to your worksheets, you could set yourself field study trips where you venture into the landscape to learn how walls interact with their surroundings, for studying further details or for gathering additional information that your reference material did not initially yield.

You might also consider using some of your study sheets to practise certain techniques such as dry brush, wet-into-wet, wash control and so on. Use the worksheets in the same way, making constructive notes as you go and analysing the problem

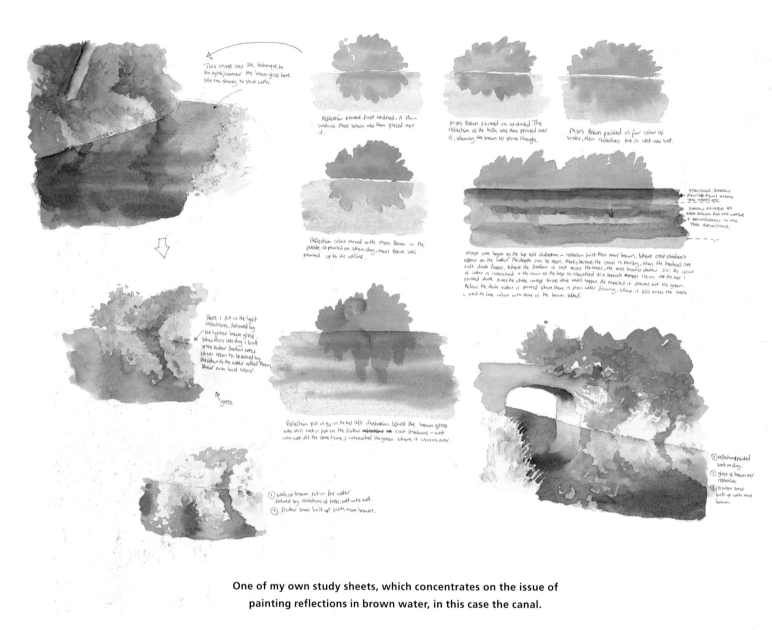

**One of my own study sheets, which concentrates on the issue of
painting reflections in brown water, in this case the canal.**

areas. When you have reached a point at where you have improved your handling of the topic, try introducing it into a simple landscape painting. For example if you were practising basic washes, you might create a landscape from a series of overlapping, simple watercolour washes. Keep all your notes and worksheets together in a folder and use them as reference in the future.

Correcting watercolours

One reason why the watercolourist holds back from being free and spontaneous with his or her work is because of the general conception that mistakes cannot be easily rectified and this creates a reserved approach to handling the medium. Not being able to eradicate mistakes in watercolour is true to a certain extent but there is a lot that can be done to restore a painting destined for the scrap heap. First of all, know your paper. Different papers have different qualities and characteristics and the only way to familiarize yourself with their individualities is to frequently use them (*see* Papers, page 18). Some papers are internally sized, meaning the paint sits on the surface rather than soaking in to it and this allows you to sponge off entire sections of dry paint pretty successfully, providing you have not used too many staining colours. Once the paint is removed and the paper is back to a dry state, the painting can be initiated again using the original drawing. Other papers may be surface sized and paint has a tendency to soak more permanently into these. Sponging out entire sections of paint on this paper is therefore

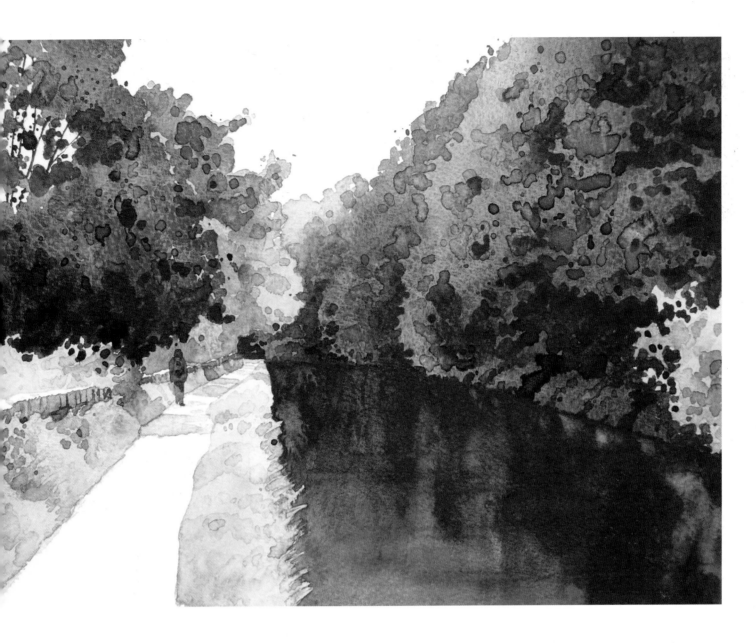

A walk along the canal, 31 x 21cm (12^{1}/$_{4}$ x 8^{1}/$_{4}$in).
**A painting of the canal exploiting my newly
learned techniques for painting the reflections in
brown-coloured water.**

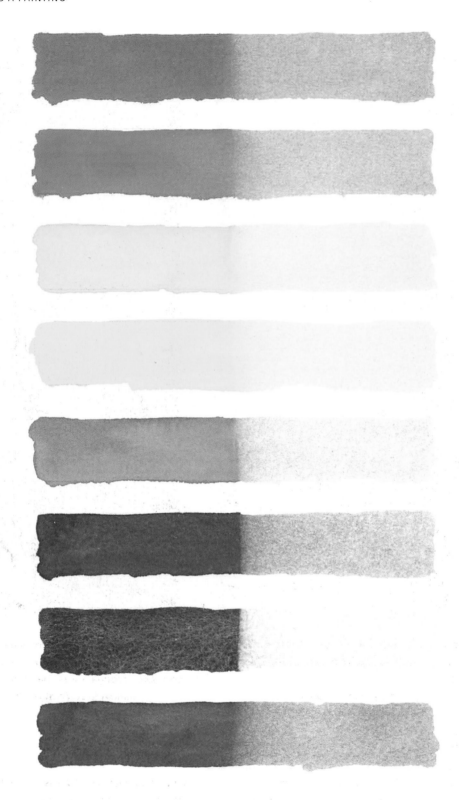

From top to bottom: I used permanent rose,
cadmium red, cadmium yellow, lemon
yellow, sap green, Hooker's green, French
ultramarine and phthalo blue. I washed the
colours off the paper evenly and this shows
how some of them stain more than others.

In this image, I formed the rising mist with a brush whilst painting the sky but the effect almost disappeared as it dried. Using a damp sponge, I was able to recreate the effect by removing some of the dry paint.

less successful than on a less absorbent one. Do not let these characteristics put you off using individual papers because each variety has its positive features too.

Certain paints are staining and in some cases can be extremely difficult, if not impossible, to remove. This does not necessarily mean that you should avoid using them – just be aware of their characteristics when you do. Staining pigments are ideal if you want to overlay a number of washes, maybe with a glaze as they will resist smudging, so think about what you want to achieve before you start painting. You can get an idea of the staining properties of a colour from the manufacturer's colour chart or you can investigate your own palette. Paint a strip of each of your colours across a sheet of watercolour paper, let them dry and then gently sponge off half of the exercise with clean water. Most colours will wash off, some completely, but the staining colours will remain to a certain degree.

Rectifying mistakes

Simply painting over a mistake is a mistake in itself as this will only exacerbate the problem. Taking off an area of paint using a wet sponge or tissue is generally the first port of call when correcting an error. For smaller areas, a stiff oil painter's brush dampened with water is ideal for loosening the paint and for larger areas a sponge or similar is required. When the paint has been washed off and removed, you need to let the area dry before repainting over it and in most cases this treatment will

sufficiently cover a mistake. If the paper has become really dirty and stained, for example where a light wash is required, then you may have to reconsider the content of the painting or the structure of your tones. I once scrubbed off an entire painting and changed the whole mood into an evening scene, using strong washes of Indigo to cover up the stained remnants of my earlier attempt – and it worked! Sometimes you may wish to restore light or white areas after you have corrected a mistake. Using white gouache can work but it can also look false in certain circumstances. The only other option is to scratch out the paint with a sharp blade or sand an area down with medium grade sandpaper. You must look upon this as a final action because if you paint over a scratched area it will soak up the paint and the mark will stand out permanently.

Creating projects

Your studies will definitely improve your technique and ability and may inspire you to take things a little further with your paintings in general. You may wish to create some study sheets of trees, covering the different seasons and styles before setting yourself a goal of painting a number of finished works based around this subject. Creating projects like this takes time so set yourself a realistic timetable and do not expect too much from yourself initially. You might consider creating a number of paintings from a forthcoming holiday, in which case you could take photographs and make sketches while you are there with future paintings in mind. Having a goal is definitely an inspiration to keep painting. After some time, you may have amassed a number of paintings based around a particular theme and as a consequence the more adventurous artist may even consider organizing his or her own exhibition.

Exhibitions take up a lot of preparatory time, especially if you are planning to do everything yourself. Firstly, the paintings need completing and although you may have twelve months to finish all the work, the period will soon pass, which is why you must break the time down into smaller manageable stretches. Painting three or four pictures a month sounds more achievable than forty eight in a year. I usually try to theme my exhibitions, even if it is a loose description such as 'Mountain and Moorland' or 'The North'. Having a title like this gives me more freedom of interpretation within the range of subjects available for me to paint. Publicity and advertising is usually set well in advance so the sooner you have a title and a theme the better.

Framing and presentation

Framing can be expensive to contract out and time consuming to do yourself. If your practical skills are not up to standard, it will be best to let a professional framer do the work for you as presentation accounts for how the picture will sell. It also reflects on you as an artist, how you see your work and how much you really care about what you are doing. Time and time again I see paintings exhibited in the most appalling manner. Badly cut mounts are common and inexcusable, as your local framer will either cut one for you at a reasonable cost or you can buy them mail order from contract framers. The wrong-coloured mount or frame can affect the appearance of the painting and chipped or damaged frames make the work look tatty. I have seen paintings hung where the picture has literally been hanging out of the back of the frame and also instances where the frame has been hanging apart so much that it really should not be on the wall. Even the best painting will look shabby in a tattered frame. If cost is an issue, try to source a contract framer who will make your frames in batches of standard sizes and these are usually cheaper than bespoke frames. The benefit of working to standard sizes means your work becomes interchangeable with many different styles of reasonably priced frames.

Keep your inspiration levels up

Occasionally painters get the blues where nothing seems to go right and motivation comes to a standstill. At times like this it pays to take a little rest from your work especially if painting has been fairly intense. Try visiting an art gallery or an exhibition by another artist and fill yourself with ideas and stimulation. Buy a painting DVD and watch your favourite artist at work, or better still book yourself onto a course or painting workshop. I often have professional artists dipping into my workshops and it is very humbling to see them leave refreshed and full of inspiration. There are many art clubs and societies in towns, villages and cities throughout the world where you can go along and share ideas, information and encouragement with like-minded people. Watching demonstrations by other artists can be both informative and stimulating.

Composition

Success with watercolour is based around planning and this is what composition is essentially all about. Paintings are often enhanced with a little consideration and composition beforehand. Oil paintings can be altered as the picture develops but

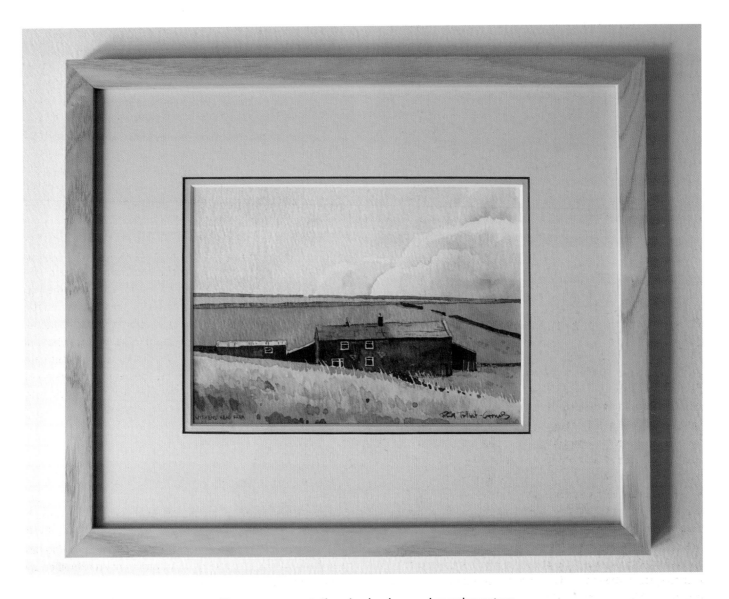

Keep your presentation simple, clean and complementary
to your work. Here a blue slip matches the sky in the
painting and a black core top mount finishes the border.
A simple frame such as this often works better than
ornate or highly decorative mouldings.

because of the very nature of watercolour, composition plays an even more important role than ever. Changing one's mind halfway through a watercolour can have disastrous consequences for the end result. Composition and planning make all the difference between a confidently executed watercolour and an over-laboured painting. Composition is the arrangement of shapes and forms within a scene into a harmonious relationship and although there are a few guidelines to follow, the results can often be varied depending on the individual's interpretation of the landscape he or she is working from. There may be many solutions to composing a particular scene so the artist should not question his or her decisions or indeed arrangement of the landscape. Each artist is individual and what one person concludes about a particular composition may not necessarily correlate with the decisions of another. It does not mean to say that either is right or wrong, providing that the design has been arrived at using standard compositional guidelines. Composition is usually worked out on scraps of paper before the painting process begins and depending on the complexity of the picture it may take up to a day to work out a design, especially if the scene contains lots of detail and distance.

LEFT: **In this photograph Pen-y-ghent sits in the distance, with the rock-strewn slopes of Ingleborough dominating the foreground. The subject is a little indistinct as it is and it required some thought and design in order to bring the image closer to what I had in mind.**

BELOW: **A quick thumbnail pencil sketch mapping out my idea of bringing the distance closer and using only a small section of the foreground. Working in this way prevents you from changing your mind halfway through the painting.**

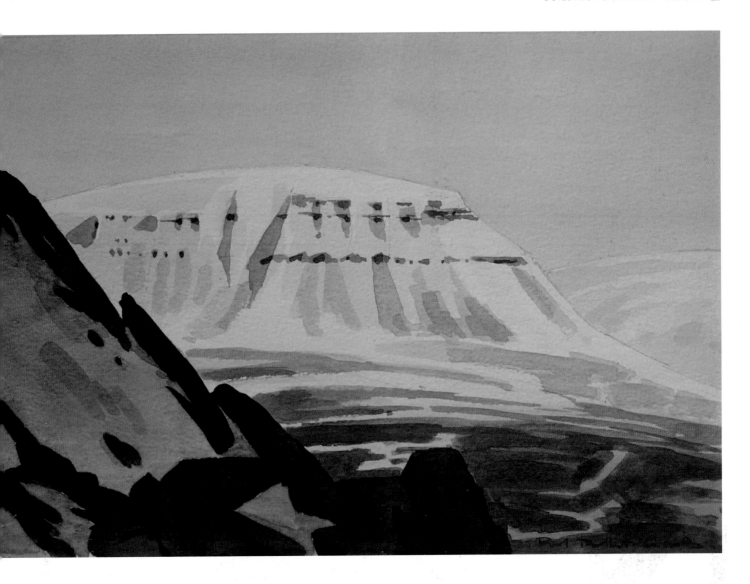

Pen-y-Ghent from Ingleborough, 36 x 24cm (14 x 9¹/₂in).
The painting was constructed from my thumbnail drawing,
using the photograph as reference for the colours and details.

Using the rule of thirds

The rule of thirds forms the underlying construction of a well-composed painting or photograph. Artists and photographers use this means of working to arrange a subject into harmonious proportions and to decide on what elements do, or do not, fit in with their design idea. To start with, simply divide your painting into three equal sections each way, either in a faint pencil line or as a mental image. Where the lines intersect is where the eye will naturally rest and with this in mind it pays to begin with a focus or focal point in or around this area. Always try to avoid visually dividing a painting in half. It can be easy to overlook these points and unfortunately they generally do not show up

until you have finished the painting! Watch out for horizon lines dividing the picture in half horizontally or for features such as posts, masts or trees halfway, dividing the picture vertically. Always be mindful of the rule of thirds, right from the point where you collect the subject matter from which to create the painting.

Using a focal point

The focal point of the painting is the element that attracts the viewer's attention and generally speaking it will be the reason why you found the scene interesting in the first place. A focus to

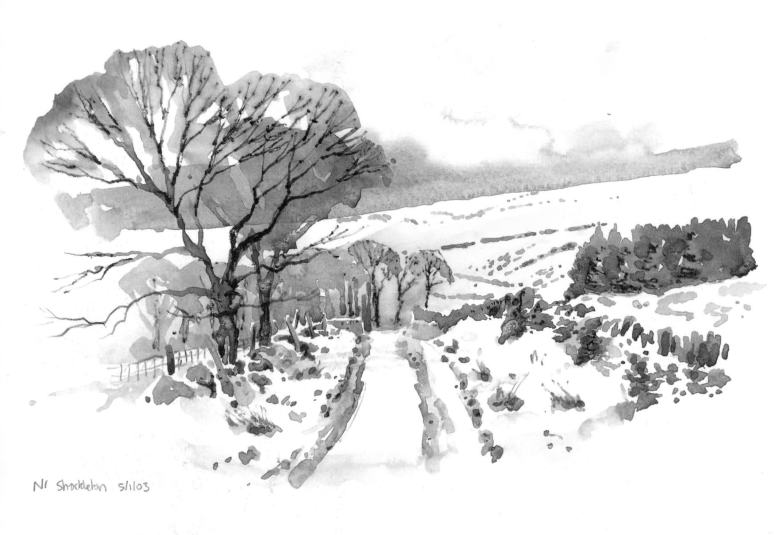

Nr Shackleton 5/1/03

**In this sketch the composition has been arranged around
the rule of thirds, dividing the scene up proportionately
and using the left-hand trees as a strong element to
balance the eye towards that side.**

a painting could be anything that stands out such as a building, a figure or an animal, a tree, a post or pole or even a rock. The list is endless and the choice of the subject is an entirely individual one. The focus does not even have to be a three-dimensional object. It could be a bend in a road or a patch of light on the landscape. The idea of the focus is to act as a visual anchor or a strong statement about the scene. Once a focal point has been established, the rest of the scene can be constructed around it.

Using a lead-in

It is generally a good idea to have a background or support behind the focal point and definitely a lead-in to the subject.

This can take any form but should visually lead the viewer to the focal point. A typical lead-in might be a road, path, wall line or stream. Again, the lead-in will be entirely subjective but it does not have to be in the original scene to be used. Elements of the landscape can be brought in from elsewhere to enhance or improve a composition. Try to make them fit topographically, for example you would not include Californian redwood trees in a painting of Greece. It does pay to look around you though when collecting subject matter because there may be bits and pieces that can be used in your picture. As an example, on one of my sketching trips I came across a tremendous mountain view from a vantage point down in the valley. The only way of leading the eye into the picture successfully was to bring the river a few hundred feet up to my viewpoint (pictorially of course!). I sketched and photographed the river before moving further up

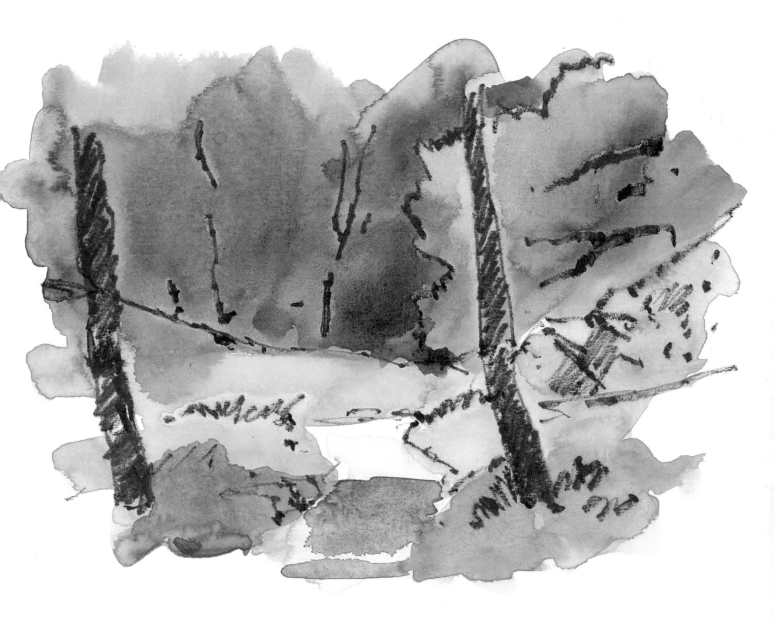

**In this ten-minute sketch the path leads the eye into
the painting and around the corner out of sight.
Where the path disappears is where the eye rests and
therefore it becomes the focal area of the picture.**

the mountainside to complete the scene, with all the mountains in place behind. When you are considering a scene to paint, give some thought to the focus, the lead-in and the background and try to play down any other distractions. Not all paintings need these elements but they do form the traditional construction of a landscape painting and as a consequence the combination generally works.

Further composition

If necessary, you can balance the scene by using other features or heavier tones elsewhere in the picture. At this point, you may decide to experiment by omitting features, moving them or even adding them. Your aim is to improve the scene and to simplify it to a certain degree, for example you might choose to leave out people, vehicles, gates or any other part of the

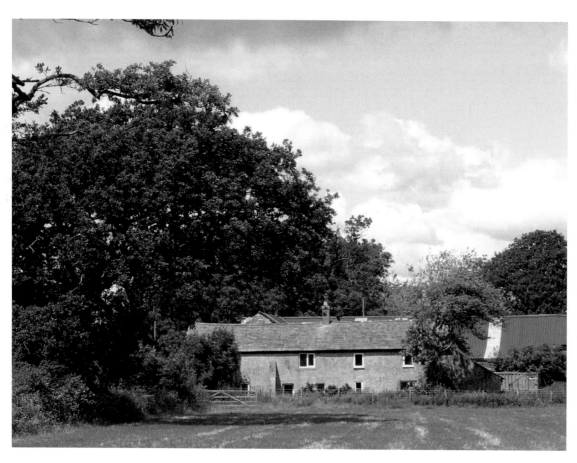

I took this photograph because I was interested in the L-shaped composition formed between the tree and the buildings. My initial thoughts were to remove the gate on the left and the buildings behind in order to place more focus on the main building.

landscape. The overall arrangement of the shapes should be pleasing to the eye. If you feel you can happily gaze at a particular scene, then the composition is probably acceptable. If however your gaze is distracted from your focal point or you feel your eyes dancing all over the scene, then you should do something to make the picture easier to look at. Do bear in mind that not every picture will naturally compose well. Those photographs that have been taken with a painting in mind stand the best chance of success, as you will have collected the appropriate material for the painting. Snapshot photos and holiday snaps may not have enough information to be used as reference material. There may be certain elements of a scene that attract you to some of these photographs; however, the overall image might just not gel as a picture. In cases like this, it is probably better to source out a different image altogether. The more preparatory composition and design work you do, the easier the whole process will become in general. This in turn makes the process of photography and subject collection much easier and so the cycle goes on.

Try out your composition

If you are considering moving or omitting landscape features then you may wish to try and visualize your ideas before you

begin painting the picture. Traditionally, artists have used thumbnail drawings for this kind of work in order to assist them with their ideas. Thumbnail sketches are basically small sketchy drawings or paintings roughed out on ordinary cartridge paper or watercolour paper. You can work on thumbnails using any medium such as pencil, ink and so on, although it often pays to use watercolour so that you are creating a true representation of how your ideas may appear. They do not have to be big or even detailed so long as they help you decide that your composition looks right for you. Keep thumbnails fairly quick and sketchy so that they do not become laboured or time consuming. Usually a few pencil lines will give you an idea of your proposed design. Sometimes you may wish to take things a little further, for example trying out a colour scheme or sky and here it may be wise to add some watercolour to the thumbnail.

Considering the size of the painting

The size of your painting should be taken into consideration at the compositional stage. Generally, the bigger the painting is going to be, the more detail will be needed to make the space exciting so make sure you can provide enough interest before you begin. For example, a painting containing a large sky and a simple strip of landscape would probably suit a smaller size of

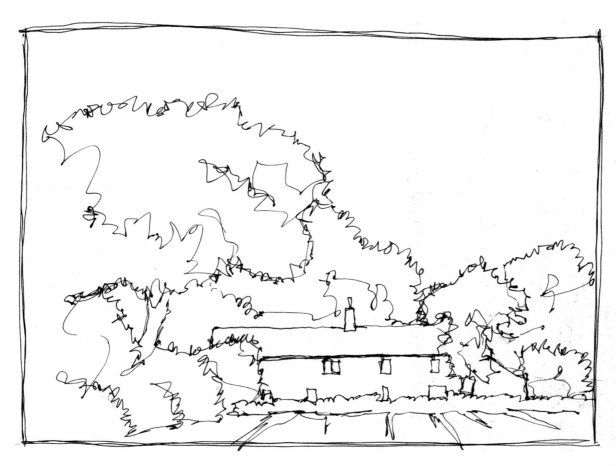

LEFT: **Using an ink pen, I made a quick thumbnail drawing of the scene to check if my ideas would work visually.**

RIGHT: **I was happy in principle with the line drawing but I also wanted to know if my colour scheme idea would work. Using watercolour and an ordinary black colouring pencil, I built up a quick image to see how things would look. Working through preparatory sketches like these helps to keep the finished painting process running smoothly.**

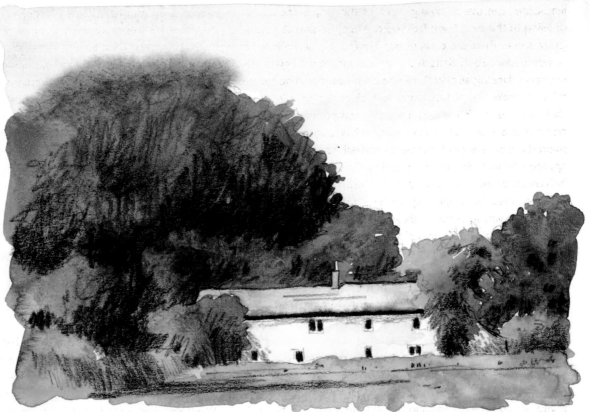

171

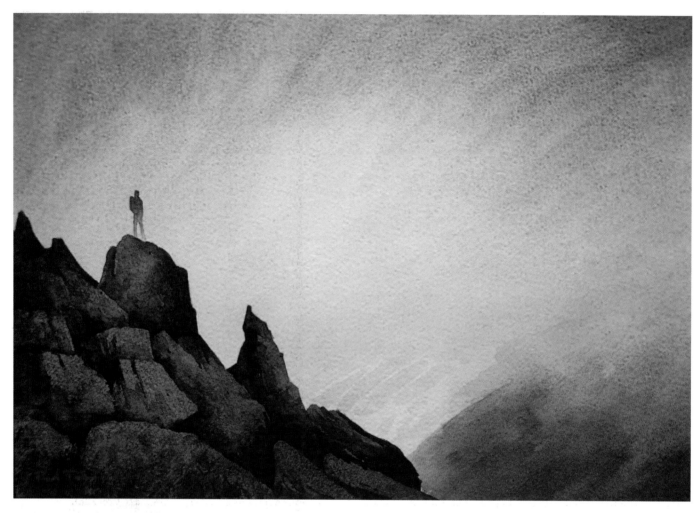

Looking through the mist on Esk Pike, 33 x 23cm (13 x 9in).
**By bringing in an atmospheric sky and isolating a large part of the landscape, I was able
to force more focus on the figure. The clean finish to this painting would not have been
possible had I not worked through a number of thumbnail ideas and trials beforehand.**

picture than a bigger one due to the lack of varied interest and detail throughout the scene.

Enhancing your overall composition

There are a number of ways of increasing the visual impact of your composition beyond moving the odd tree or omitting vehicles and so on. Consider simplifying your scene further still, to make the focus as prominent as it possibly can be. Alternatively, you might increase the amount of contrast around the focal area for the same reasons. You could consider the sky as part of the scene and bring in some atmosphere. Rain and mist are great excuses for simplifying the landscape as they can be easily made to cover unwanted hills, trees or buildings. Try to think of any other ways you can increase the prominence of your focal point before you succumb to the finished painting process.

There have been occasions where I have spent hours composing a scene and then finally moved the focal point before I started to paint because it did not quite look right where I had initially decided to put it. Until you actually begin painting, do not discount moving elements of your picture but make sure you get everything out of your system before putting brush to paper. Taking breaks between ideas will help you to pace yourself, they will keep you refreshed and they will stave off the desirable urge to just get on with the painting regardless. Sketching subjects outdoors really helps to familiarize artists with their subject. Even if your sketches do not turn out quite as you would have liked, the fact that you have looked and studied is enough. In the same way, composing scenes involves you in the process of looking and after all the hard work of creating thumbnail trials and so on, the final painting process should become a little easier.

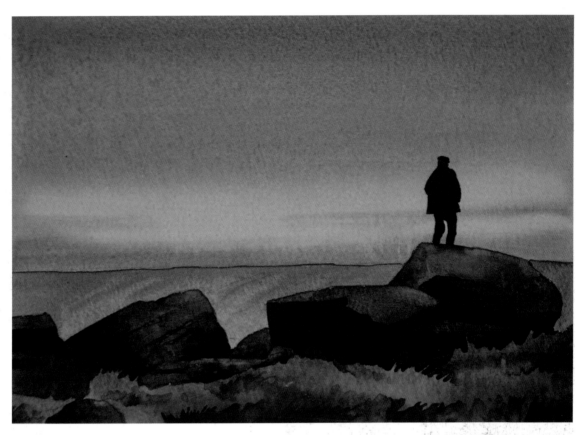

The end of the day, 28 x 20cm (11 x 8in).
I brought the figure into this scene from some of my photographic reference material, thus creating a strong focal point.

Working on your own painting

When you have worked out your composition and maybe created a sketch or sketches based on your alterations and ideas, you are ready to turn your plan into a finished painting. Surround your workspace with your photographs of the scene and of course your final thumbnail drawings, which will act as your blueprint. When you are painting, try to refer to your thumbnail sketches more than your photographs, although photographs do make great reference for details and colours. It is easy to become drawn more towards the photograph but the risk here is that you may end up copying every single detail, drifting away from the changes that you made earlier.

Creating your own workspace

Finally, it can be of immense benefit to have an area set aside for your painting, whether it is a corner of a room or an entire room in itself. Space can be an issue, especially if you are also in control of a family but having to move things out of the way on a regular basis is not the foundation for inspiration. Watercolour does not require much room and you could keep your materials to a minimum or just well organized so that they do not take up too much space. Have a table or desk specifically

COMPOSITIONAL AWARENESS CHECKLIST

Although composition is a personal decision about our own work and how we wish to portray it, there are a few common guidelines to follow that will keep your paintings interesting and well balanced. Here is a checklist to consider when you are working through your next composition:

● Do not point anything with a face out of the picture, as your gaze will naturally follow it. People, animals, buildings and vehicles should all be faced into a picture or omitted altogether.

● Try not to place your focal point centrally (unless the balance of the overall picture weighs to one side).

● Do not cut the picture in half, either vertically (watch where you put those poles!) or horizontally (check your horizon is not halfway up the picture).

● For a traditional arrangement, make sure your composition contains a focal point, background and a lead-in.

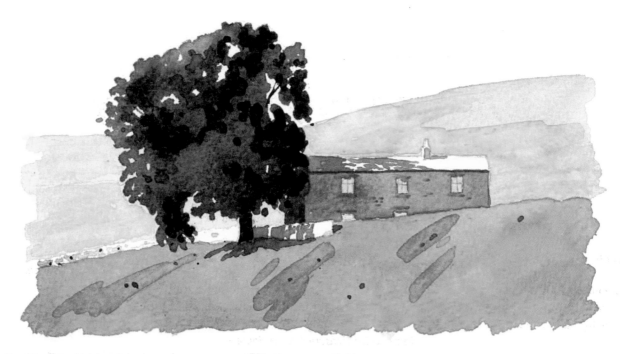

Cottages near Keld.

organized for your painting. Being able to walk away from a project and return to it as you left it can be beneficial to your progress as this allows you to take breaks or have time off from painting itself. Searching for a particular colour whilst halfway through a wash will have a negative effect on your concentration so keep things tidy and know where all of your materials are. Those who are lucky enough to have a room dedicated to their craft will be able to store things like paper, frames and mount board and maybe have an easel permanently set up. Try to make sure you have good lighting, either natural or via daylight-simulation bulbs. These provide a clear light that does not change the hue of the colours you are using. There is nothing worse than working on a painting under electric lighting only to see the colours change when the picture is displayed in natural light. North light provides good, consistent flat light without sun glare or yellowing so try to set your painting table underneath a north-facing window if possible.

If a room in the house is unavailable, why not look towards the garden? Summer houses and sheds offer an external working environment that is separate from your home life and in that respect they can make you focus on your work more or inspire you to take your painting more seriously. Without family, television or telephones to disrupt you, they can present an oasis of relaxation offering total concentration. I know a number of people who paint in their sheds and even one lady who uses a caravan next to her house. With a little bit of thought and initiative, you can help yourself to improve your work and at the same time maybe increase your output by setting yourself your very own working space.

Summary

Landscape painting in watercolour involves a love-hate relationship for many artists. The enjoyment one can find in creating one's own idyllic landscape is indescribable and the hours of lost time in achieving it is often the best relaxation anyone can have. No wonder then that painting holds its own therapeutic tendencies. On the other hand, striving to gain perfection can be a frustrating as well as a long and arduous battle. I have known people pack their watercolours away in defeat only to start painting again several months later. My own inauguration to painting was a great disappointment that hit me square in the face as I had assumed for many years previously that I would find it easy. I rose to the challenge, however, and eighteen years later I am still learning.

That is not to say that it takes eighteen years to master the medium as we all have our own learning levels and the rate at which we pick up and master information is entirely governed by our circumstances and personal ability. Painting is definitely a subject that can be learned and improved upon and it is not reserved only for those with a natural talent. We all want to paint like a master but unfortunately there is no shortcut around learning and practice. However the best policy is to enjoy what you do and let your improvement come naturally. Those lucky enough to be able to venture into the landscape will find pleasure in visiting the scenery they enjoy painting. Those unable to get about can share the same experiences through painting the scenery they would like to visit. Remember – a day spent on a landscape painting is a psychological visit to that location.

FURTHER INFORMATION

By the Same Author

For more information about the author's work, visit www.talbot-greaves.co.uk.

Books

Watercolour for Starters
(David & Charles)
30-Minute Landscapes
(Walter Foster Inc)
30-Minute Landscapes in Watercolour
(Harper Collins)

DVDs

Watercolour for Starters
(Teaching Art Ltd)
Create Light and Shade in your Painting
(Teaching Art Ltd)
Create Atmosphere and Mood in your Painting (Teaching Art Ltd)
Improve your Tone and Contrast
(Teaching Art Ltd)

Other Resources

Art-related Book Club

Painting for Pleasure, Brunel House, Newton Abbot, Devon TQ12 4BR
Tel: 0870 442 21223

DVDs

APV Films, 6 Alexandra Square, Chipping Norton, Oxfordshire OX7 5HL
Tel: 01608 641798
www.apvfilms.com

Teaching Art Ltd, P.O. Box 50, Newark, Nottingham NG23 5GY
01949 844050
www.saa.co.uk

Magazines

Artists & Illustrators, 26–30 Old Church Street, London SW3 5BY
Tel: 020 7349 3150
www.aimag.co.uk

International Artist, P.O. Box 4316, Braintree, Essex CM7 4QZ
Tel: 01371 811345
www.artinthemaking.com

Leisure Painter, Caxton House, 63/65 High Street, Tenterden, Kent TN30 6BD
Tel: 01580 763315
www.leisurepainter.co.uk

Art of England, Woodgate Cottage, Trentham Estate, Stone Road, Trentham, Stoke on Trent ST4 8AX
Tel: 01782 644 845
www.artofengland.uk.com

The Artist, Caxton House, 63/65 High Street, Tenterden, Kent TN30 6BD
Tel: 01580 763673
www.theartistmagazine.co.uk

Art Suppliers

SAA, P.O. Box 50, Newark, Nottingham NG23 5GY
01949 844050
www.saa.co.uk

St Cuthberts Mill, Wells, Somerset BA5 1AG
Tel: 01749 672015
www.inveresk.co.uk